Coloring for TRANQUILITY

Bath • New York • Cologne • Melbourne • Delhi

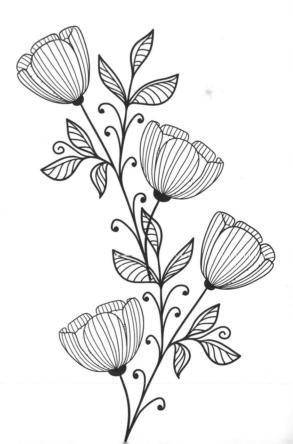

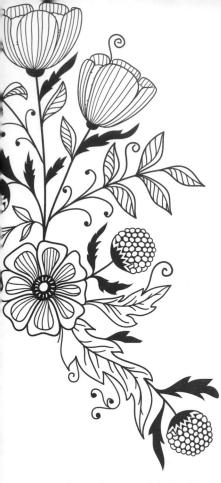

This edition published by Parragon Books Ltd in 2015 and distributed by

Parragon Inc.
440 Park Avenue South, 13th Floor
New York, NY 10016
www.parragon.com

Copyright © Parragon Books Ltd 2015

Images are courtesy of Shutterstock and iStock Cover design by Beth Kalynka

All rights reserved. No part of this publication may be reproduced, stored in a retrieval system, or transmitted, in any form or by any means, electronic, mechanical, photocopying, recording, or otherwise, without the prior permission of the copyright holder.

ISBN 978-1-4748-1742-4

Printed in US

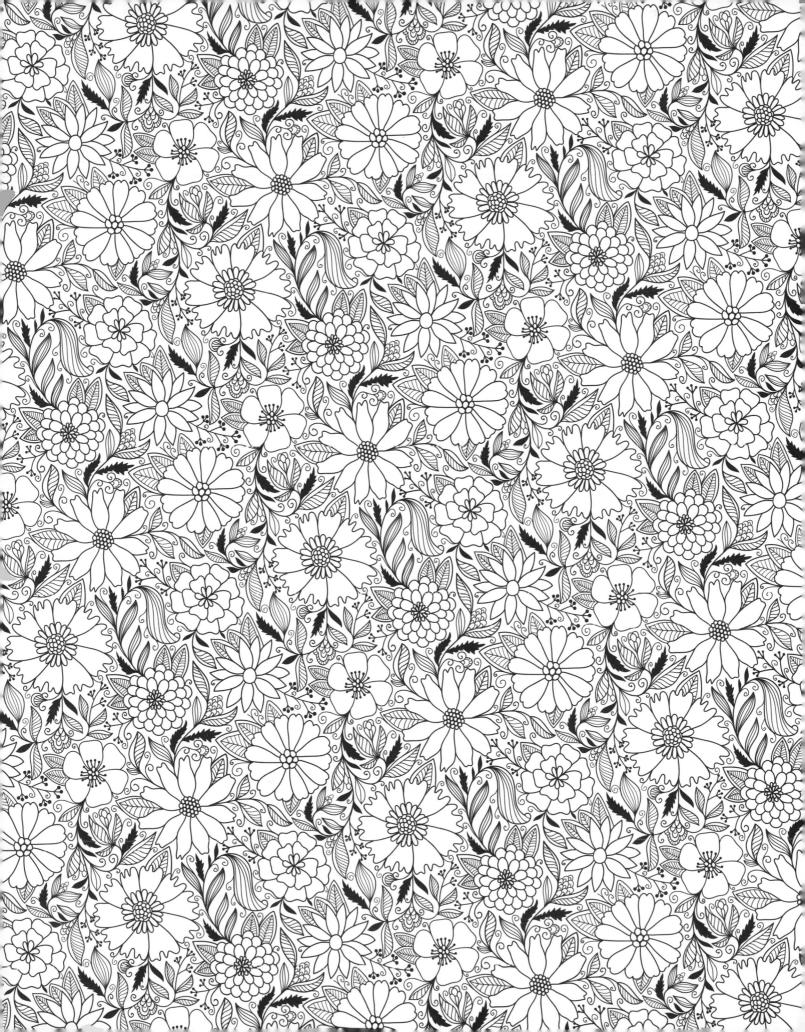

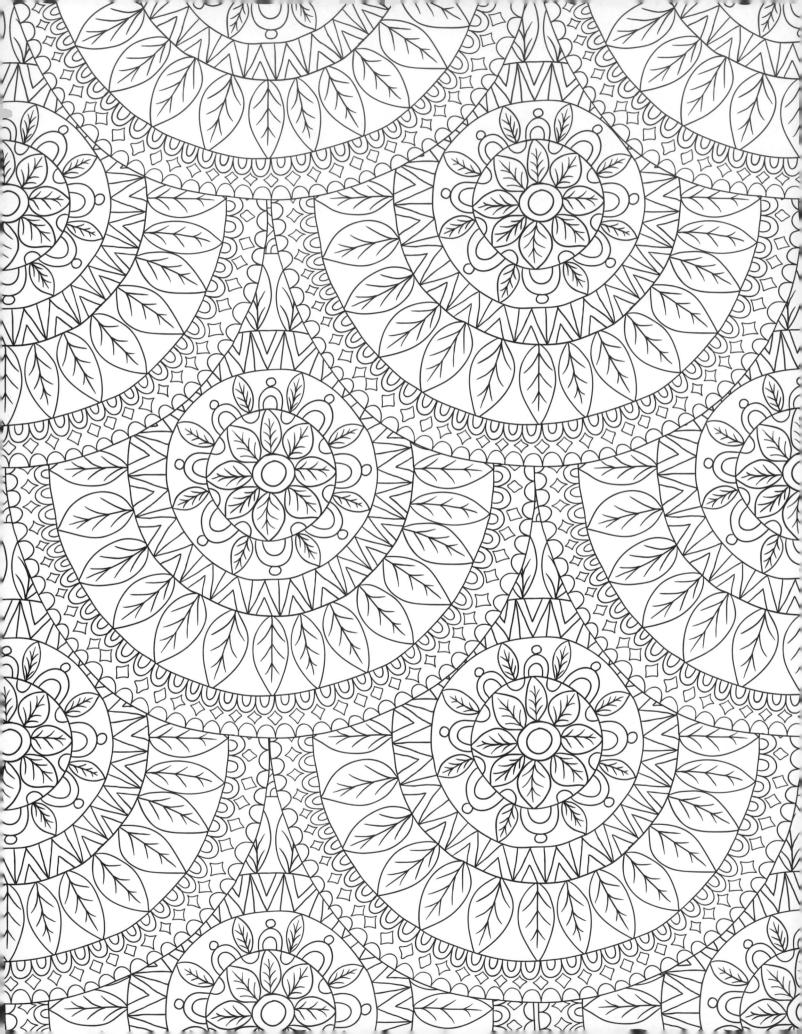

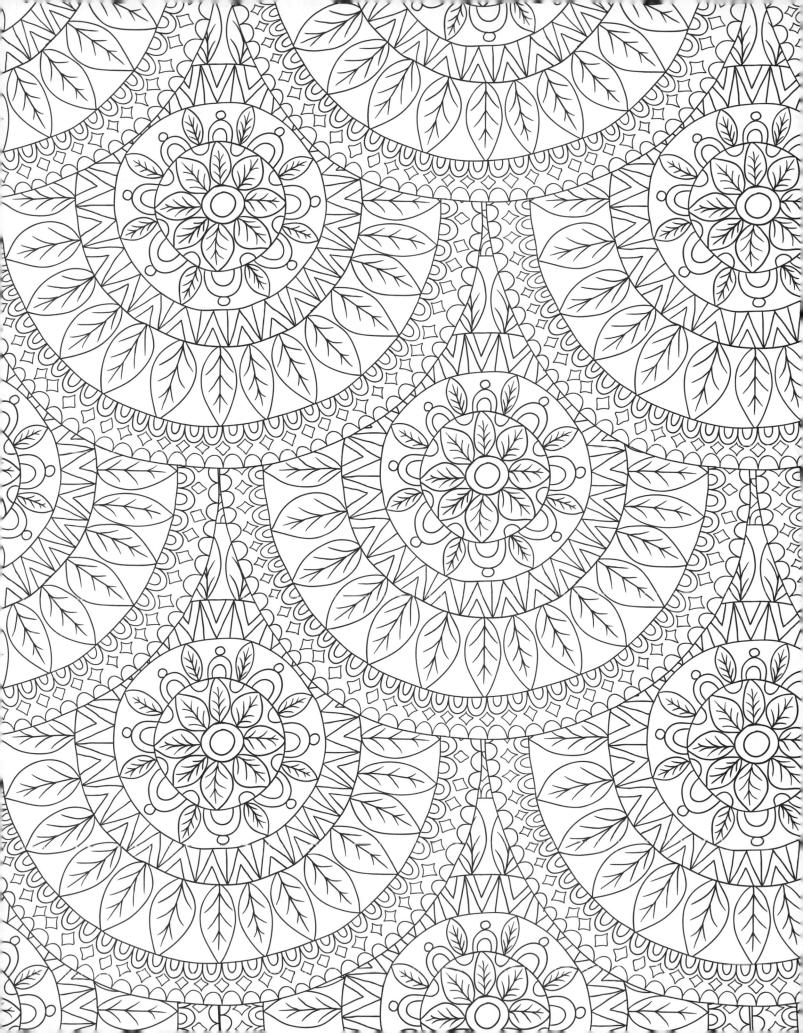

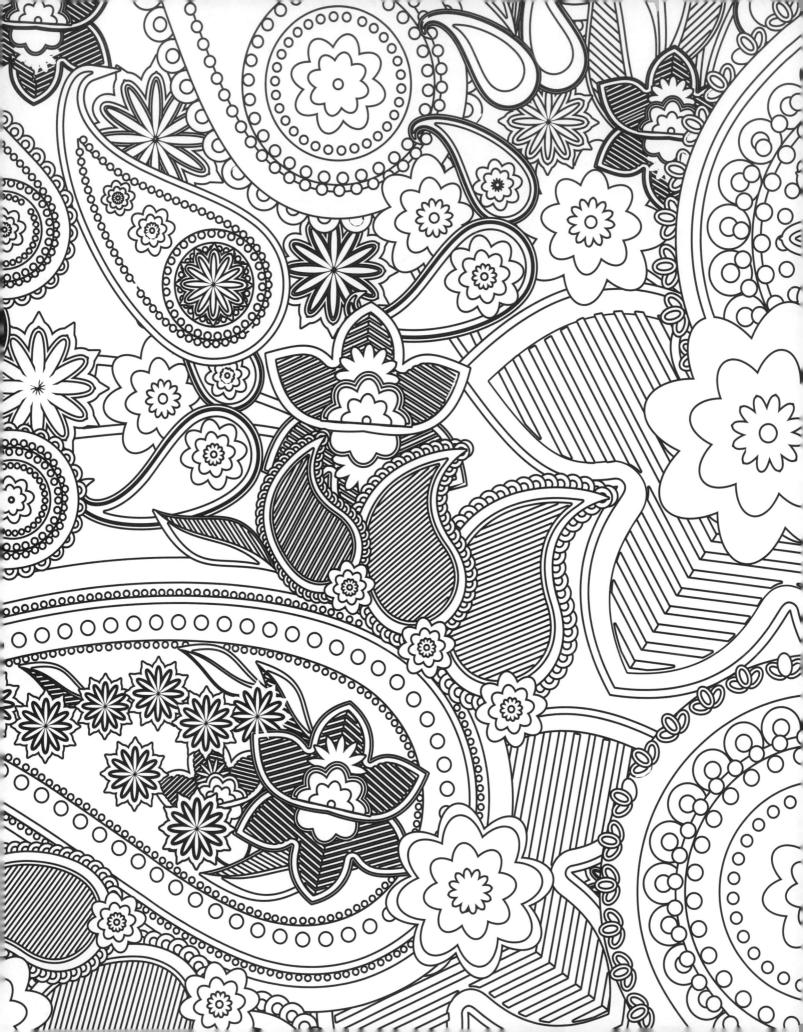

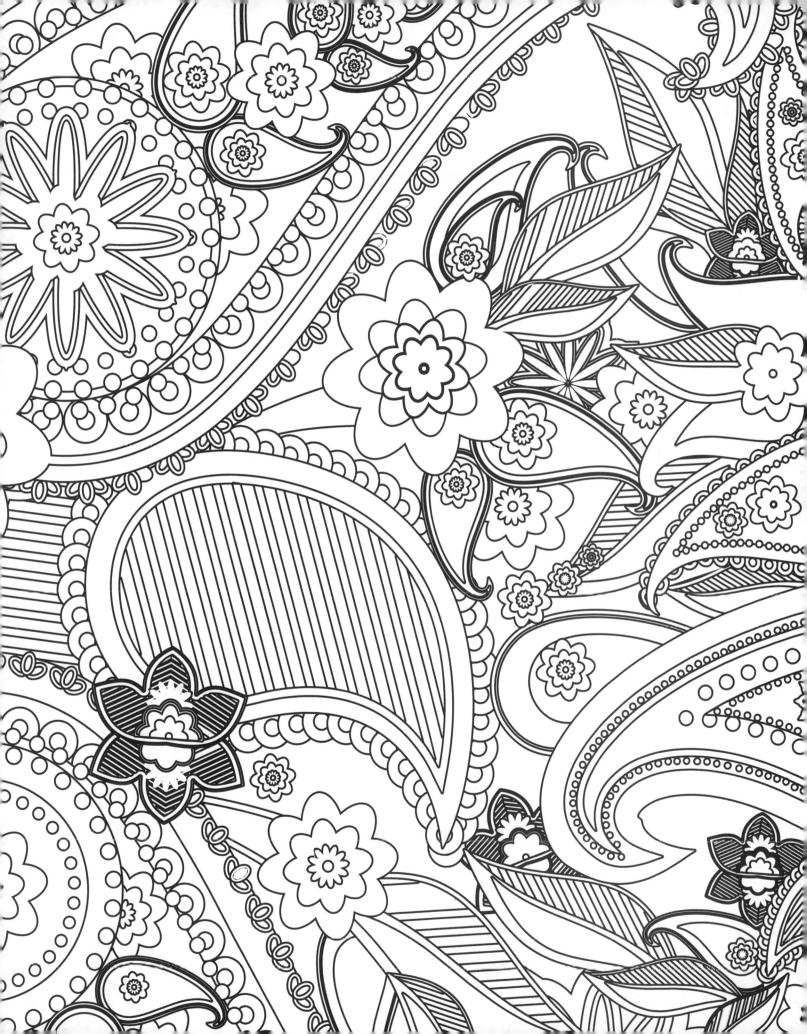

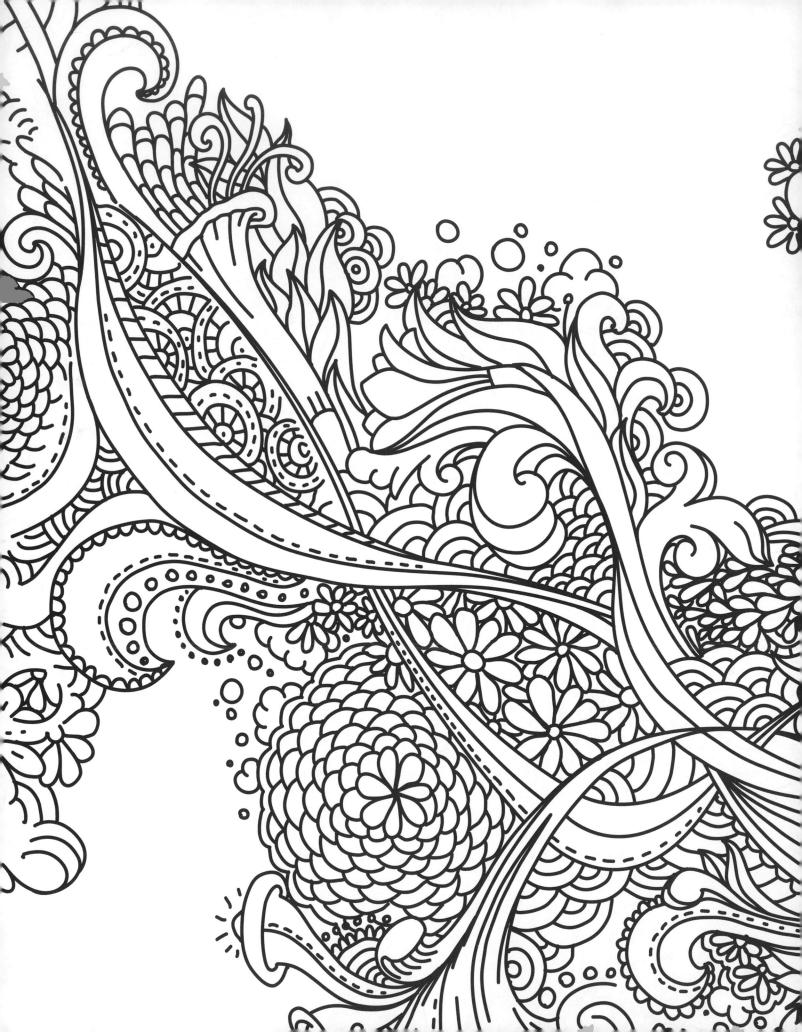

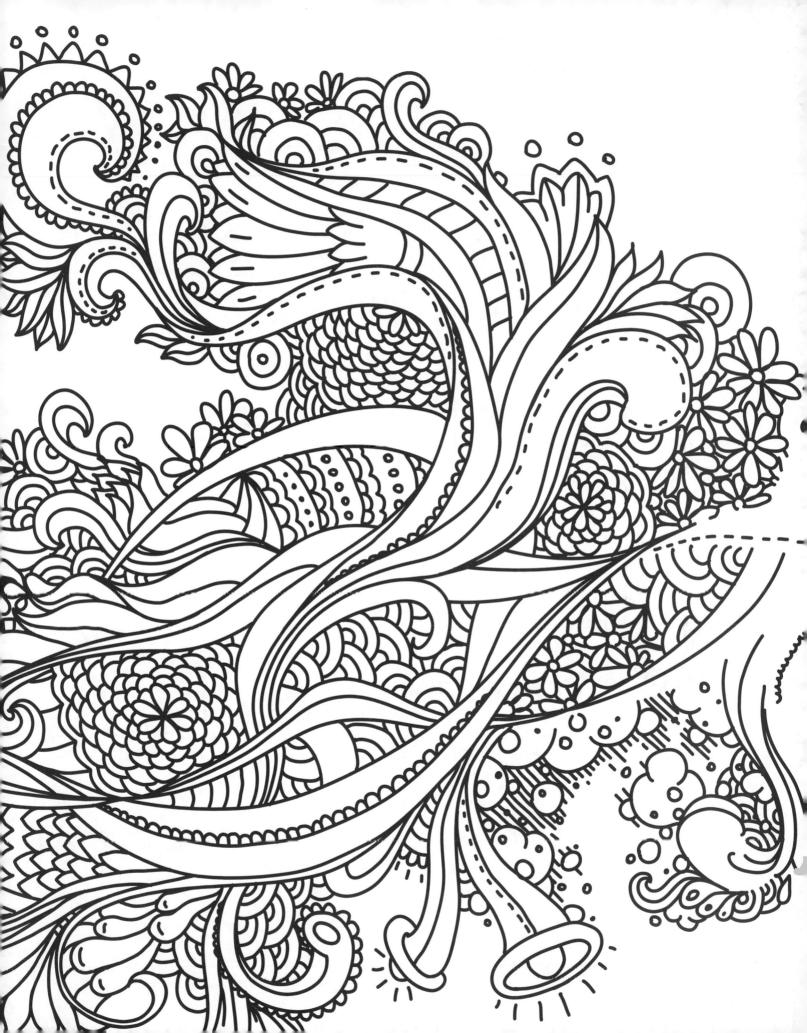

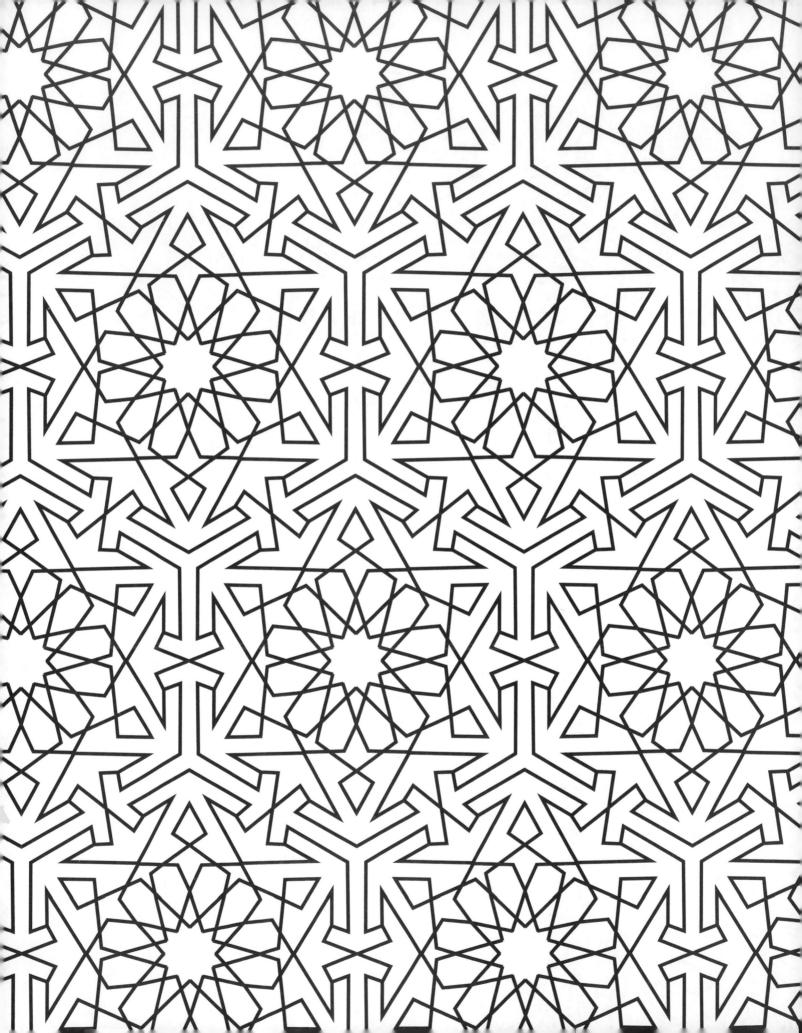

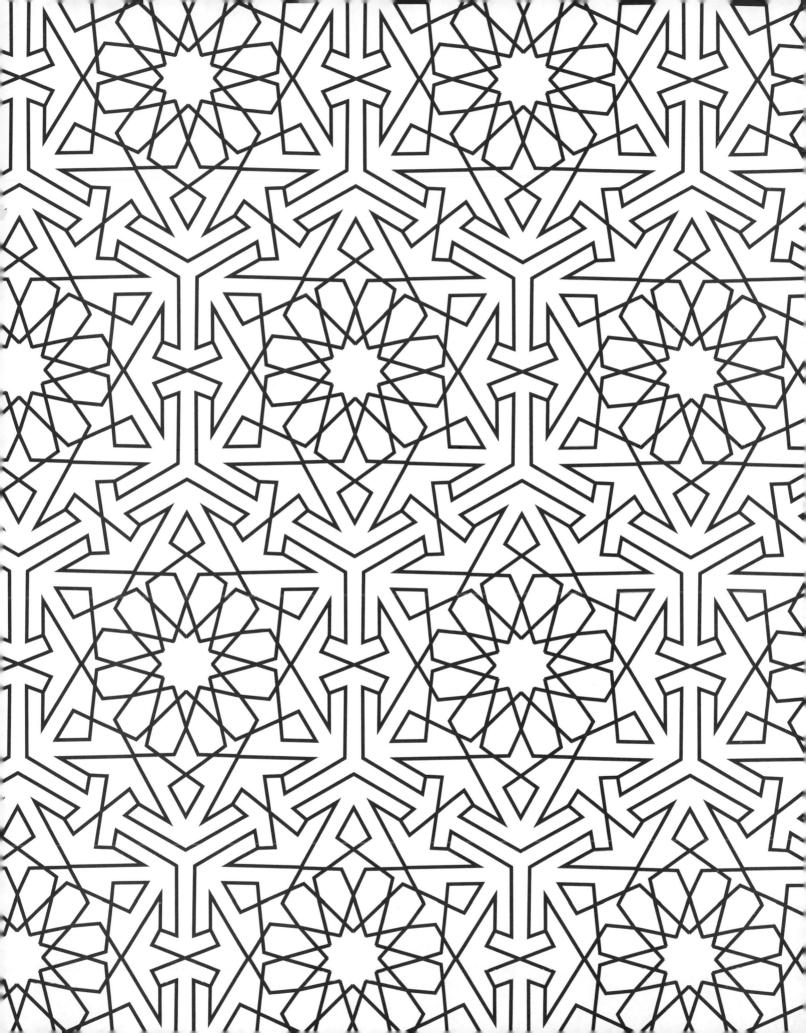

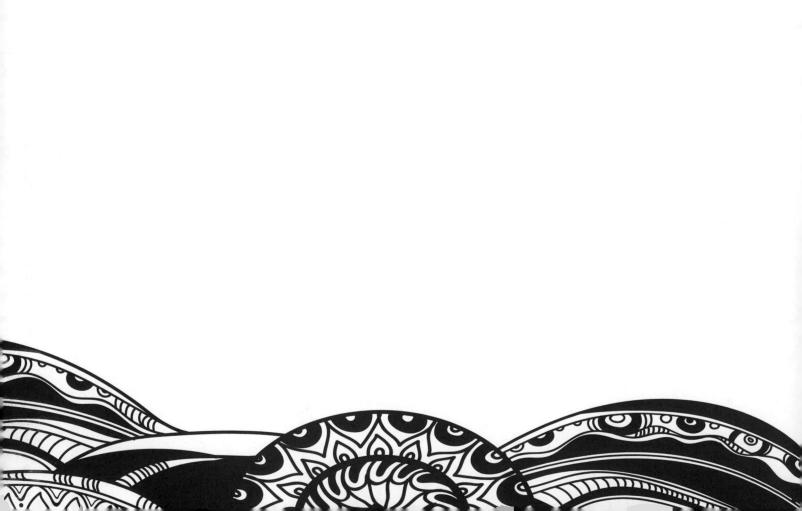

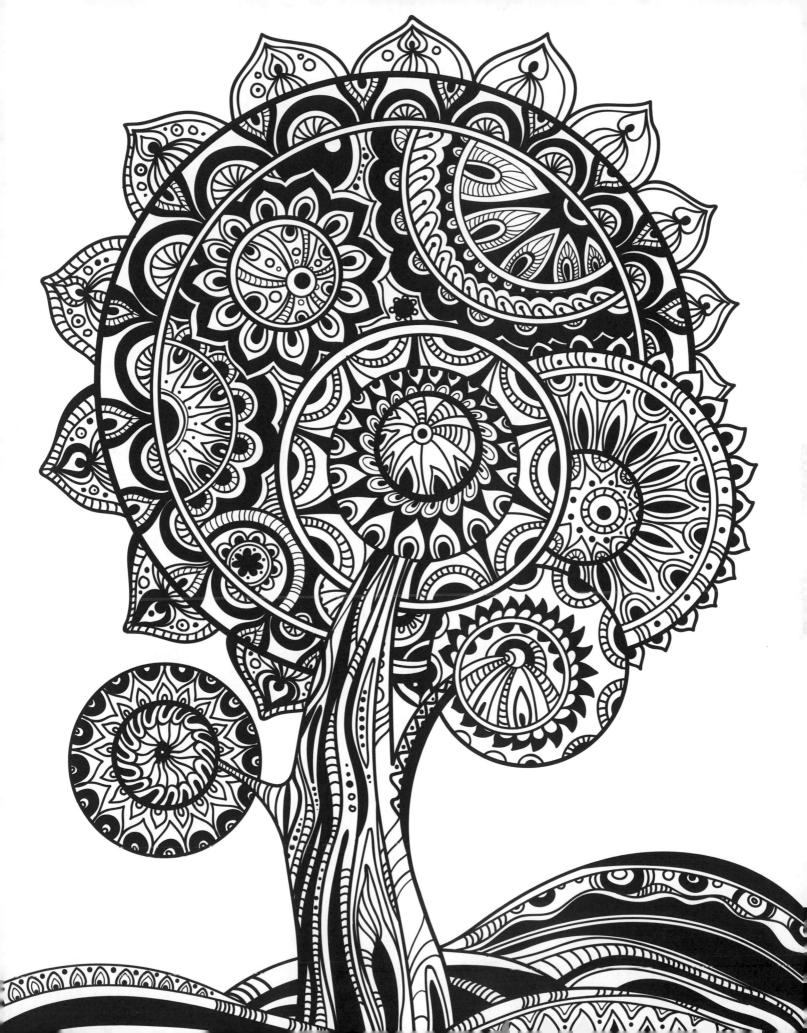

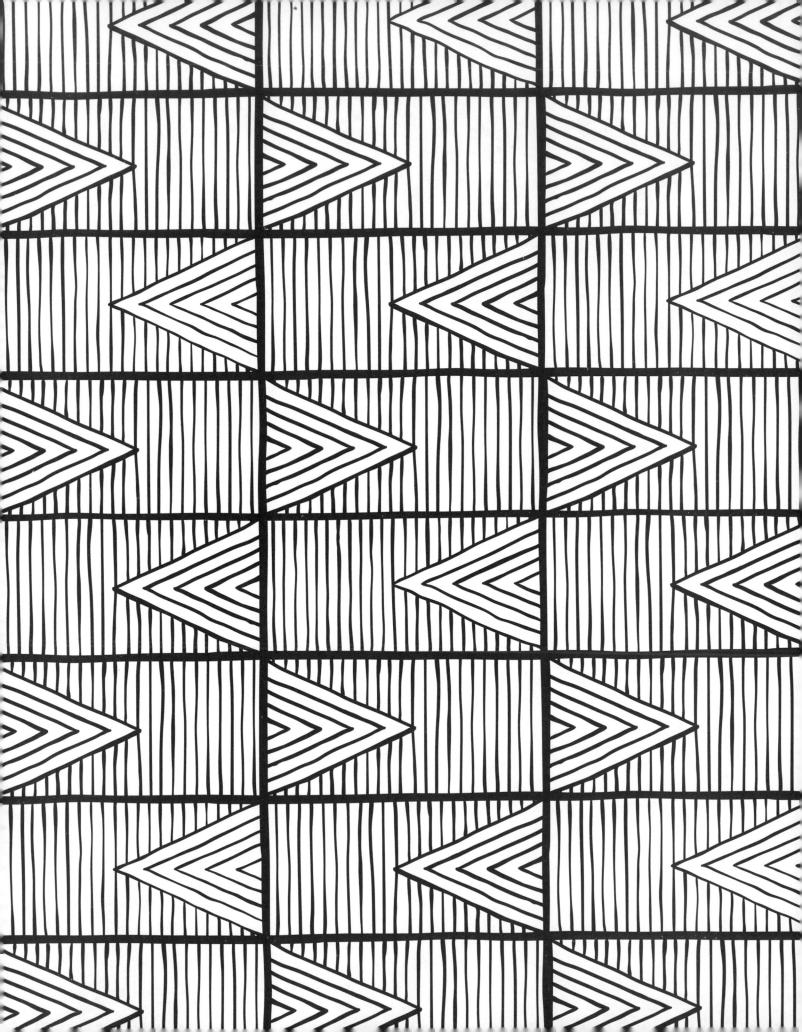

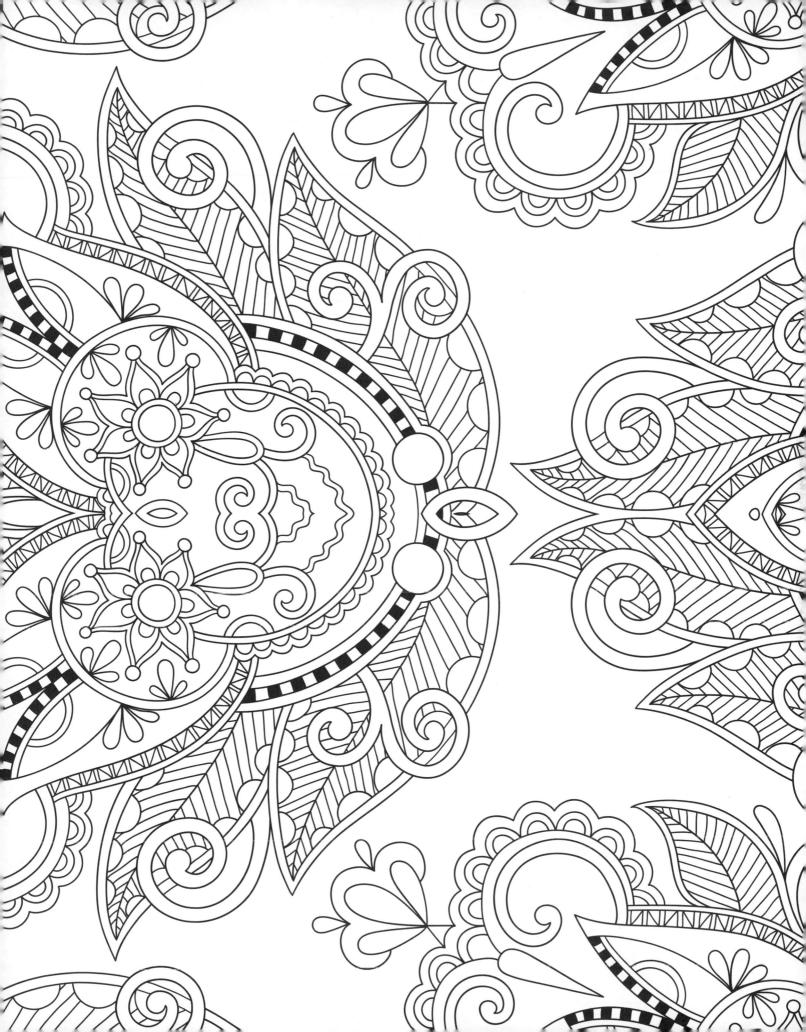

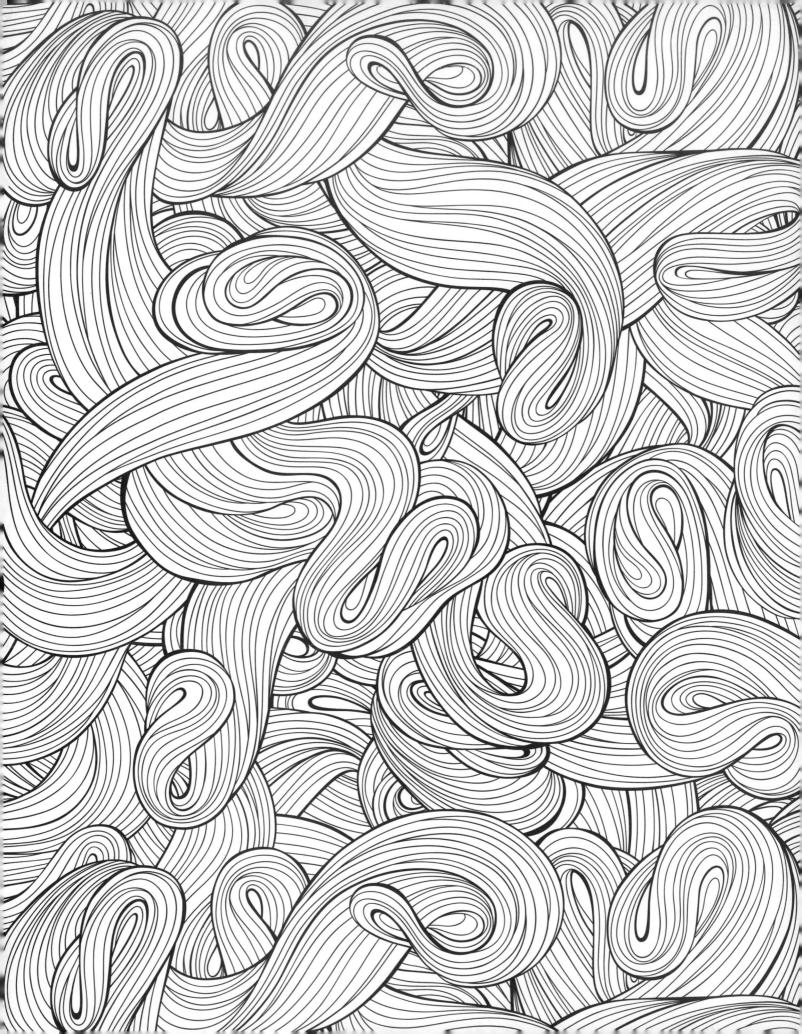

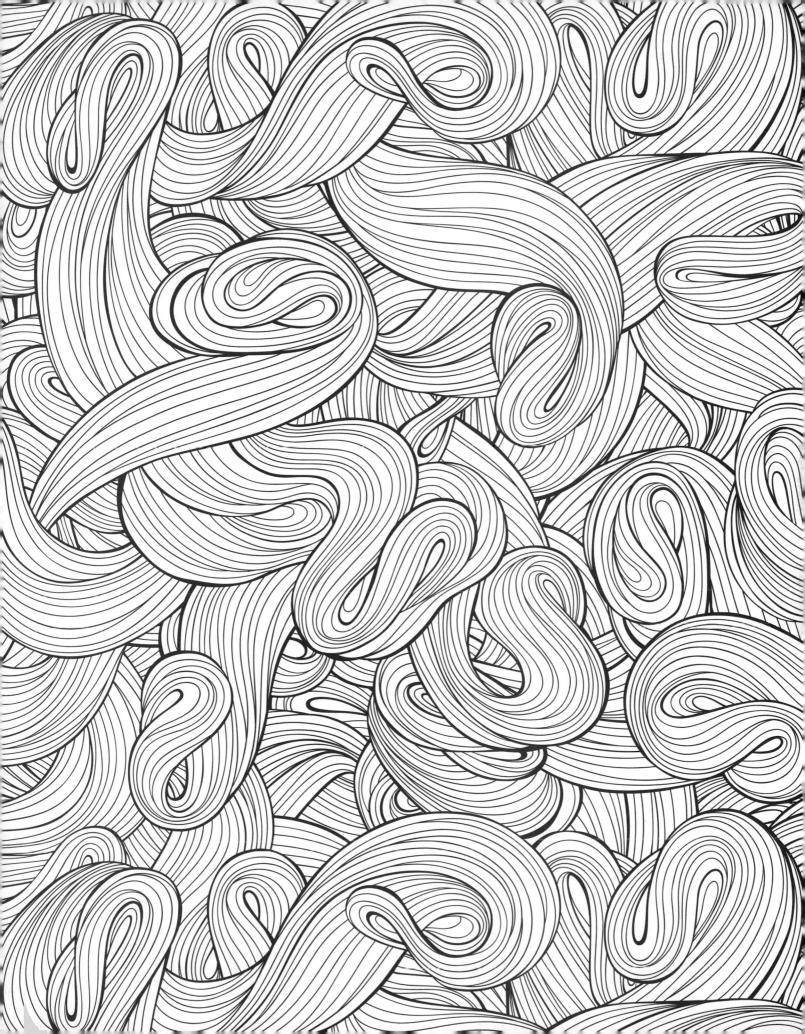

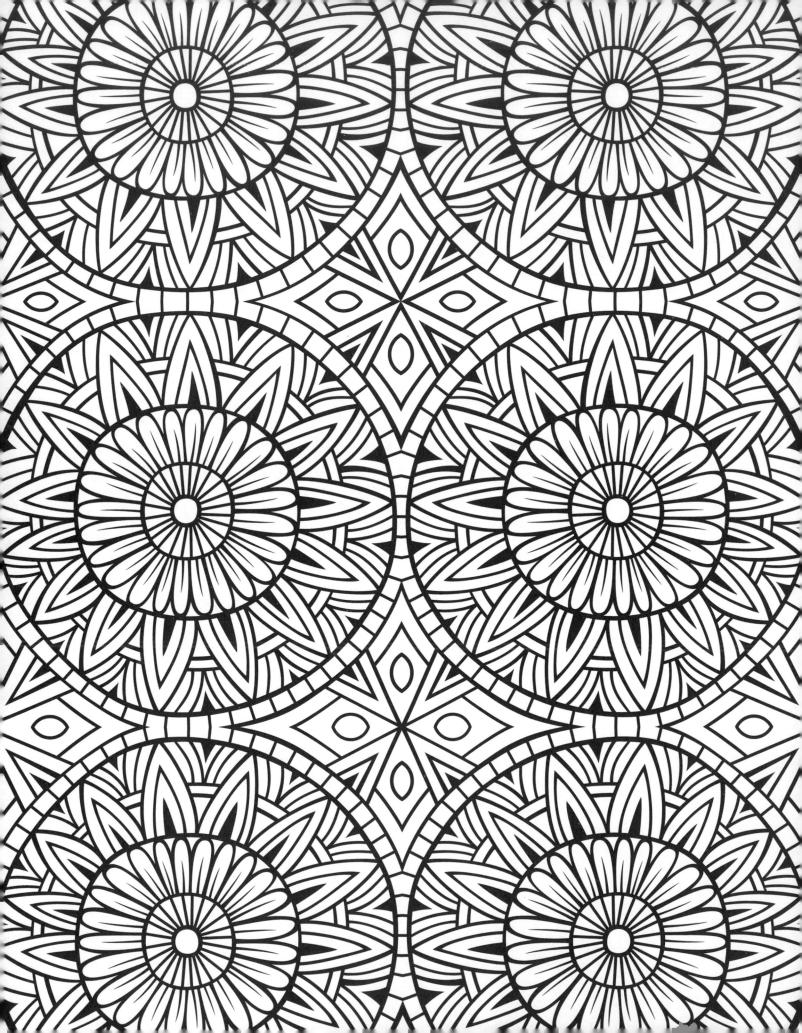

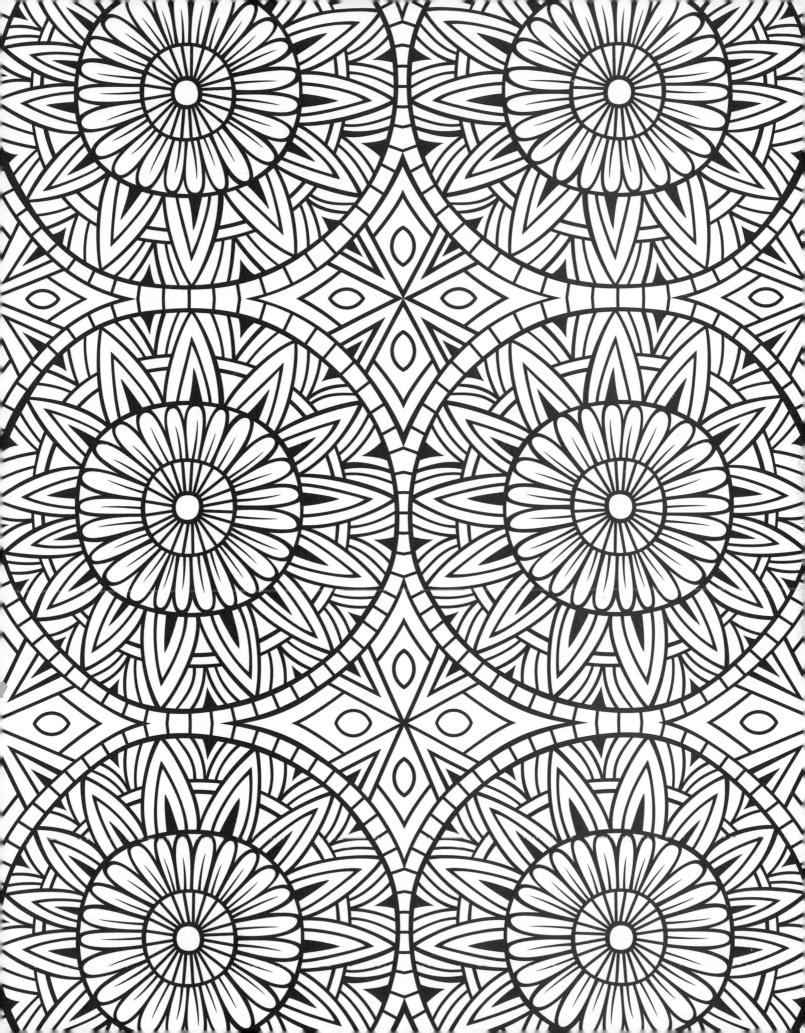

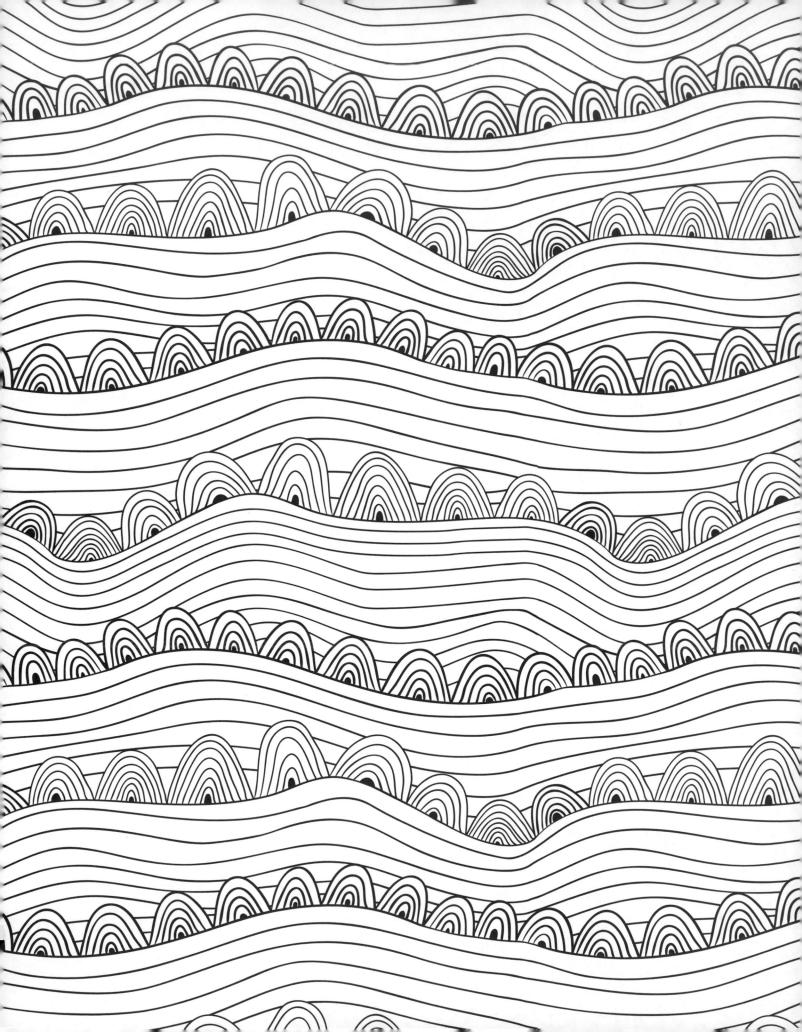

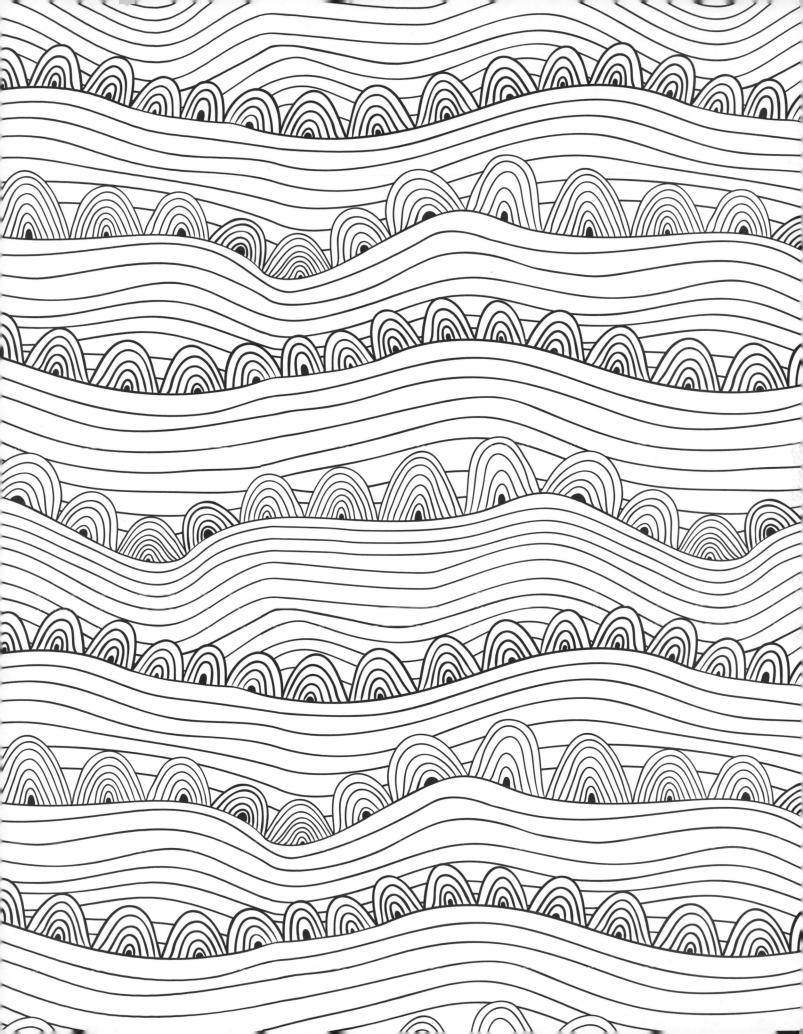

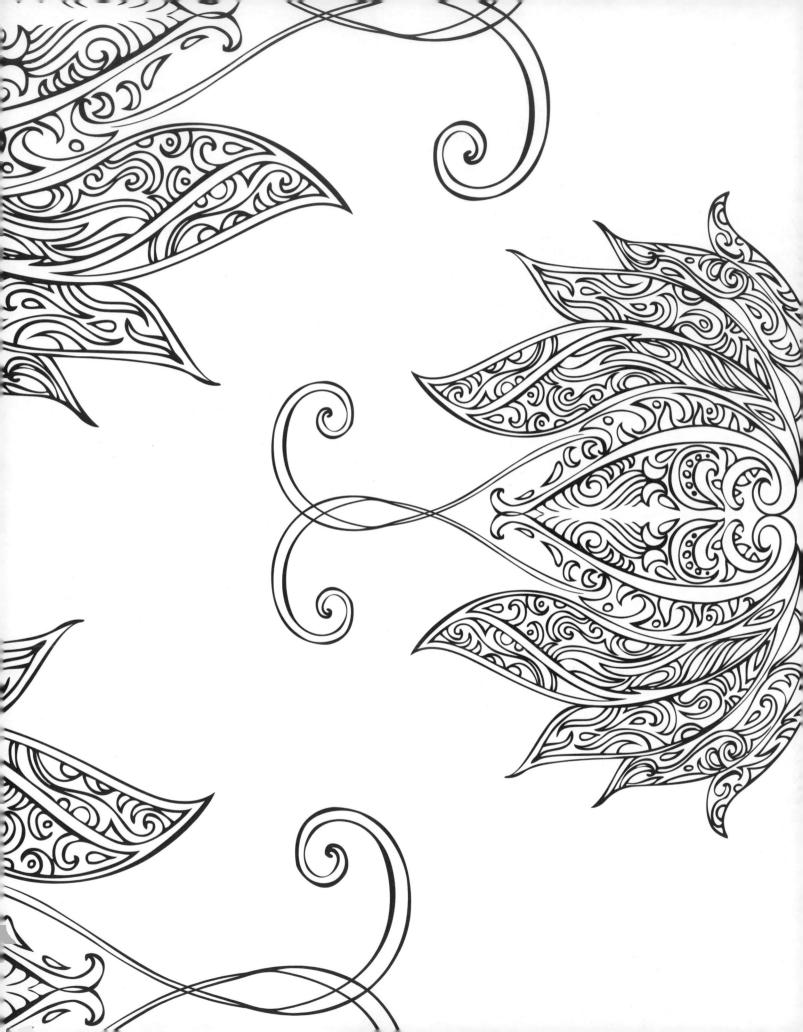

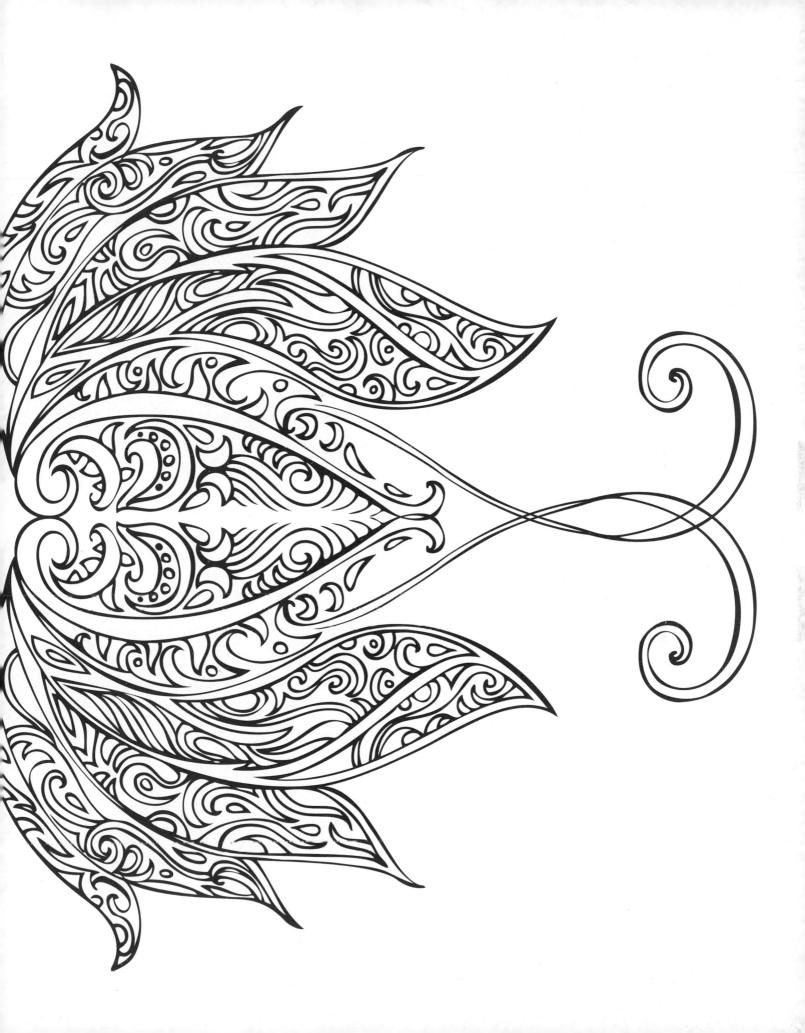

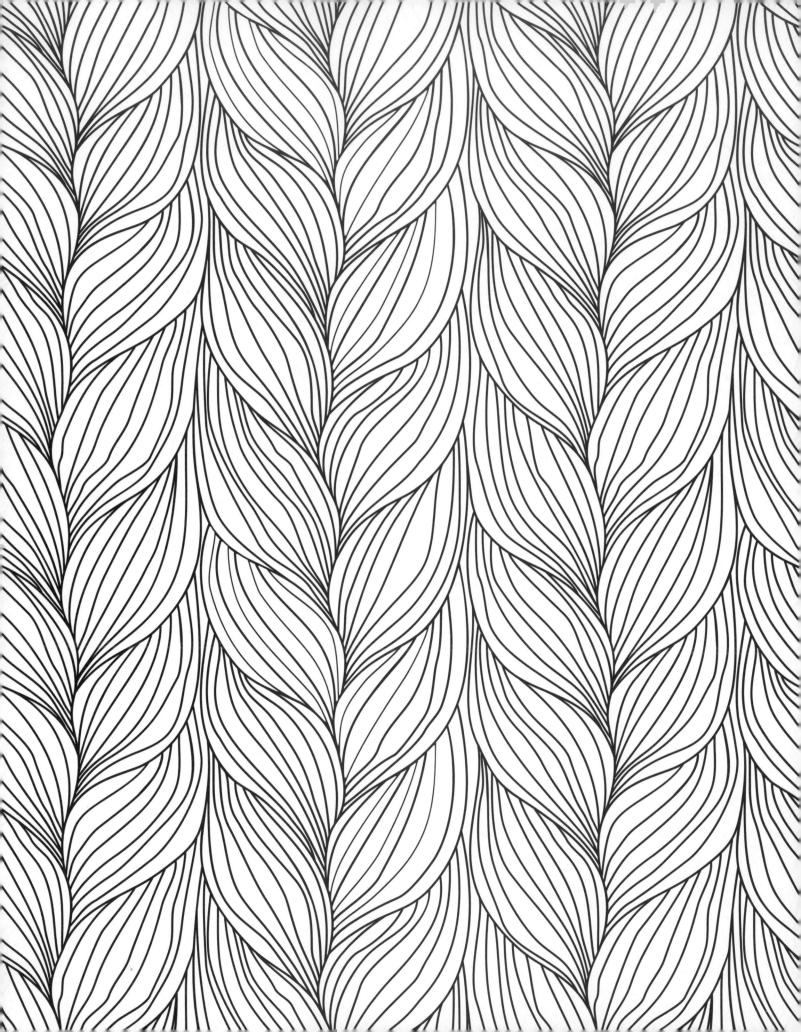

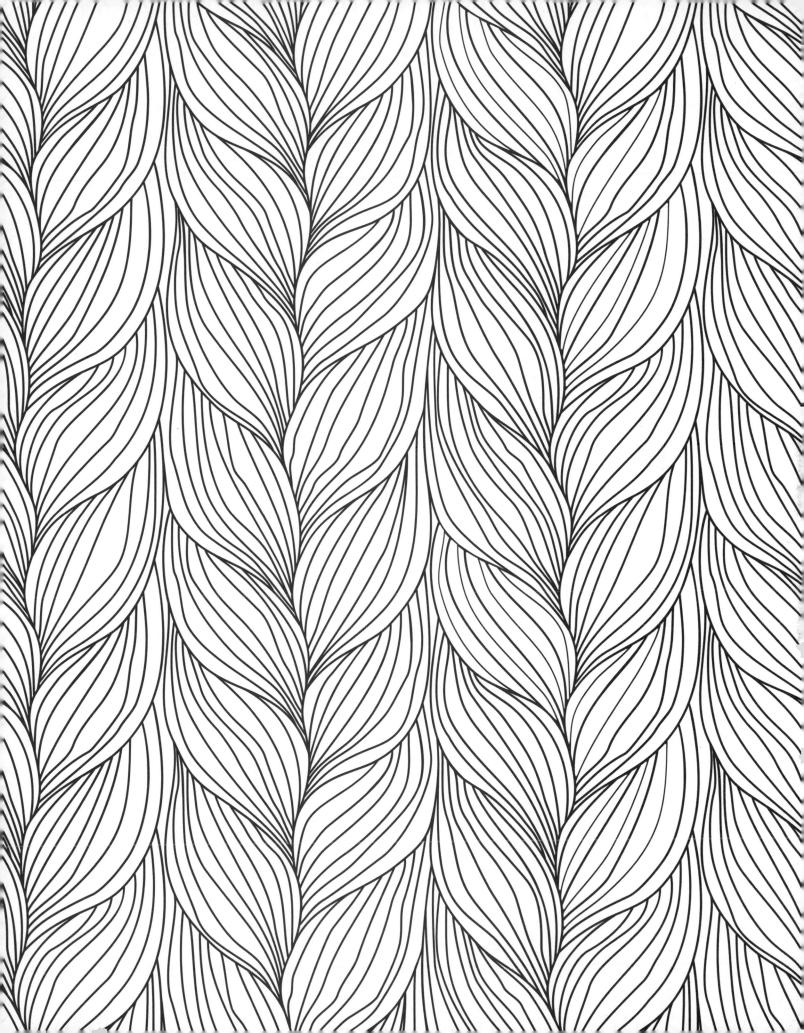

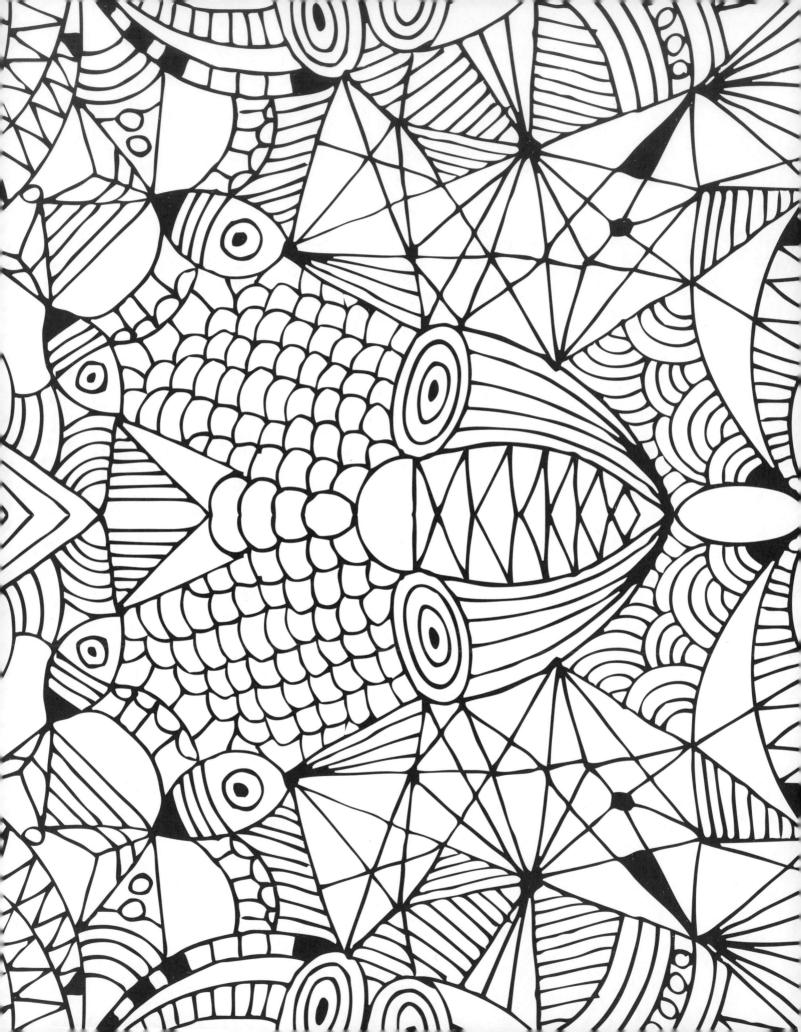

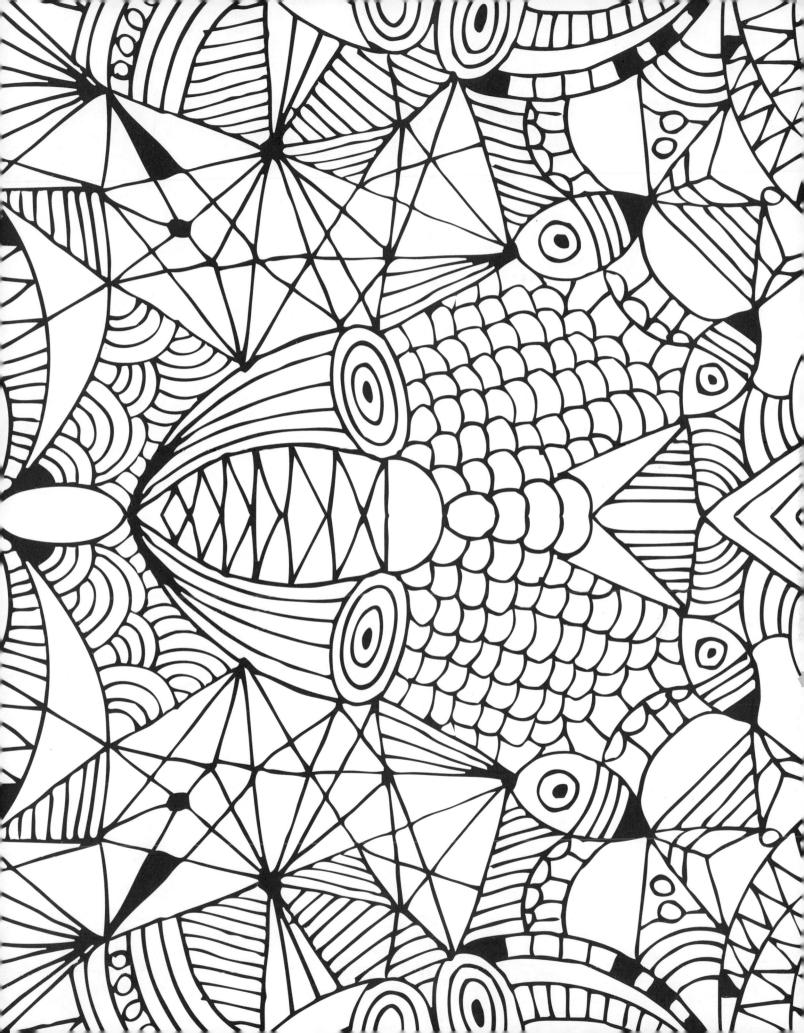

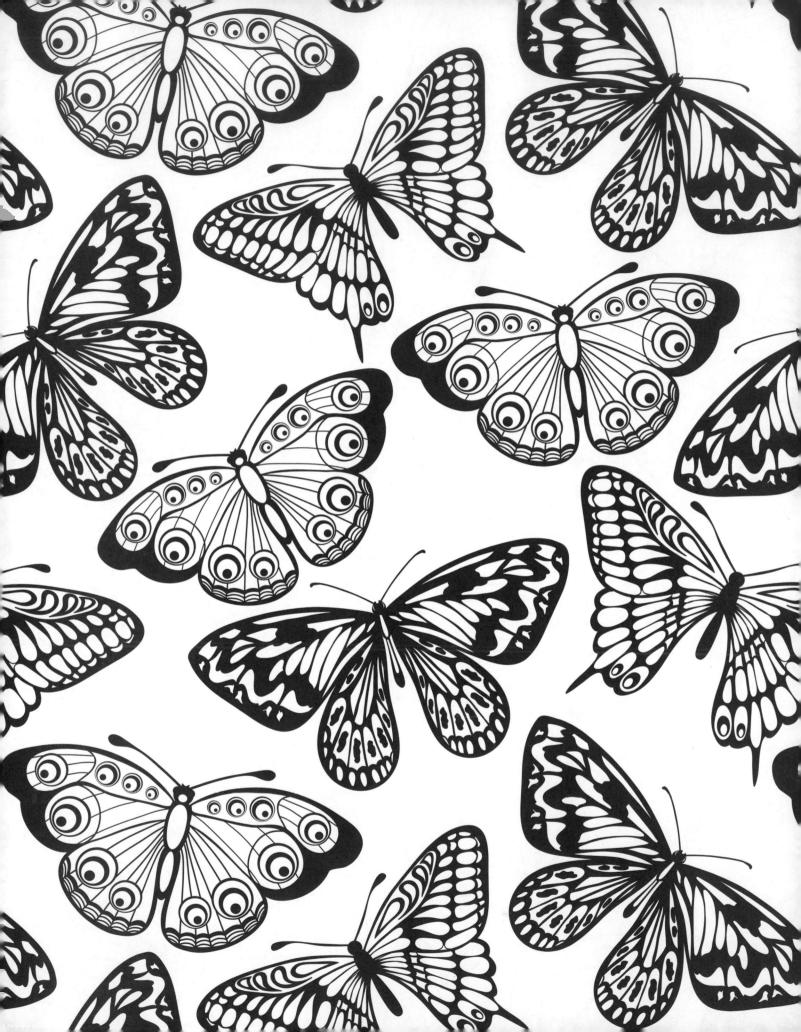

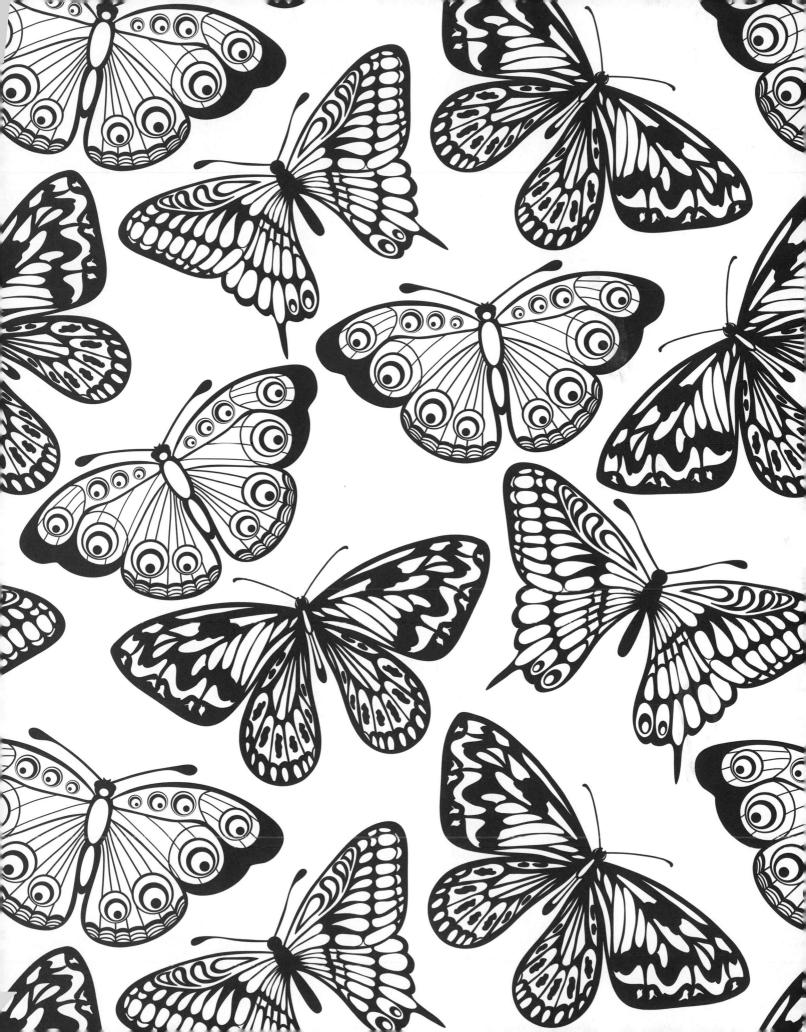

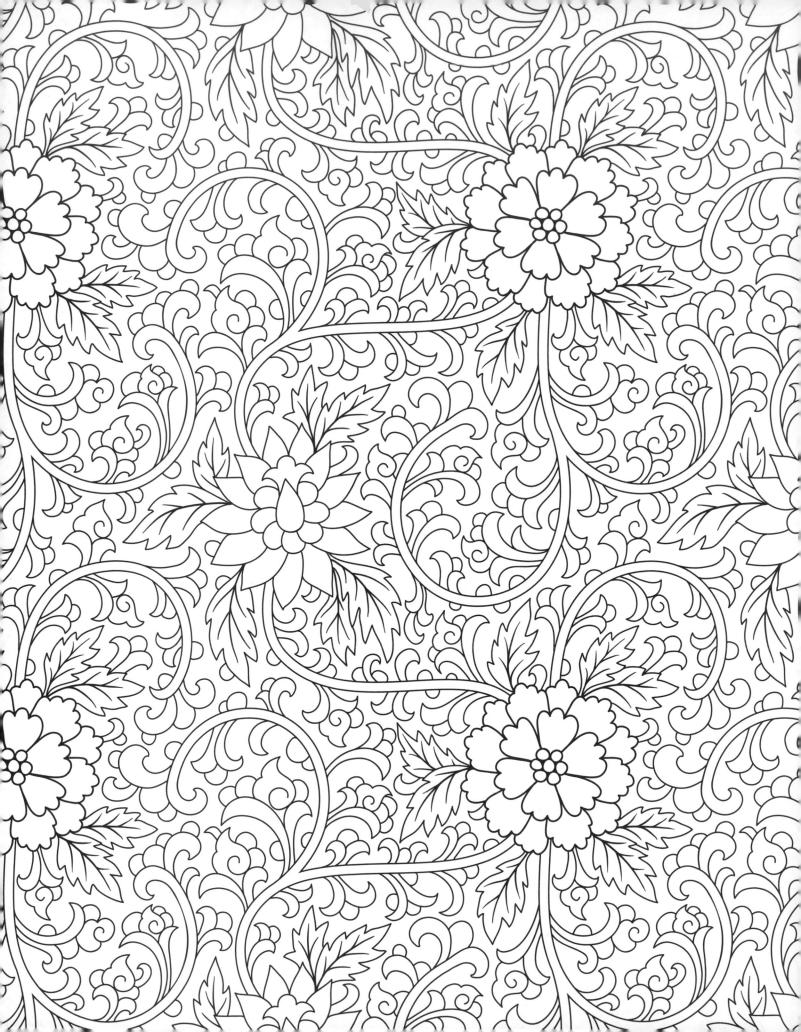

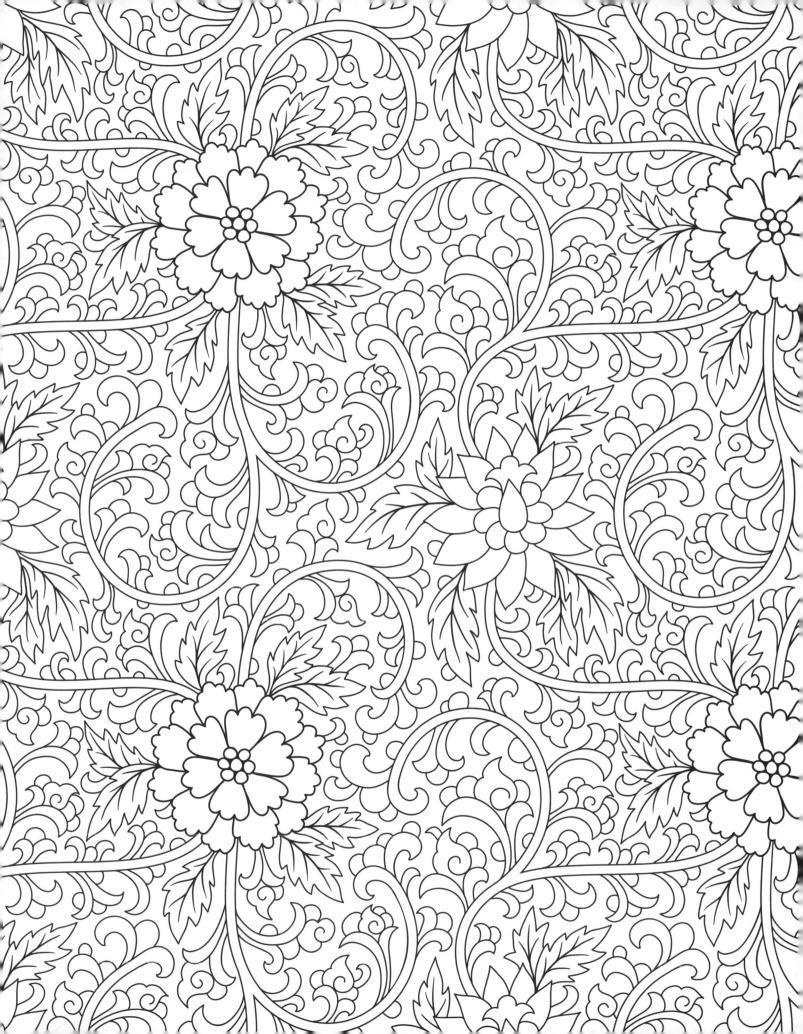

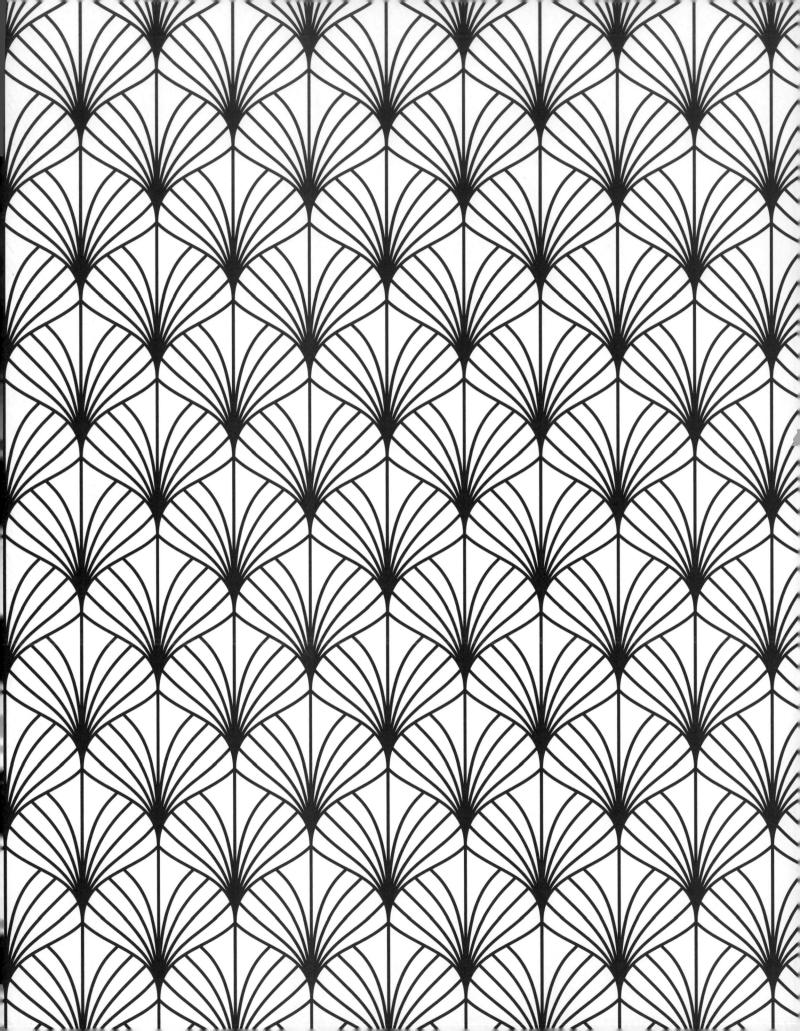

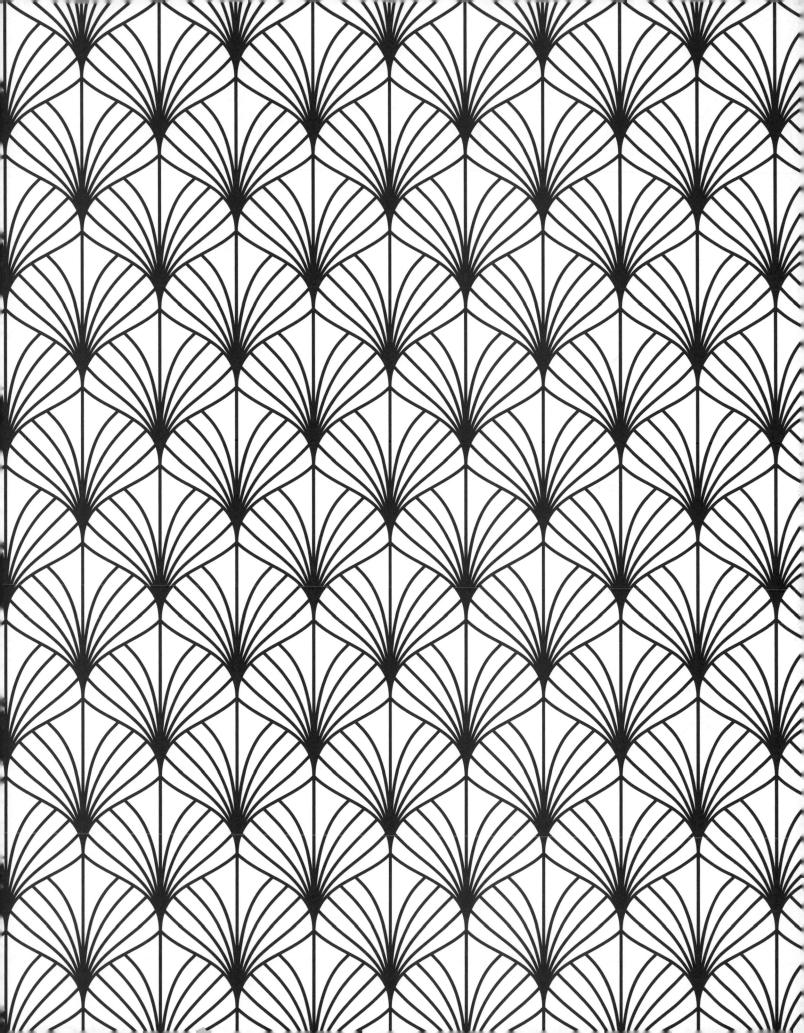

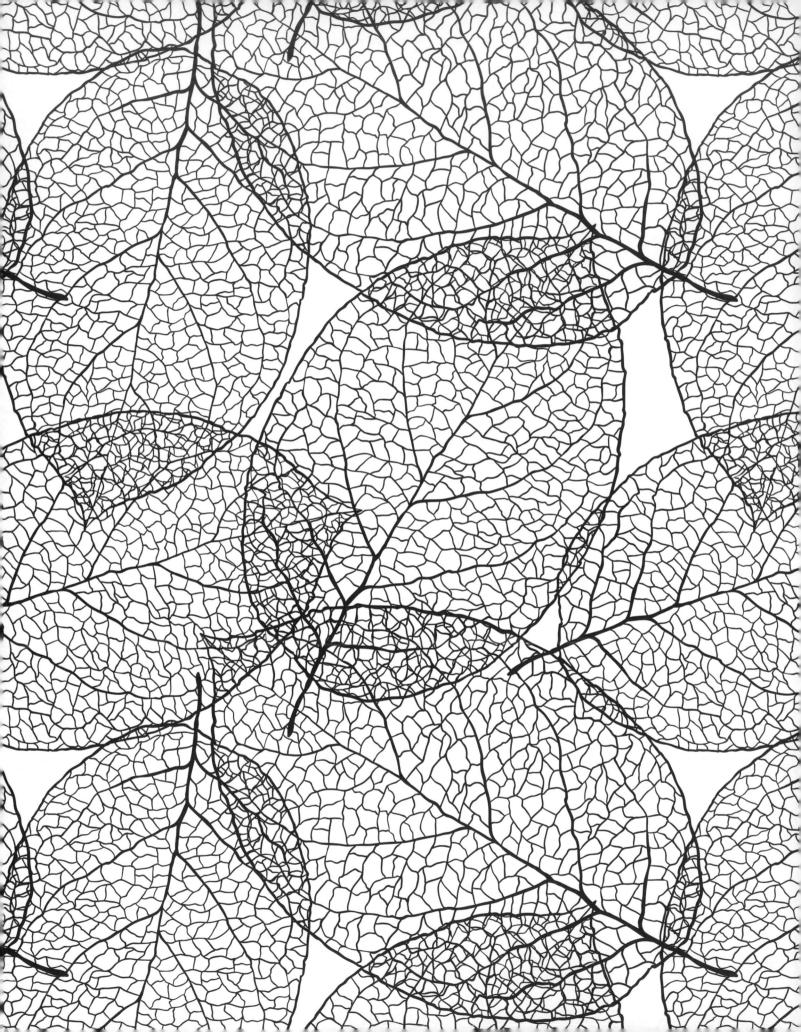

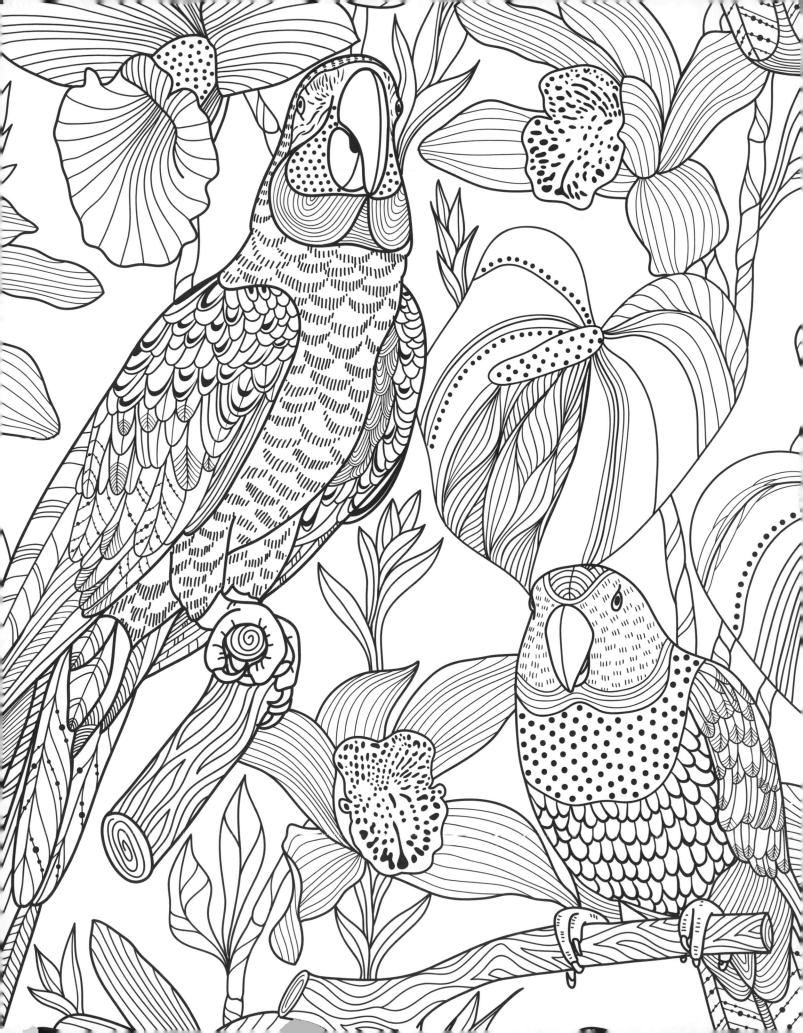

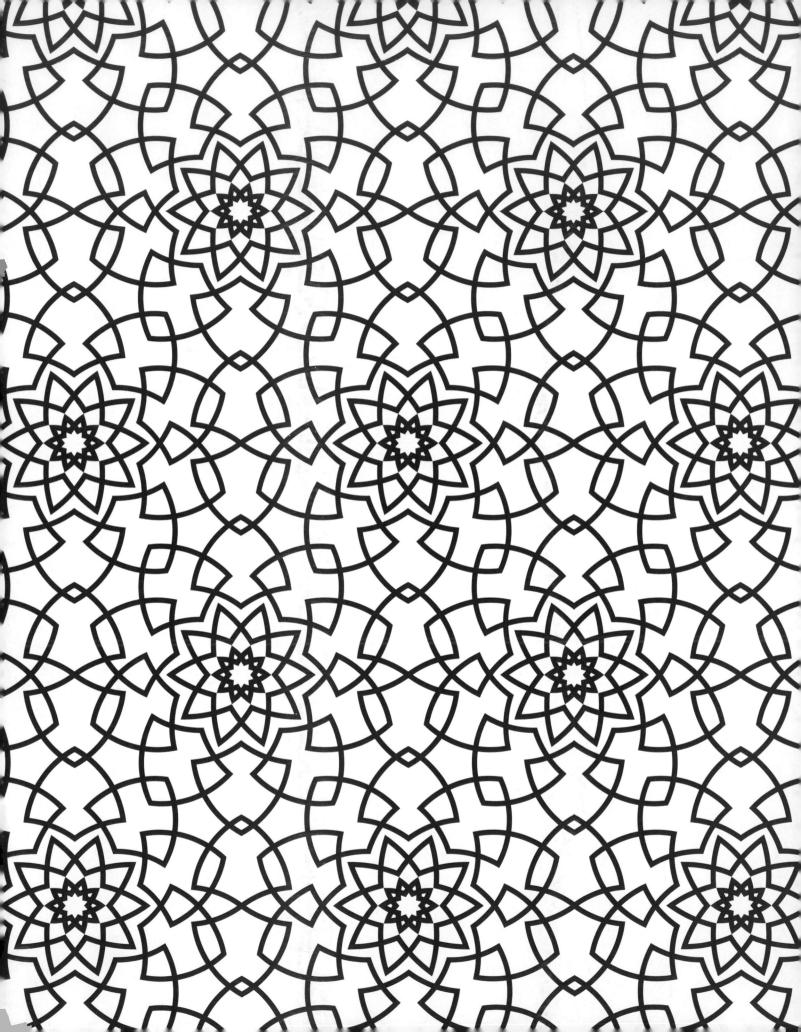

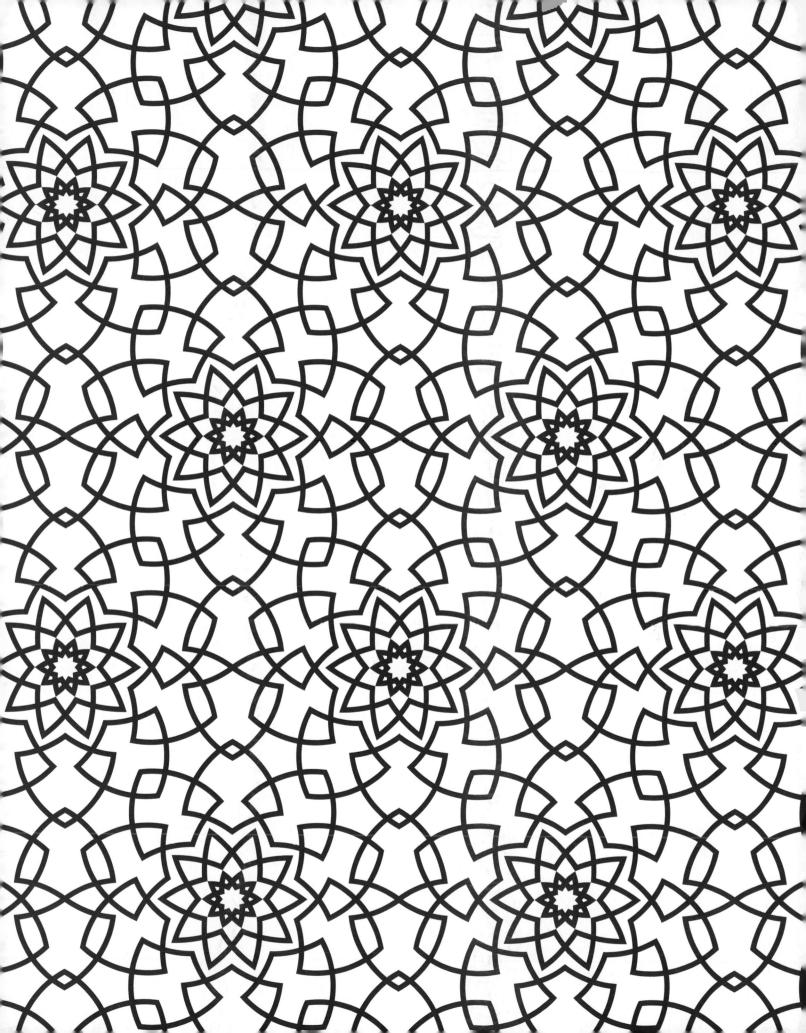

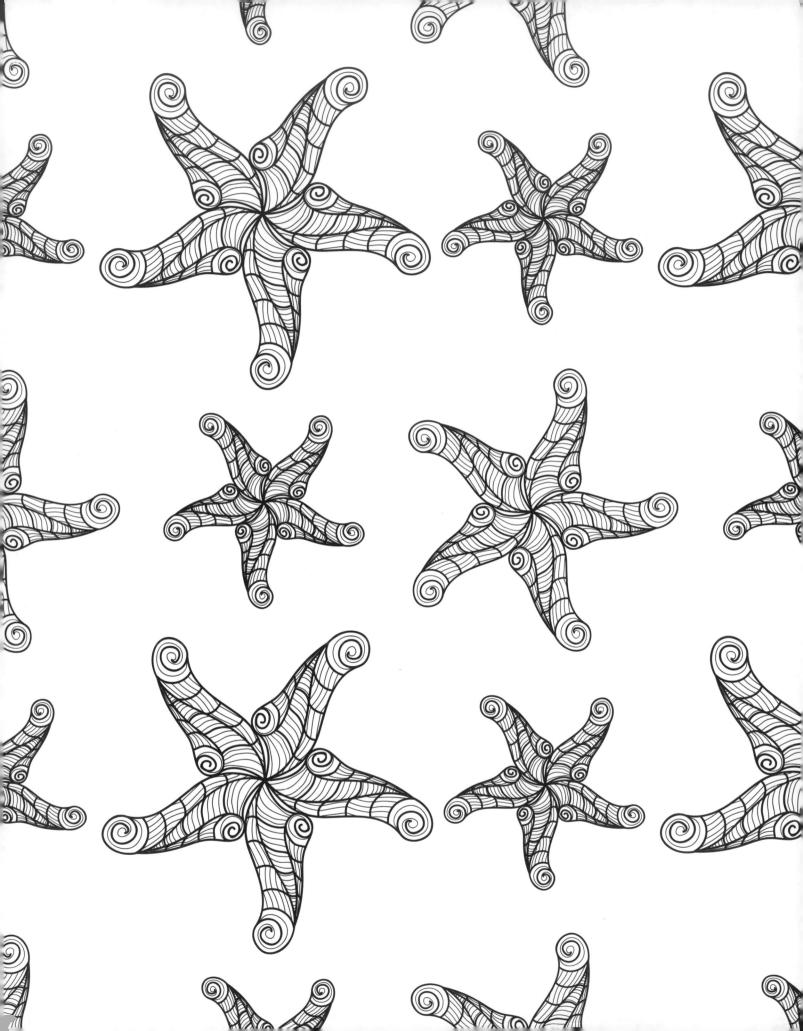

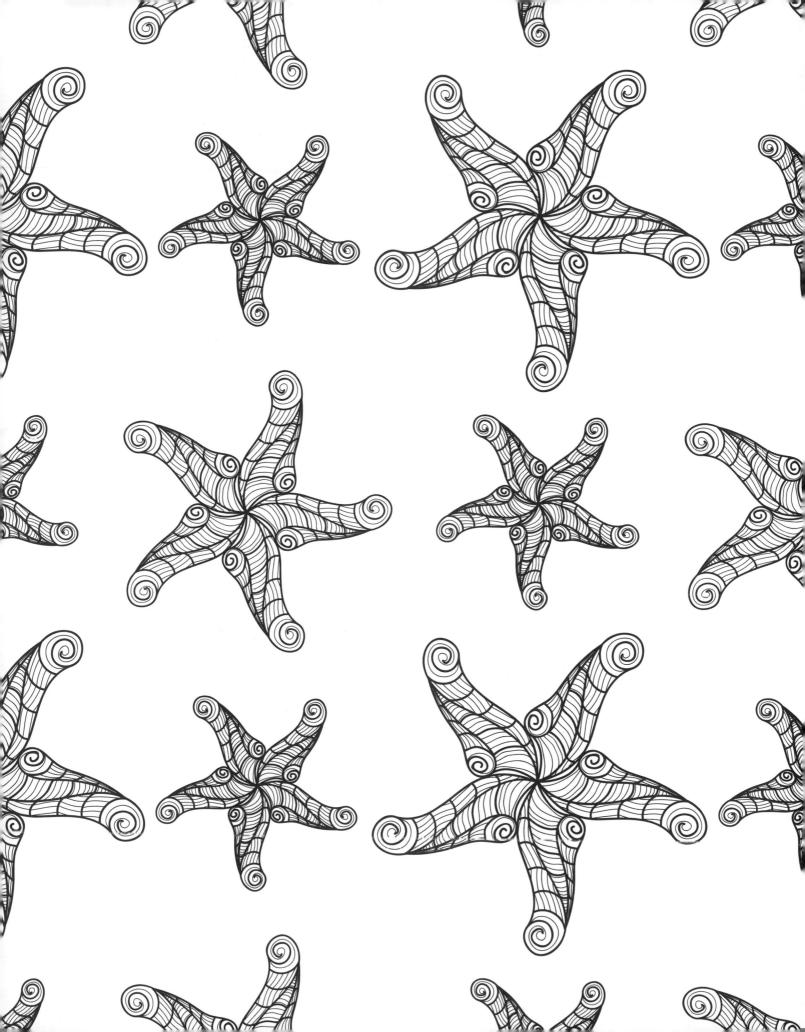

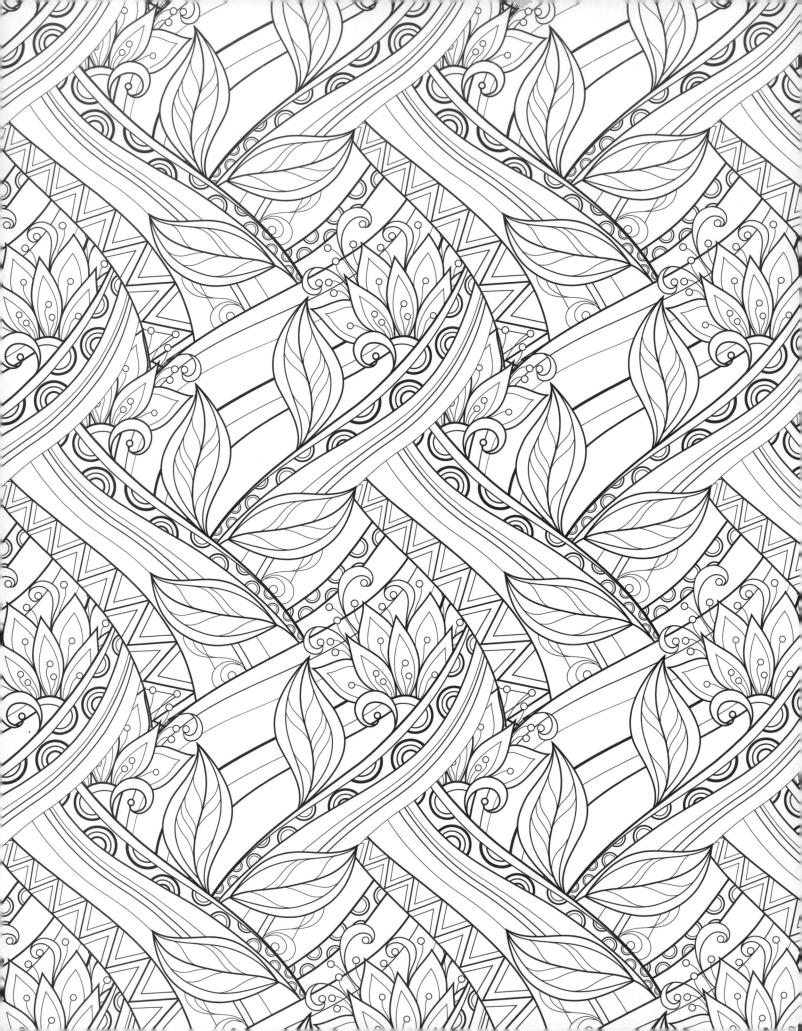

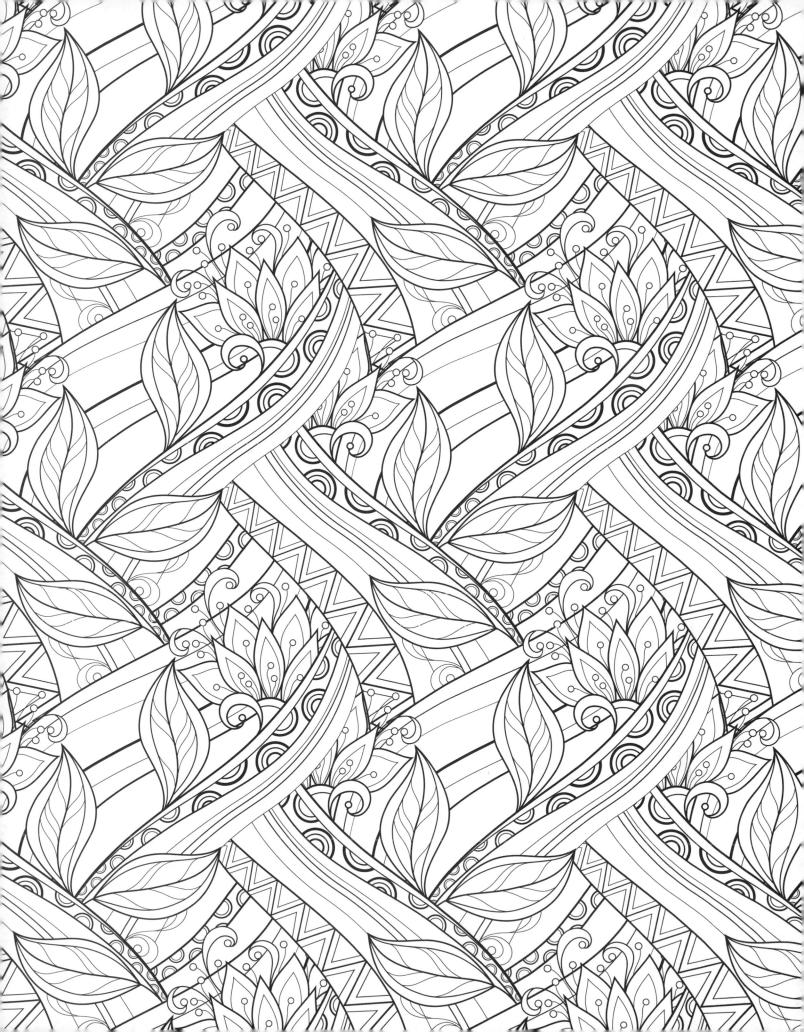

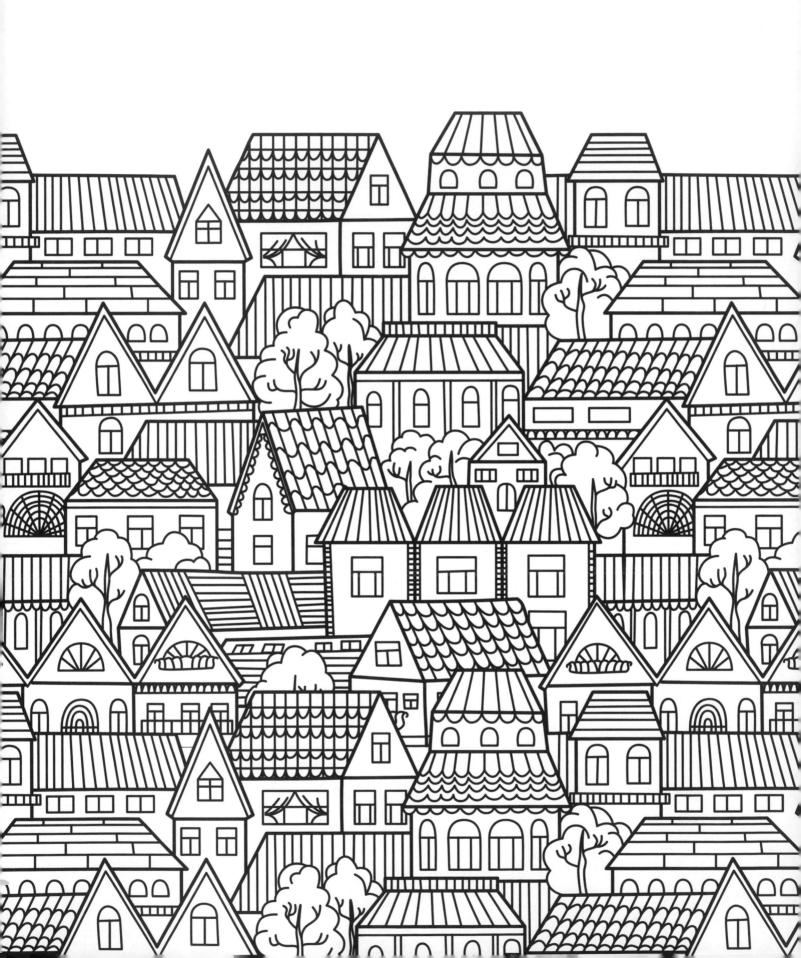

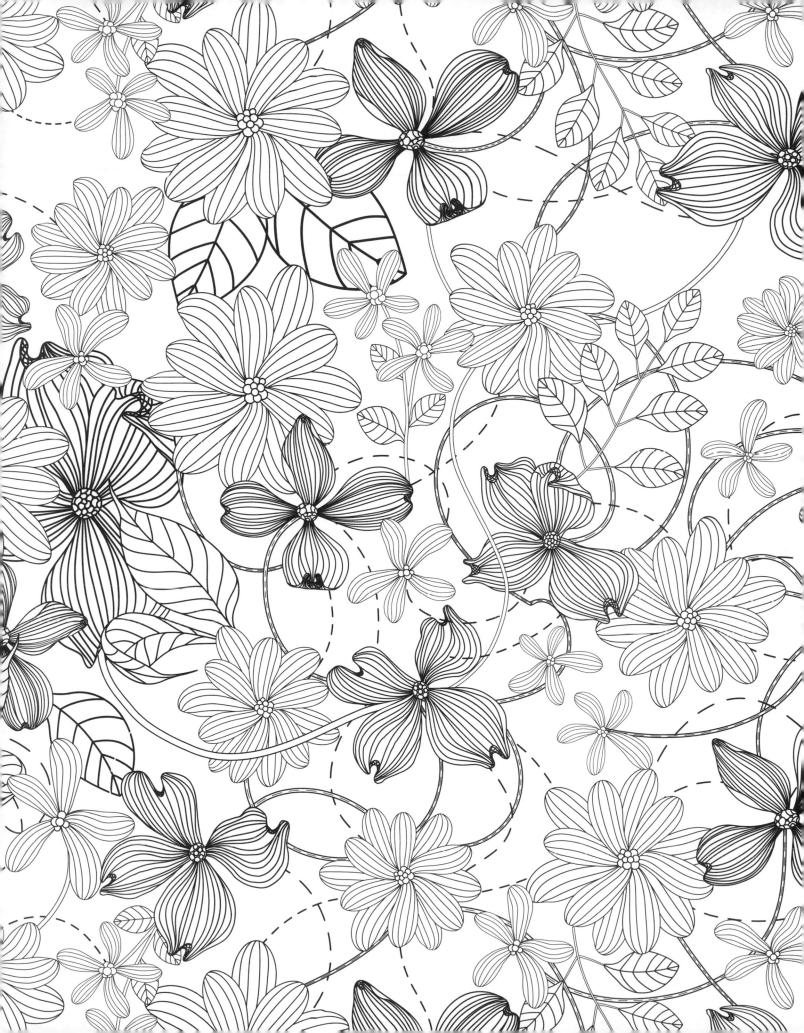

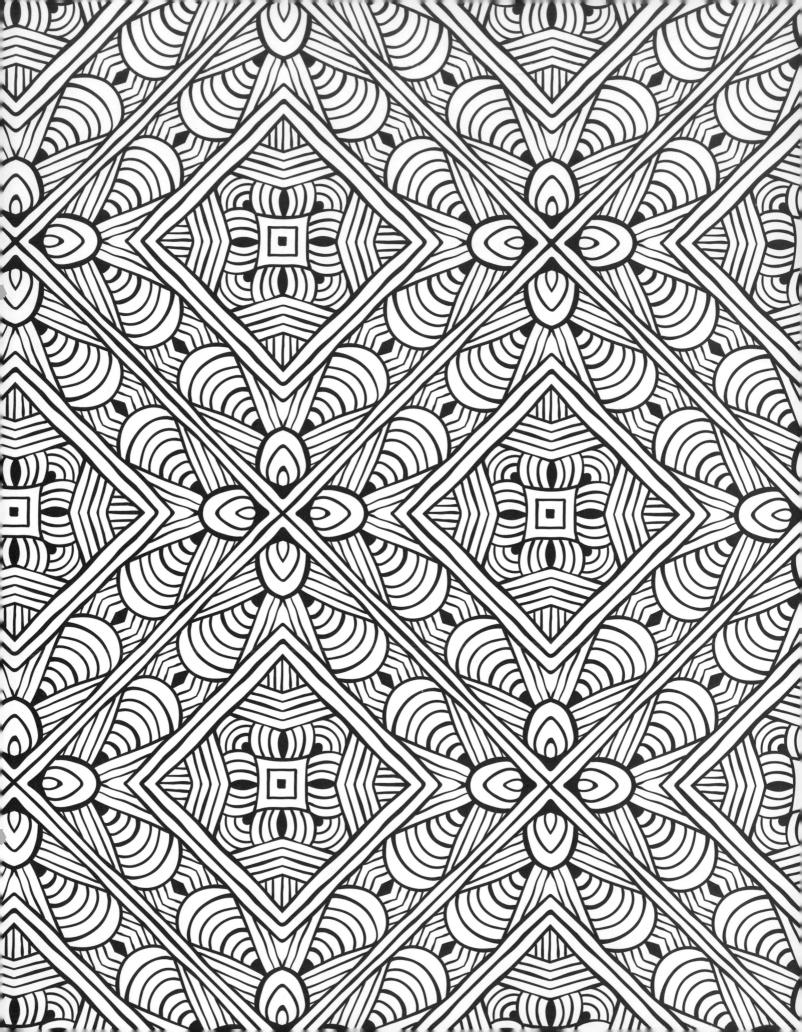

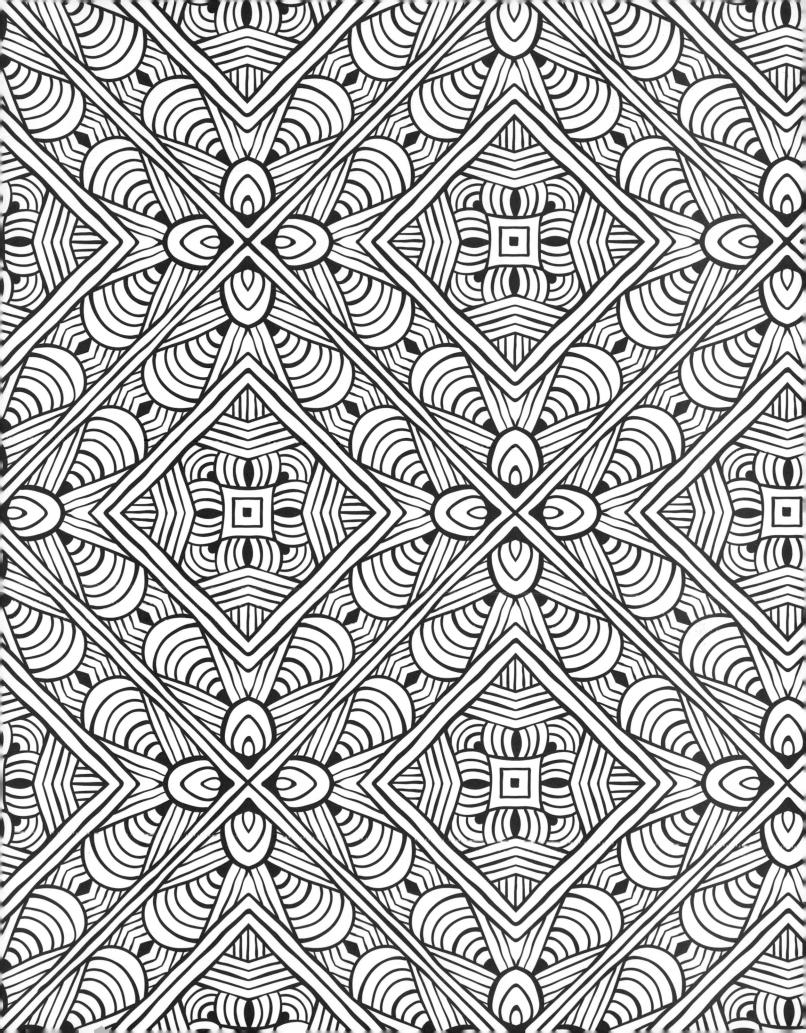

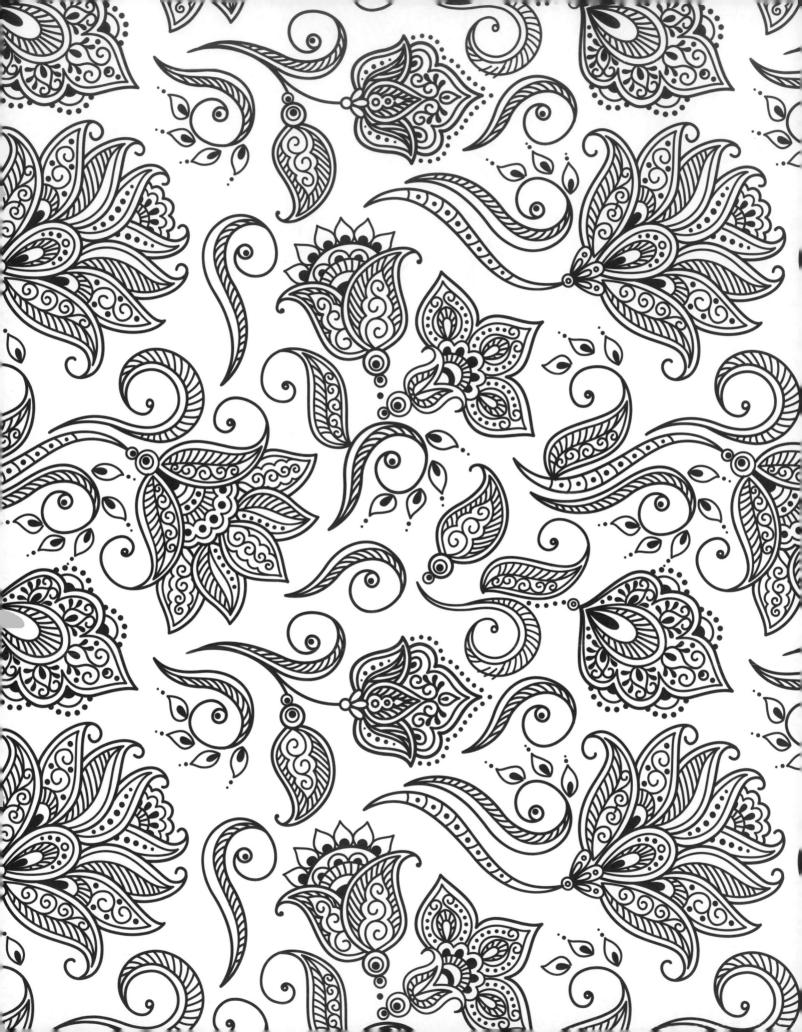

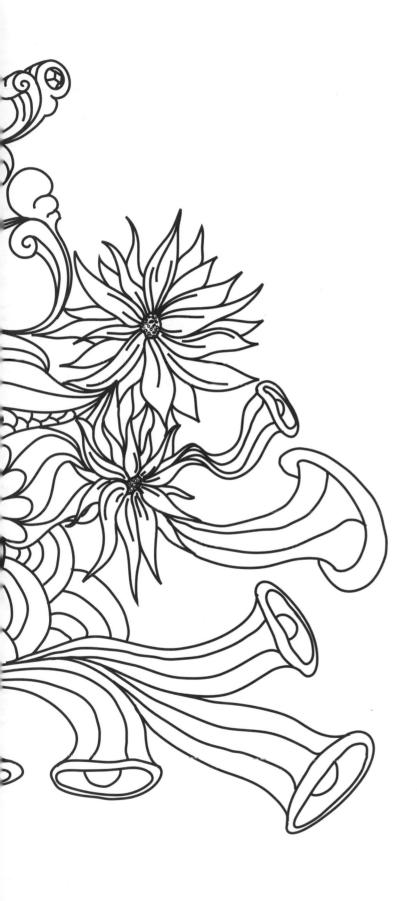

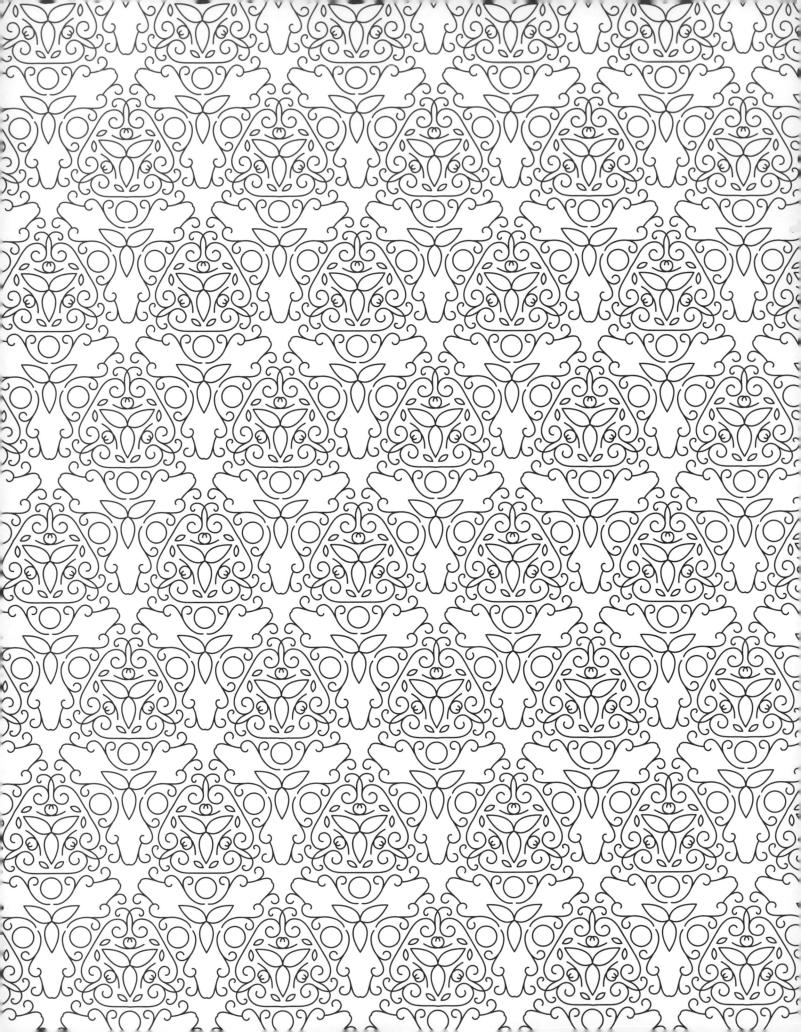

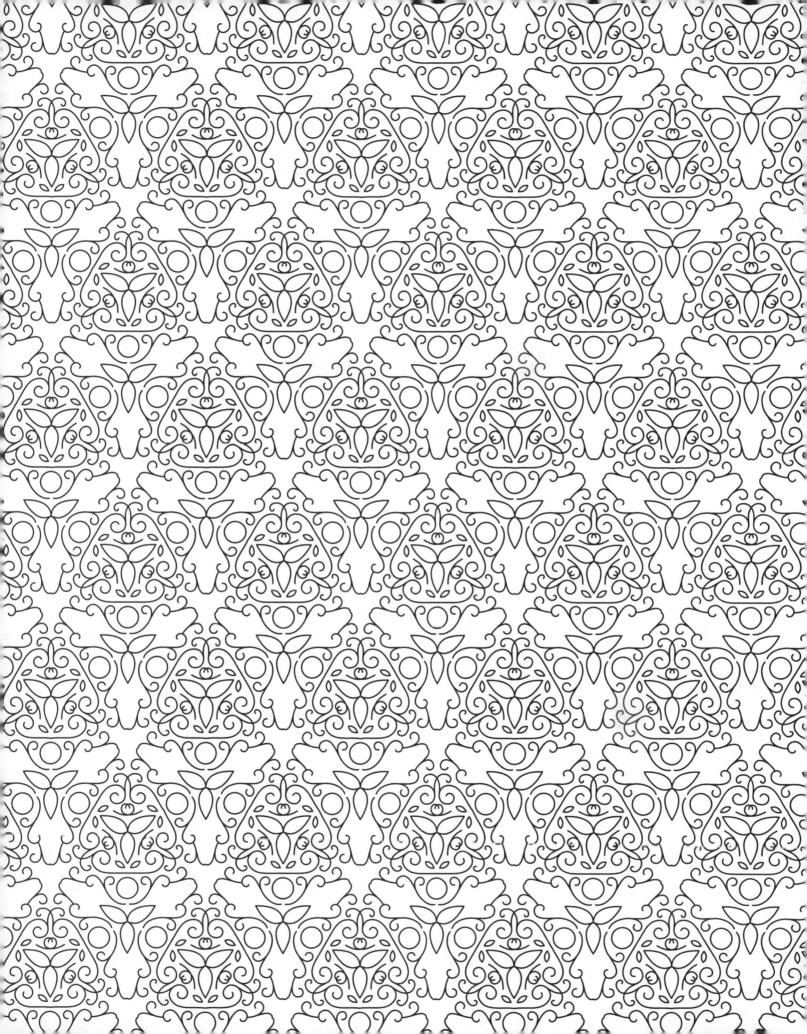

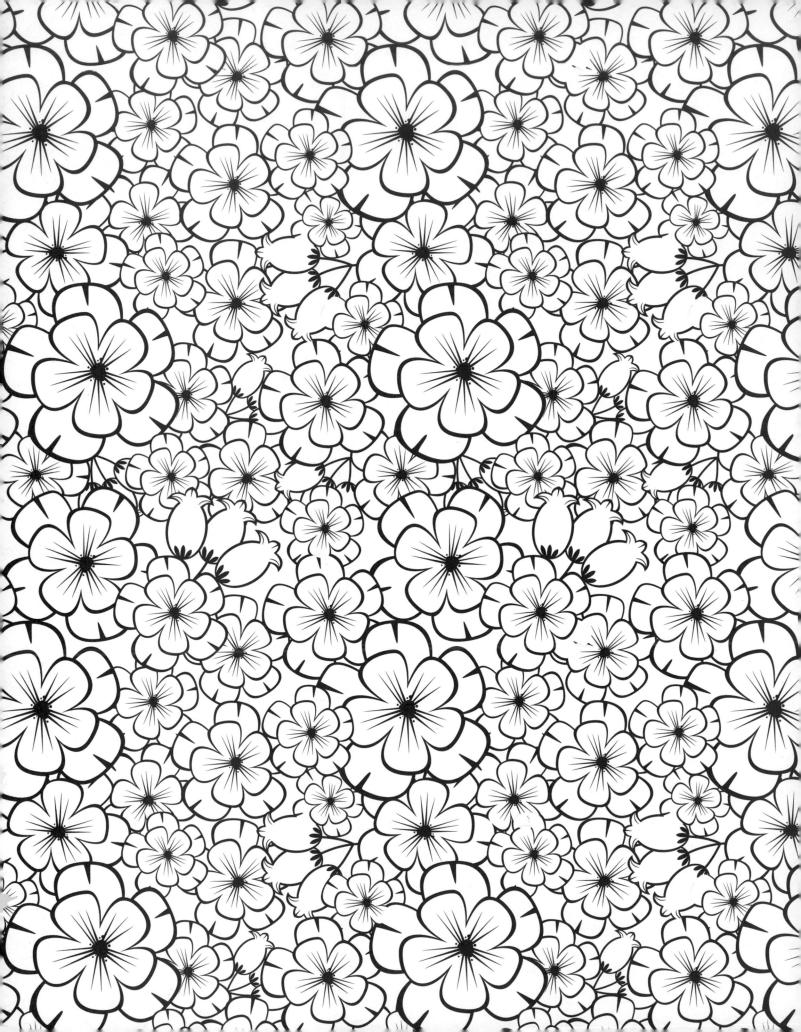

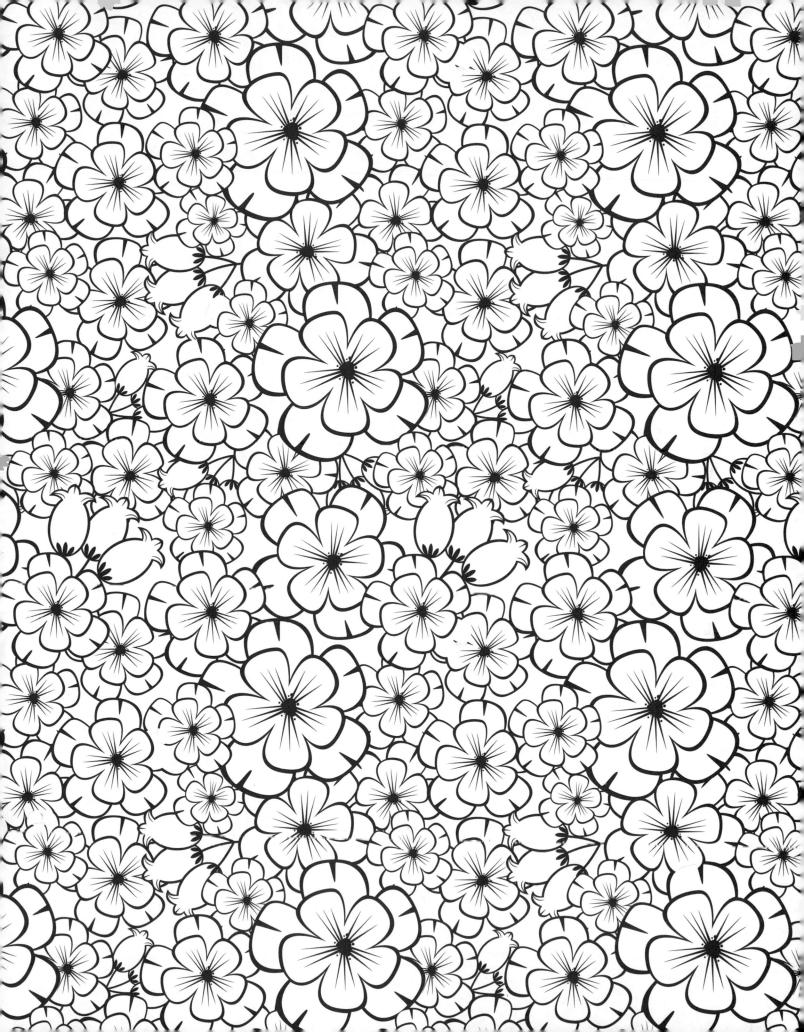

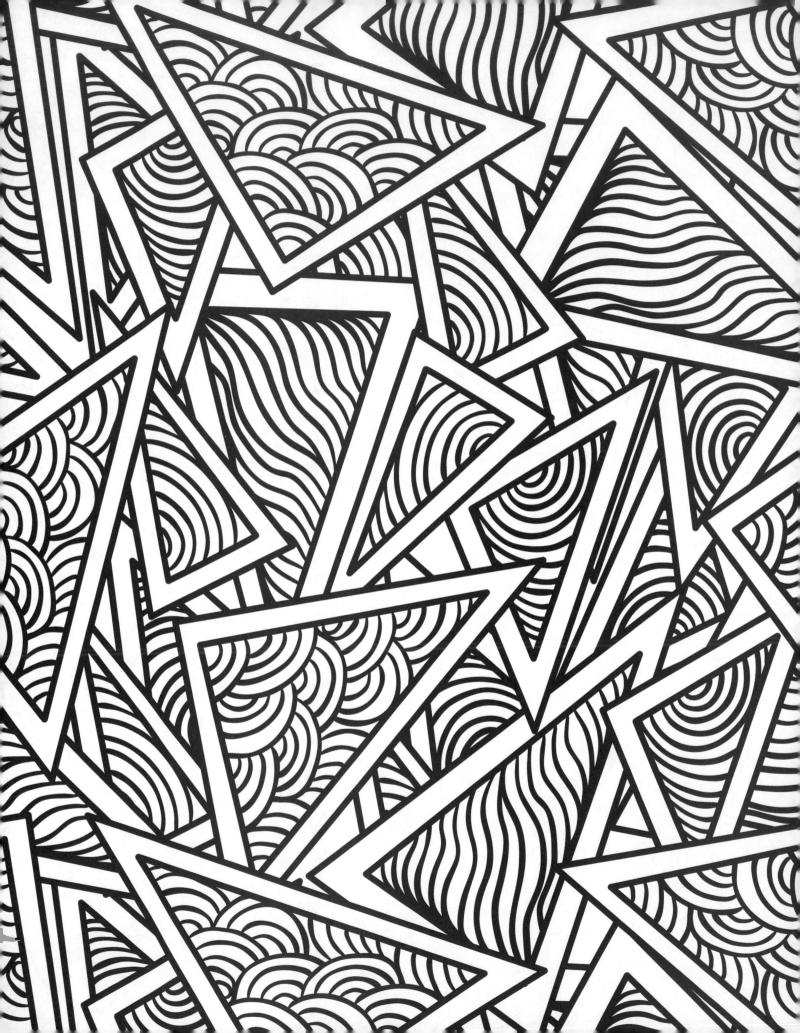

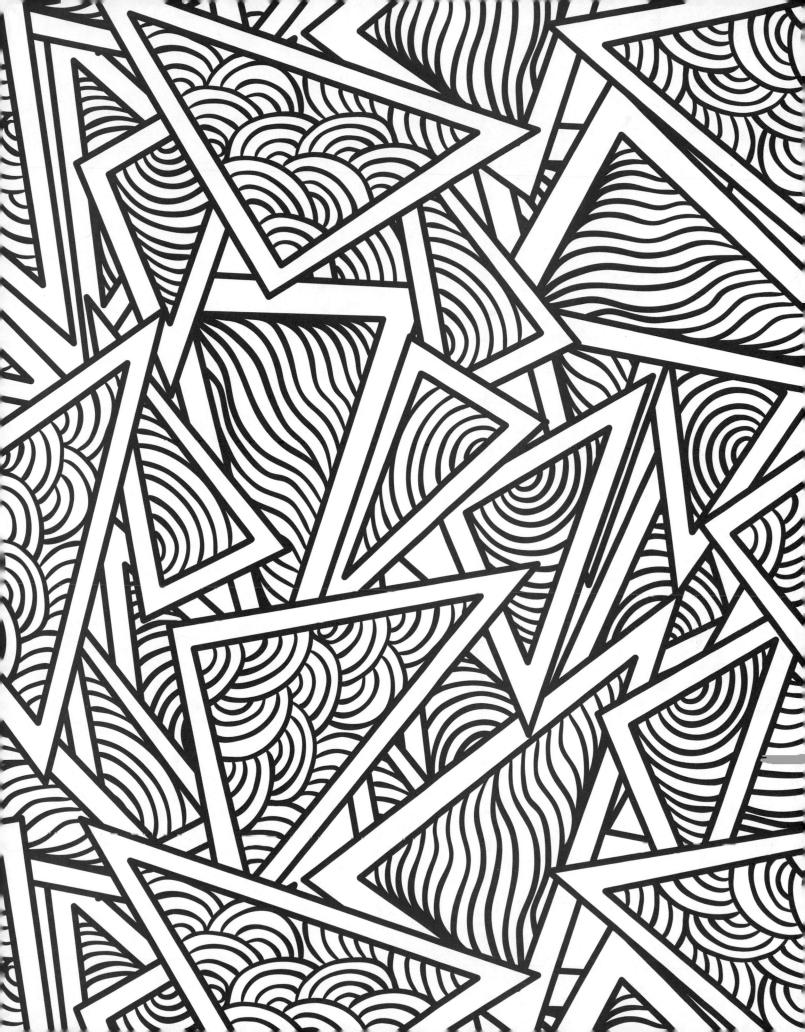

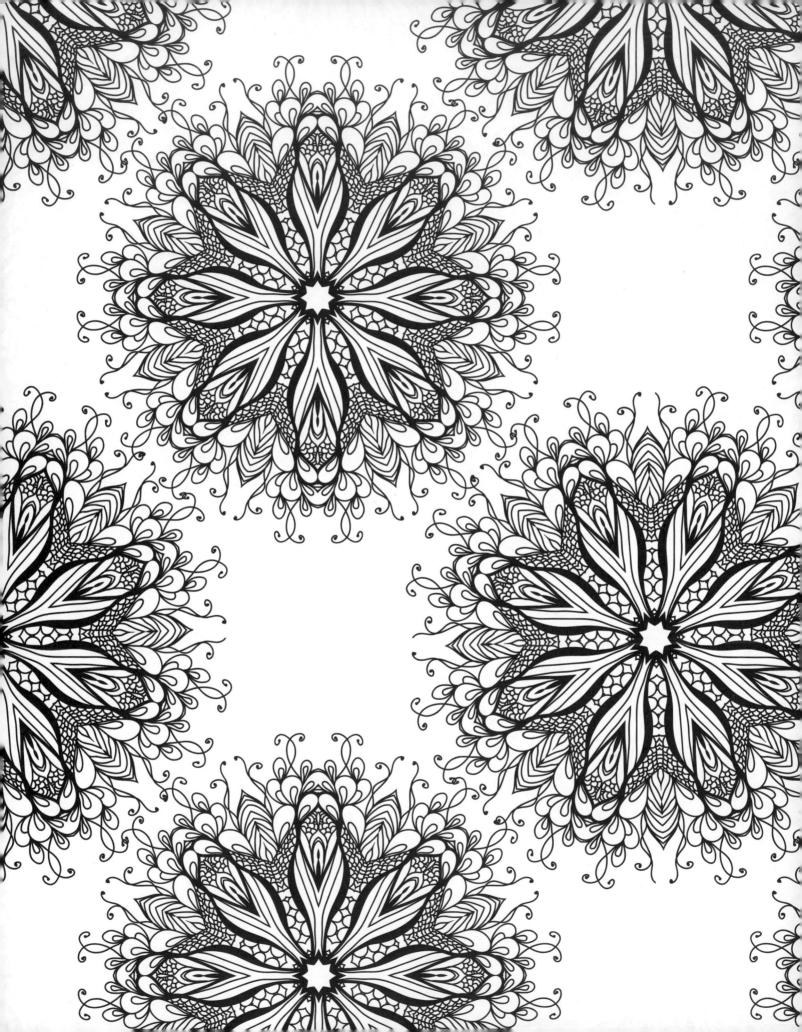

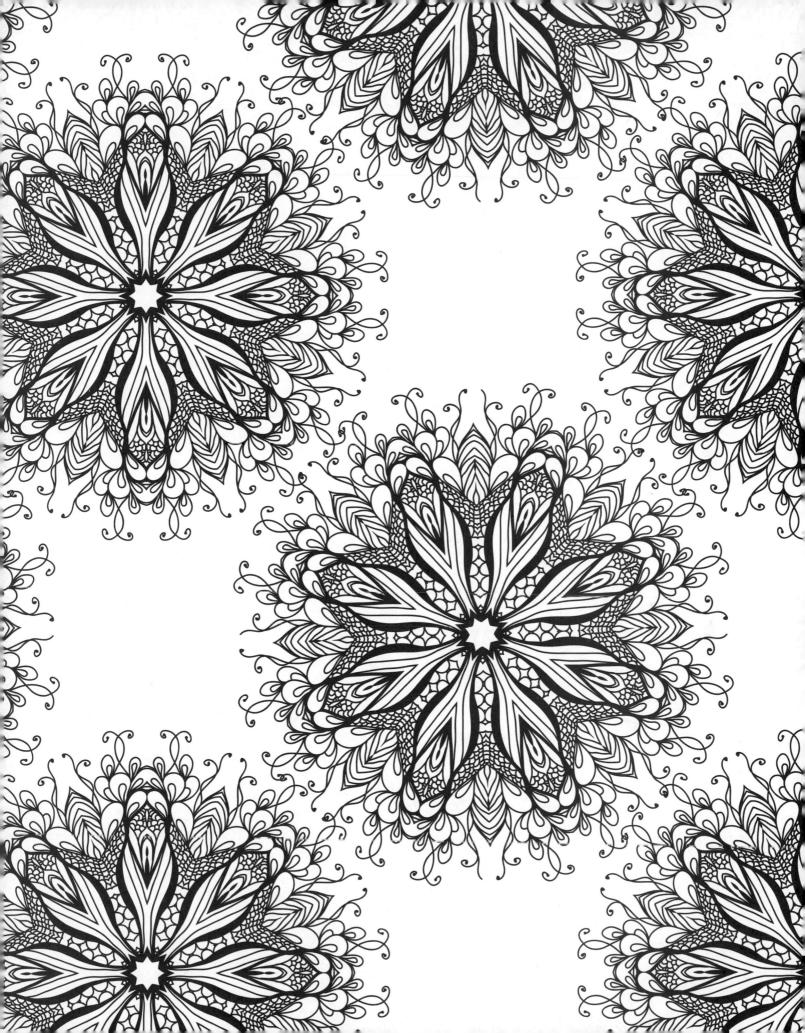

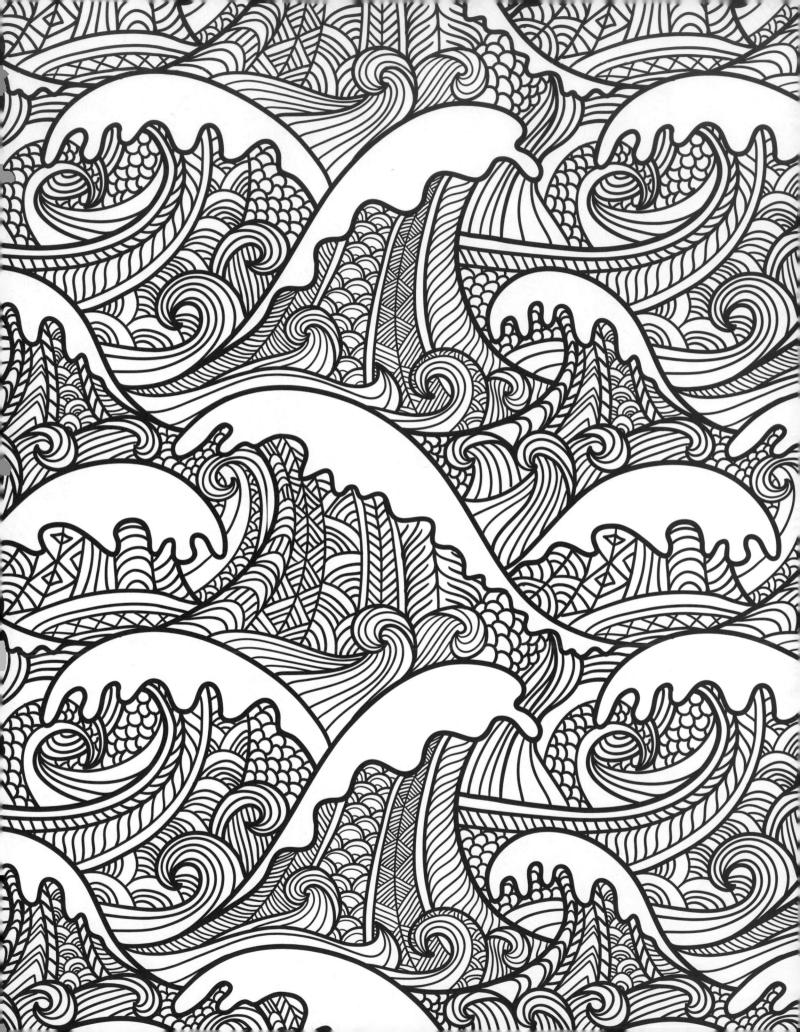

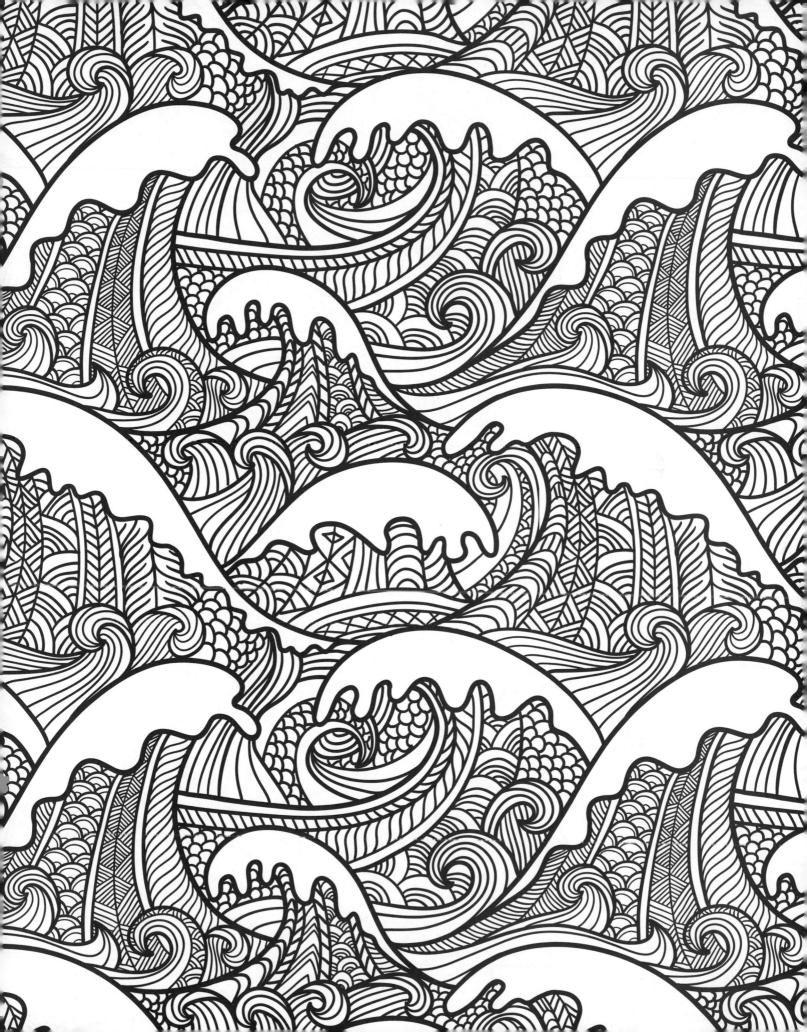

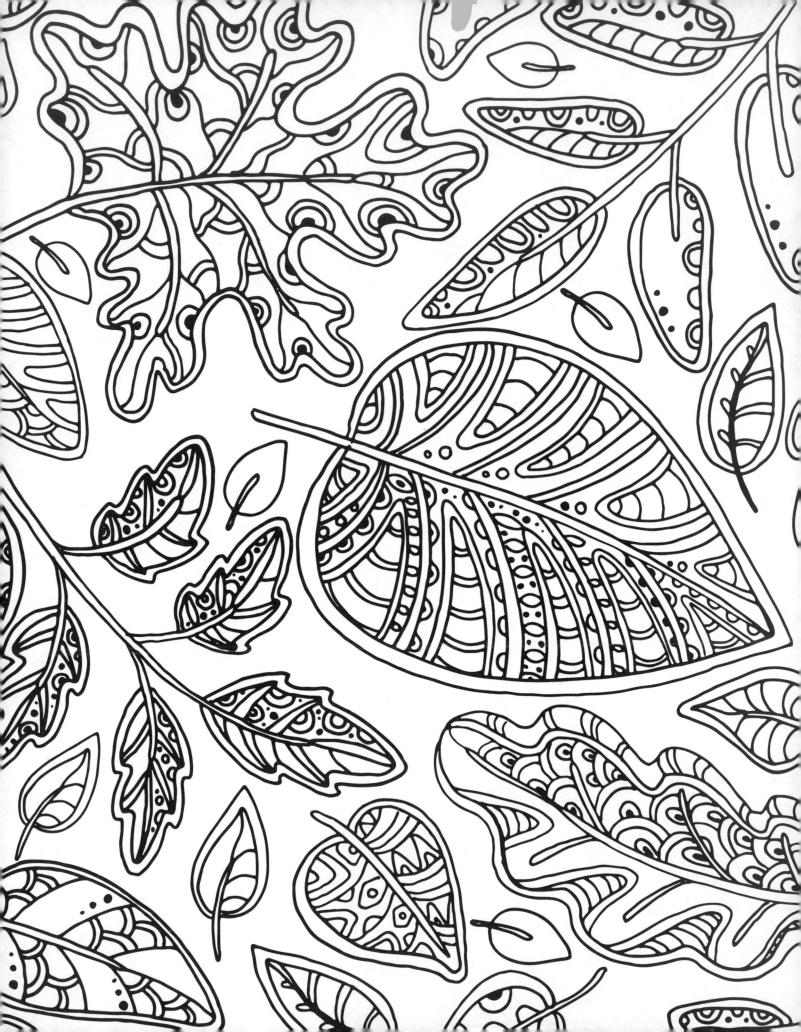

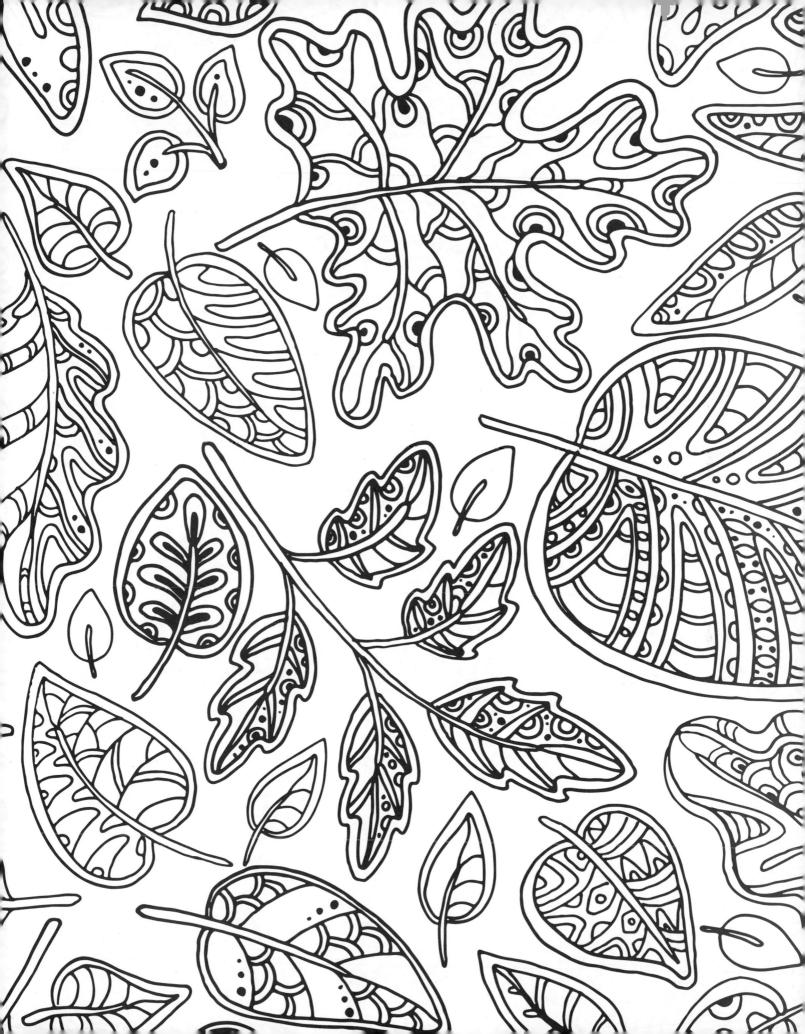

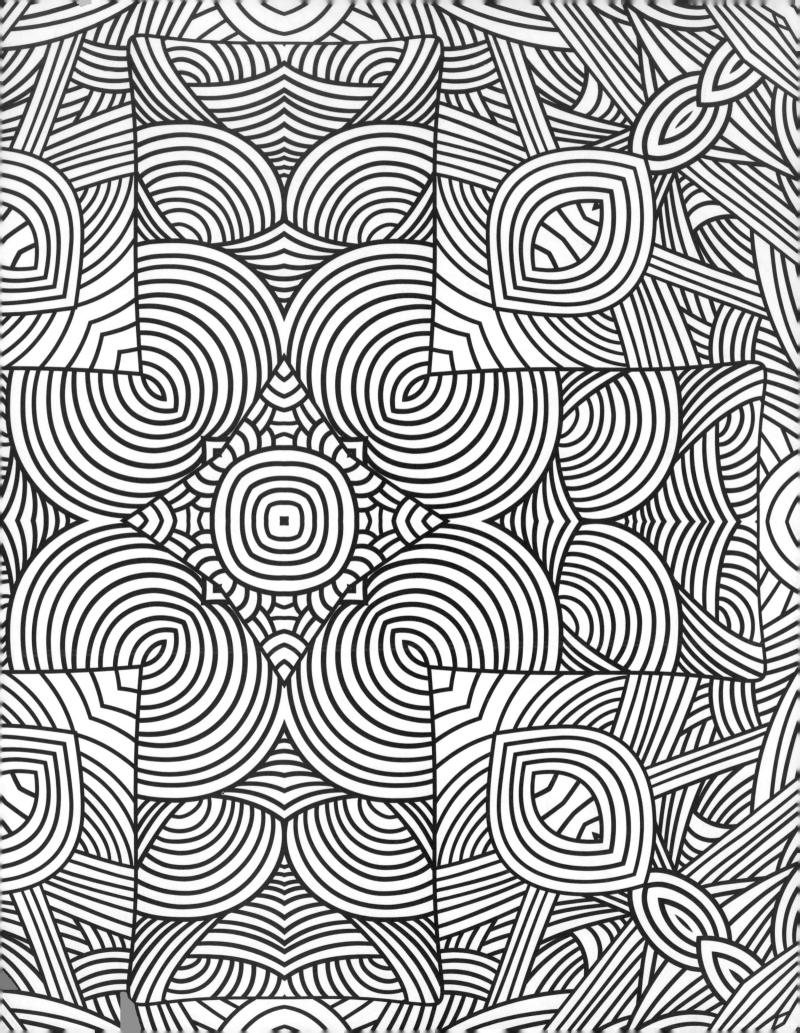

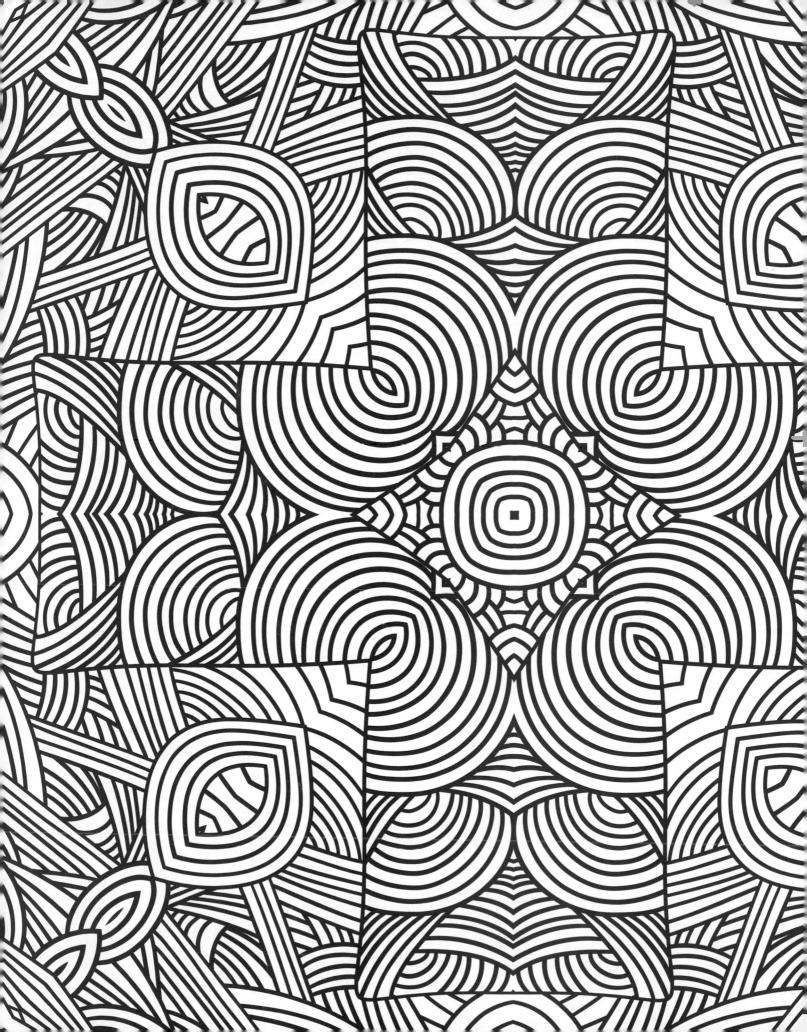

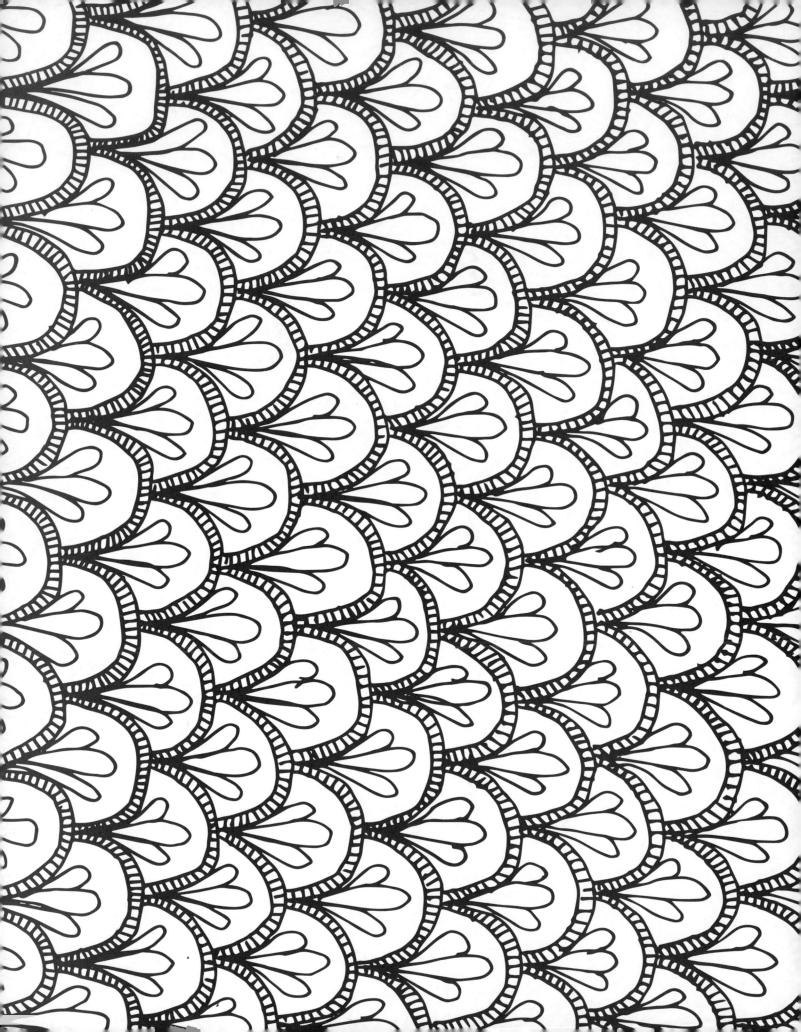

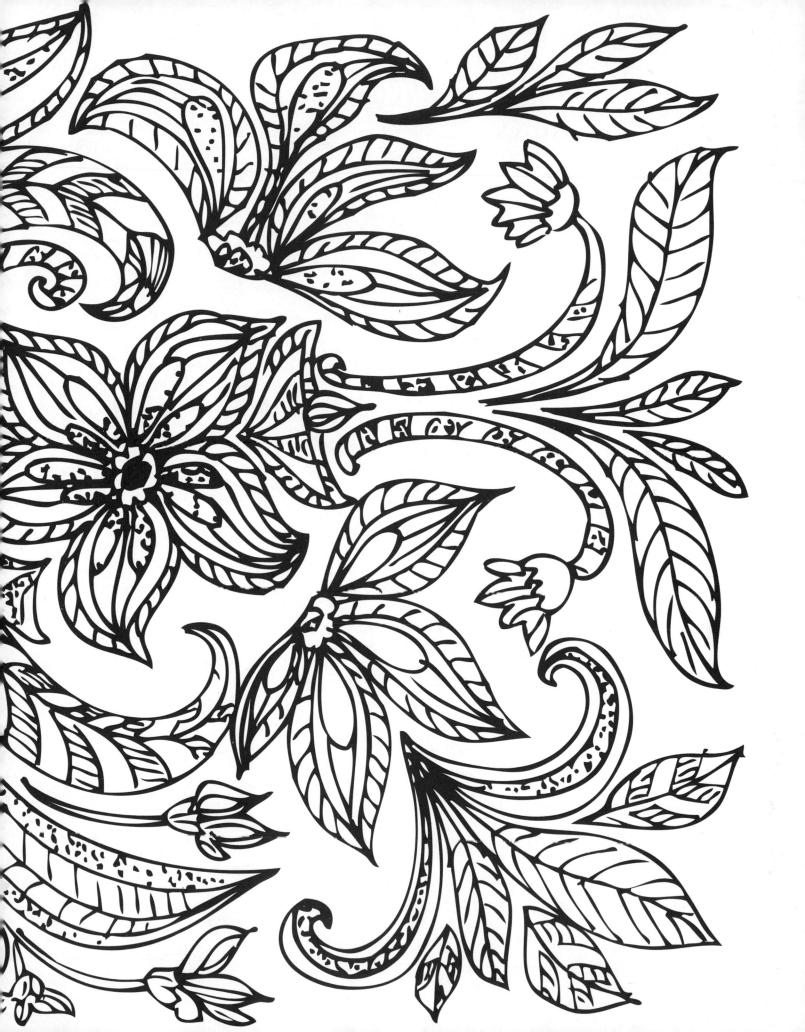

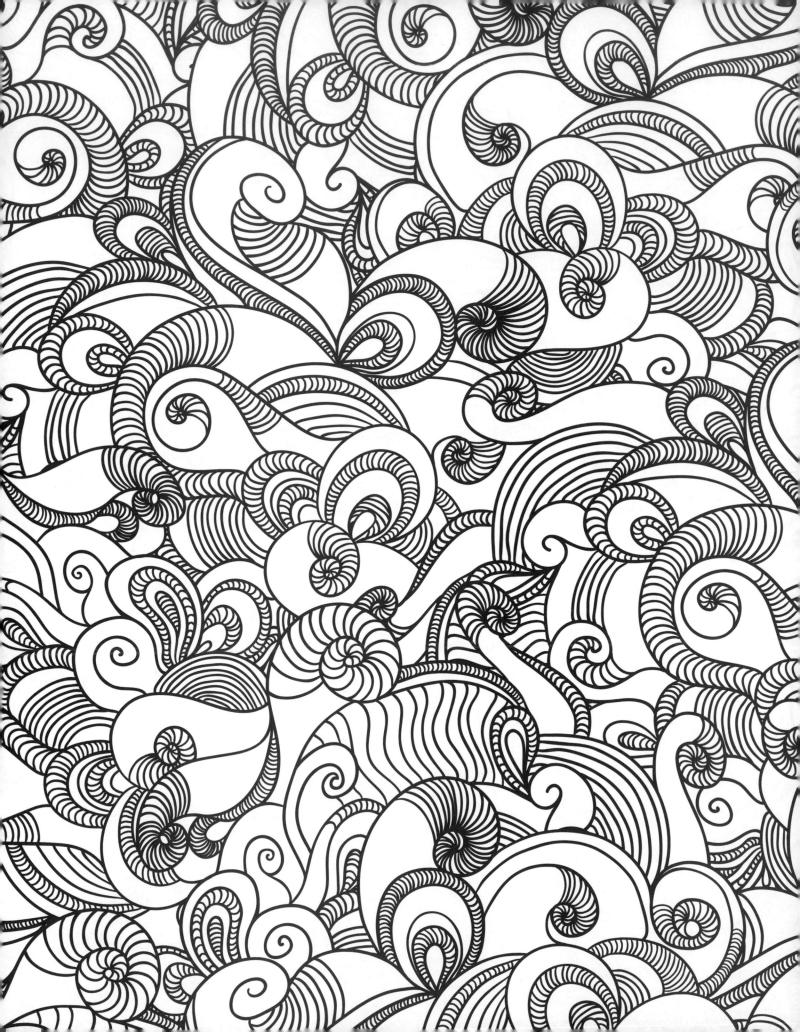

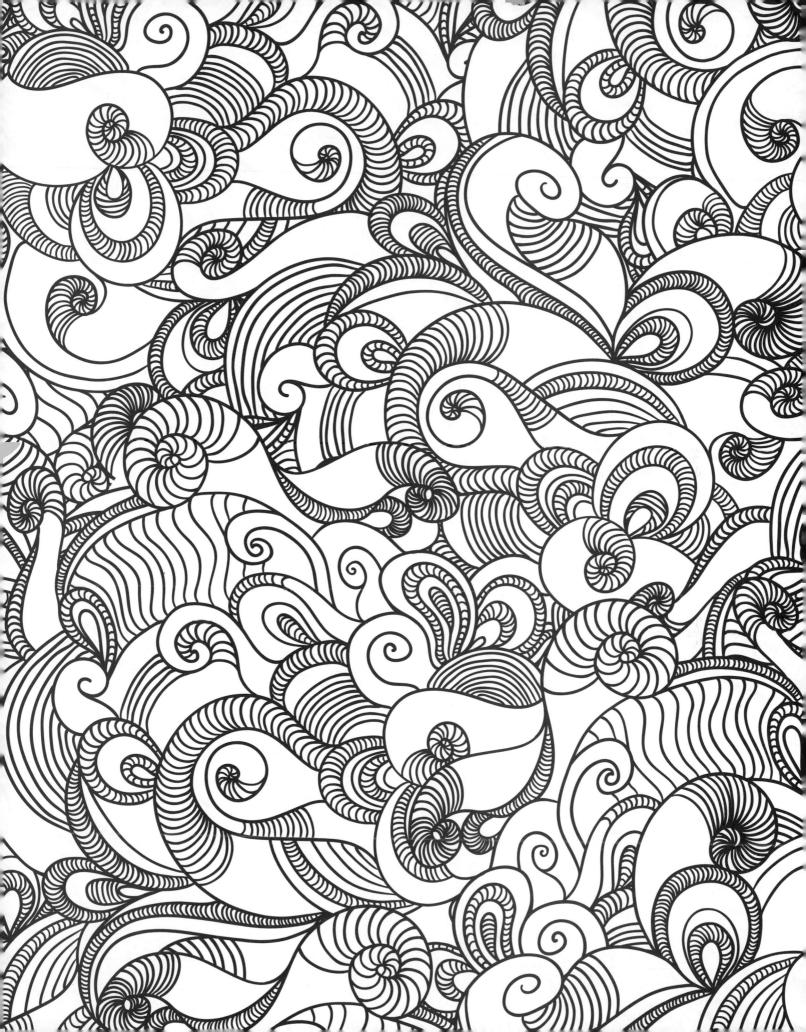

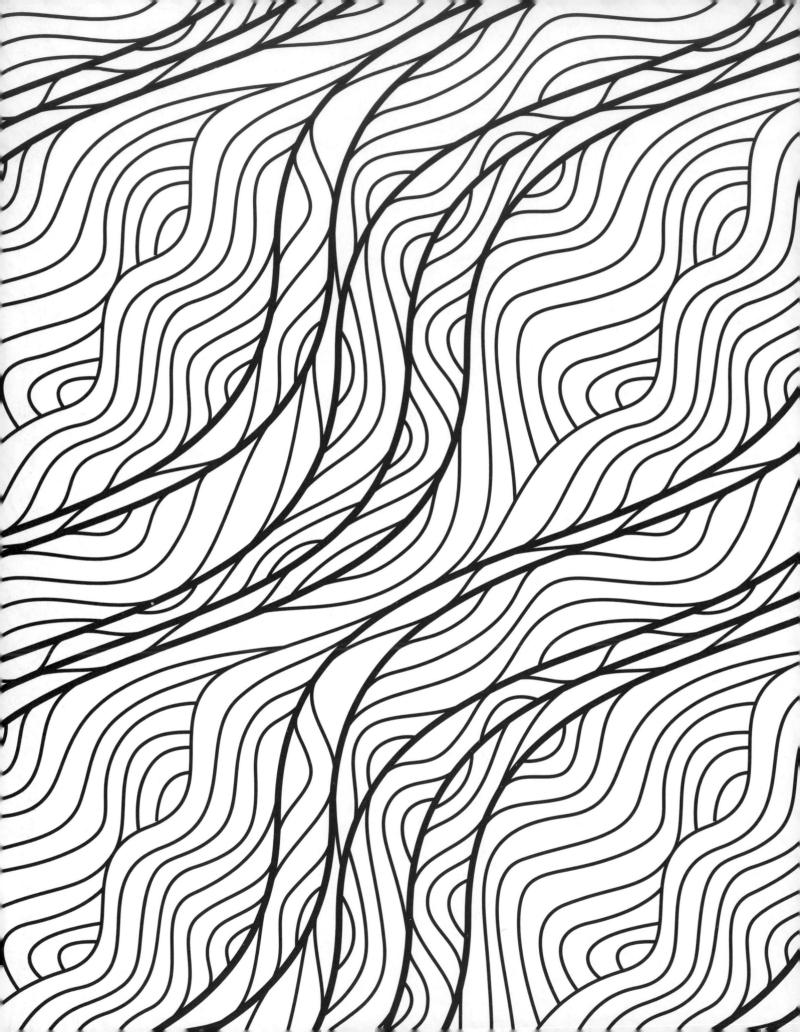

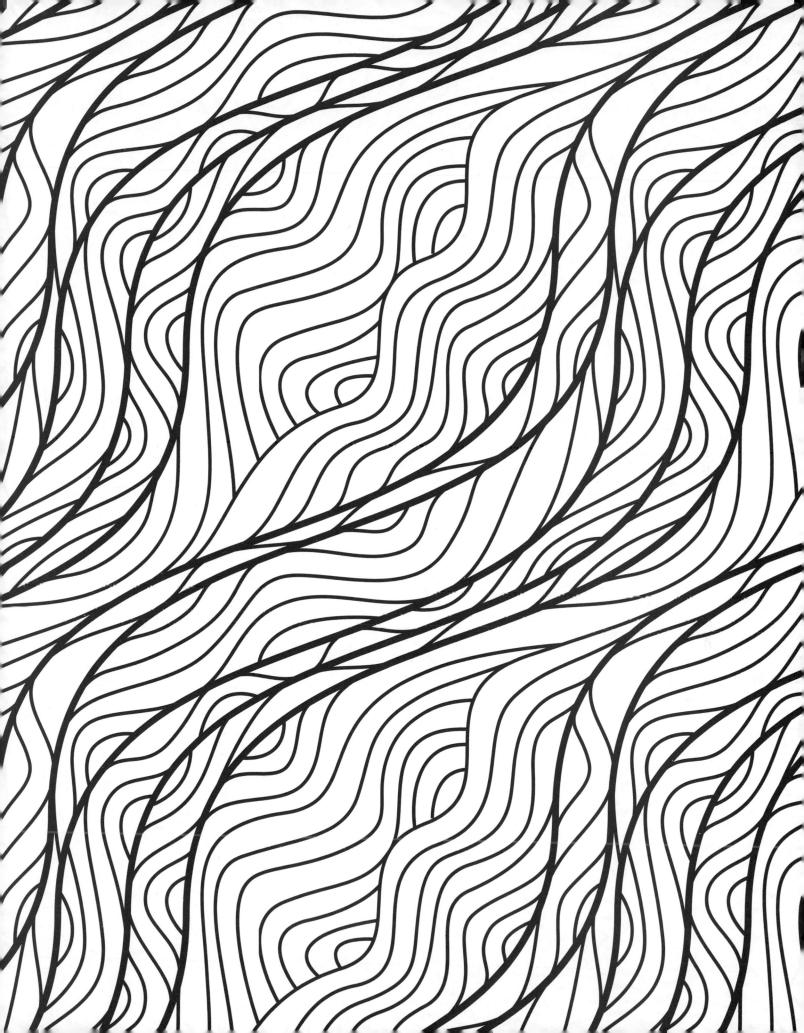

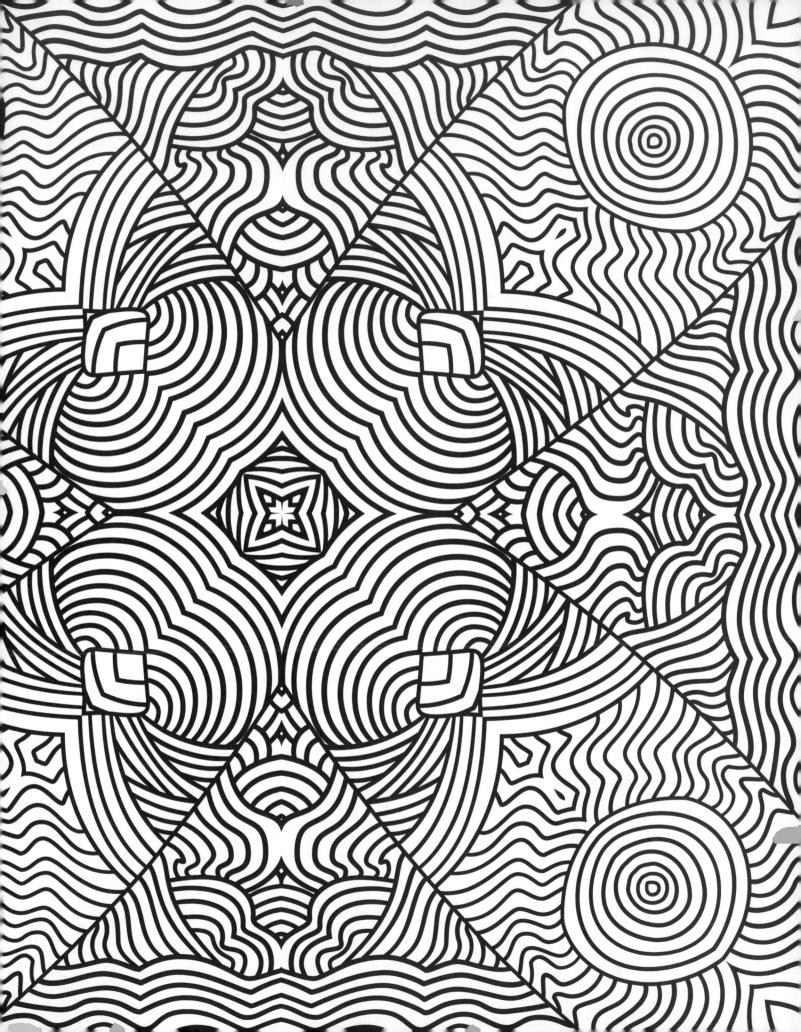

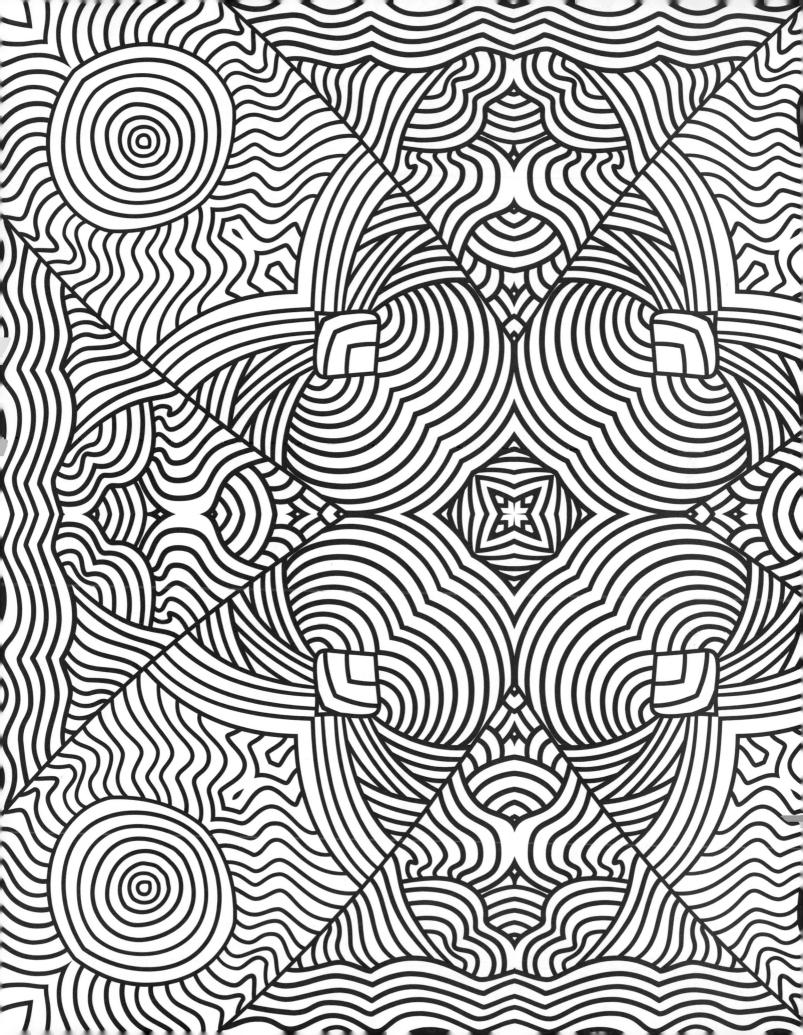

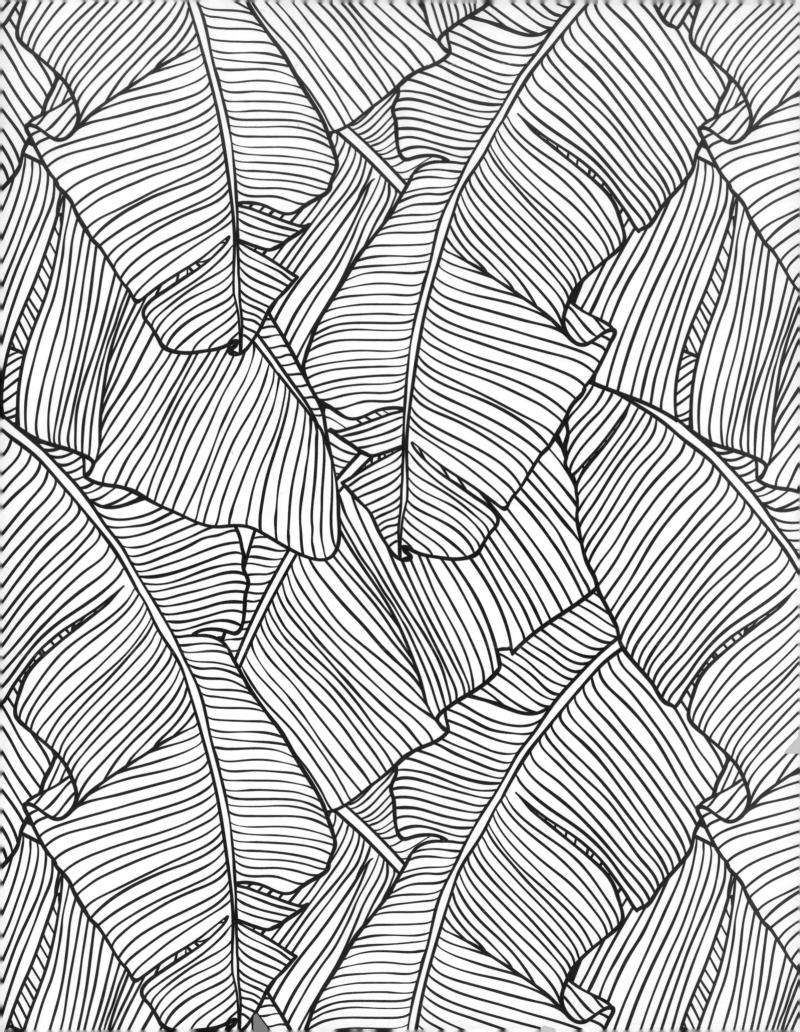

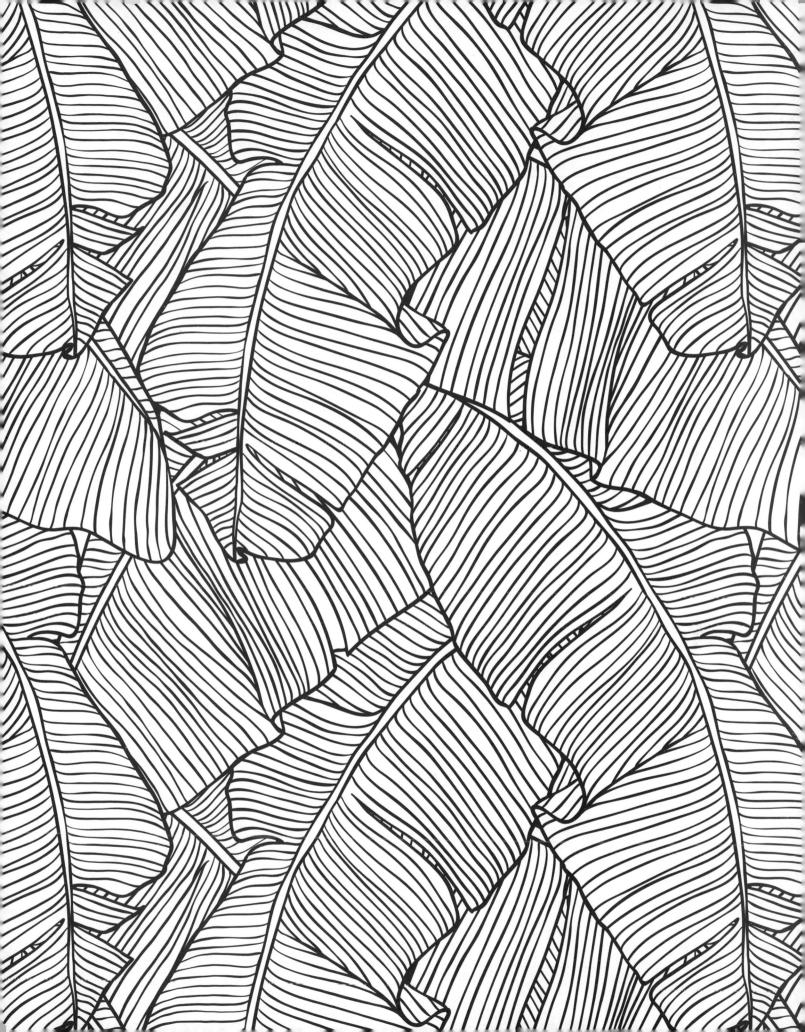

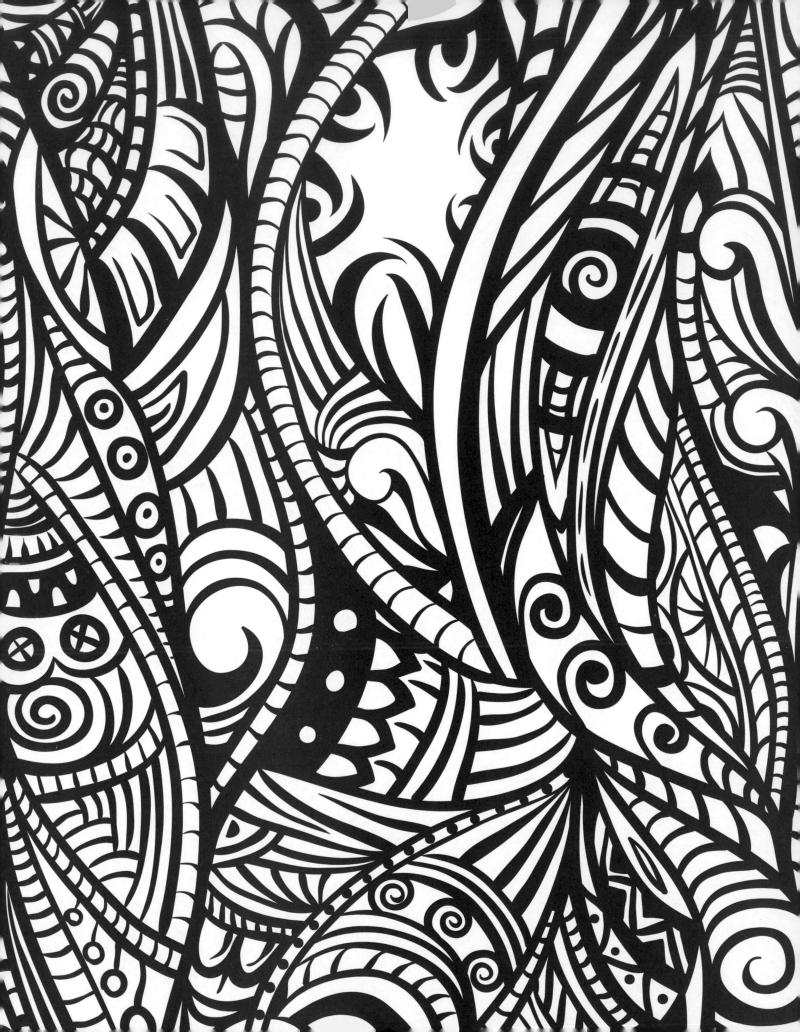

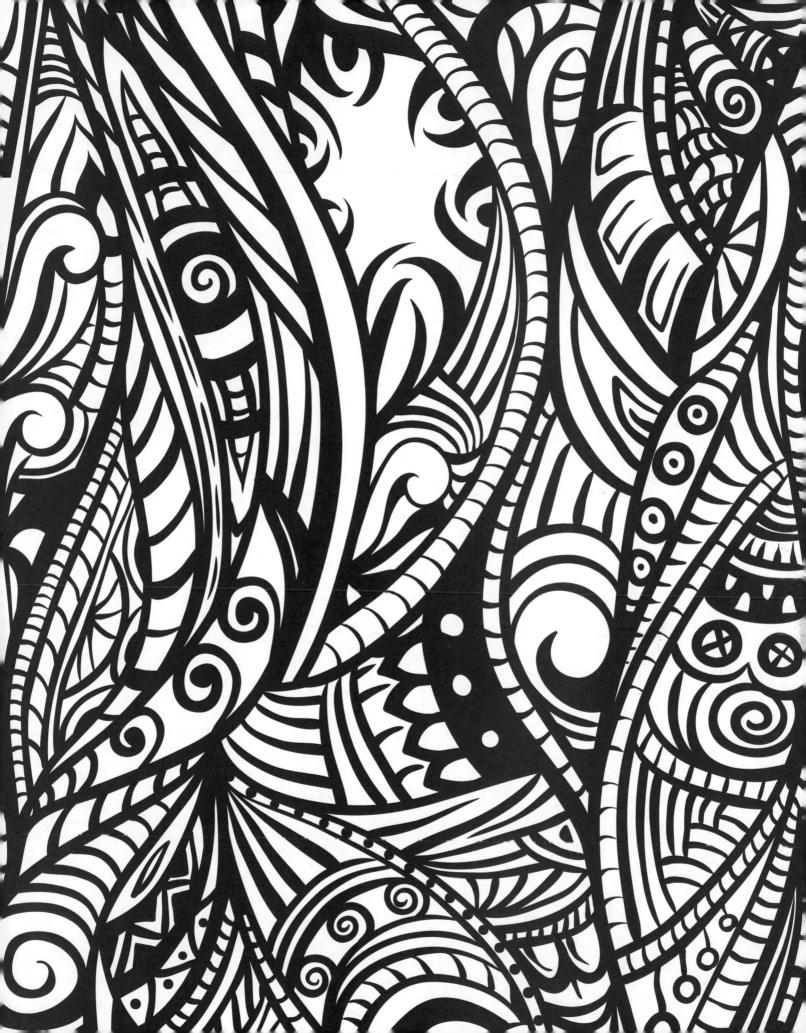

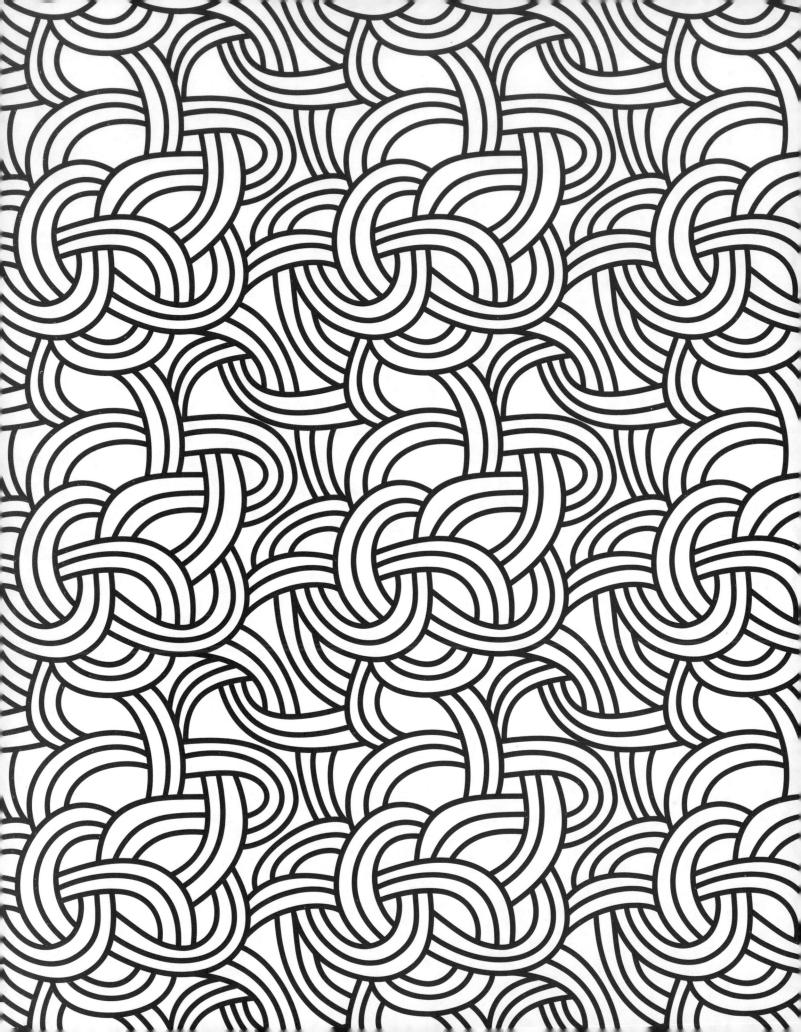

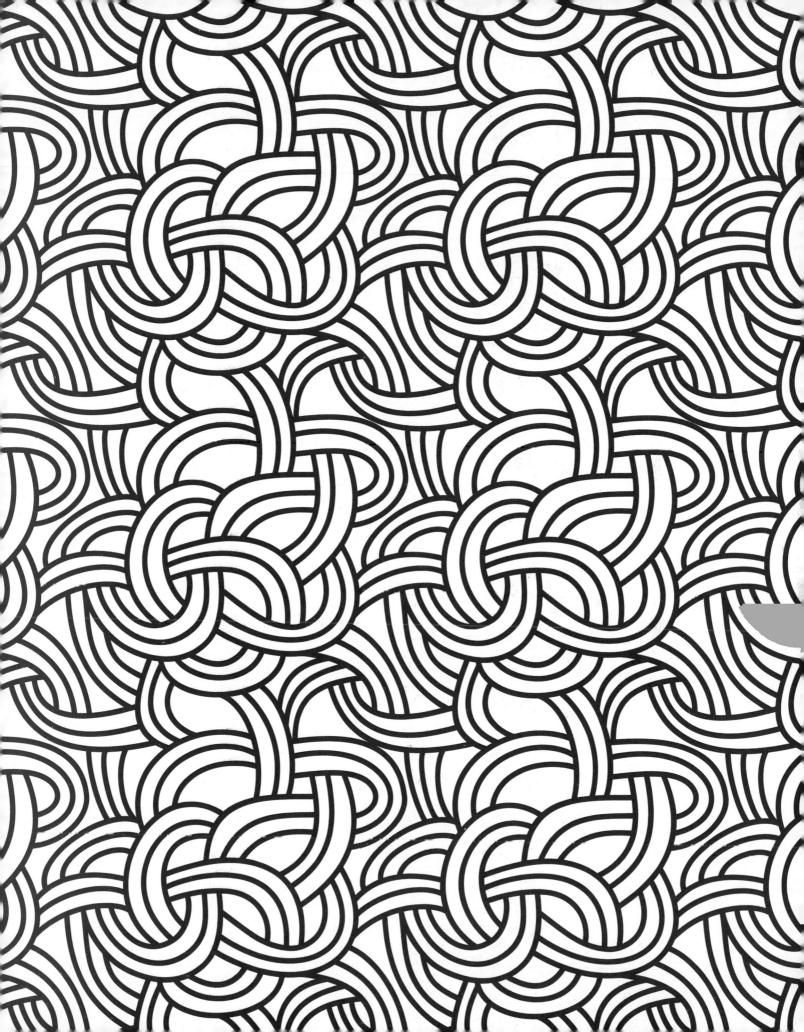

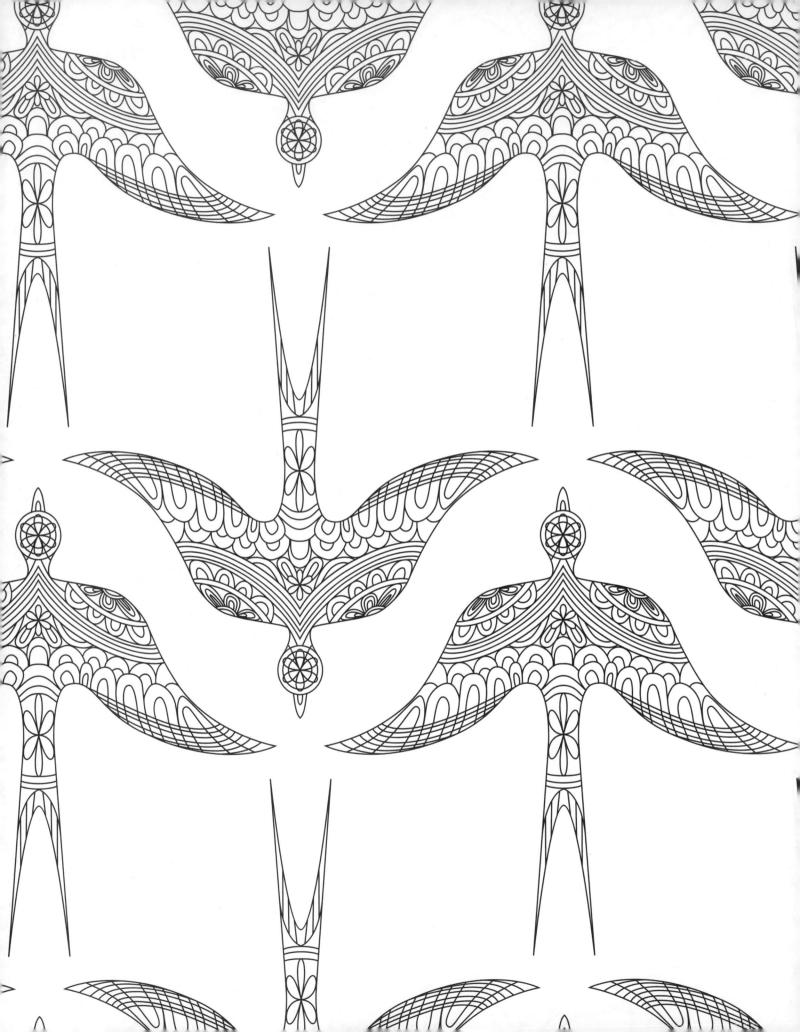

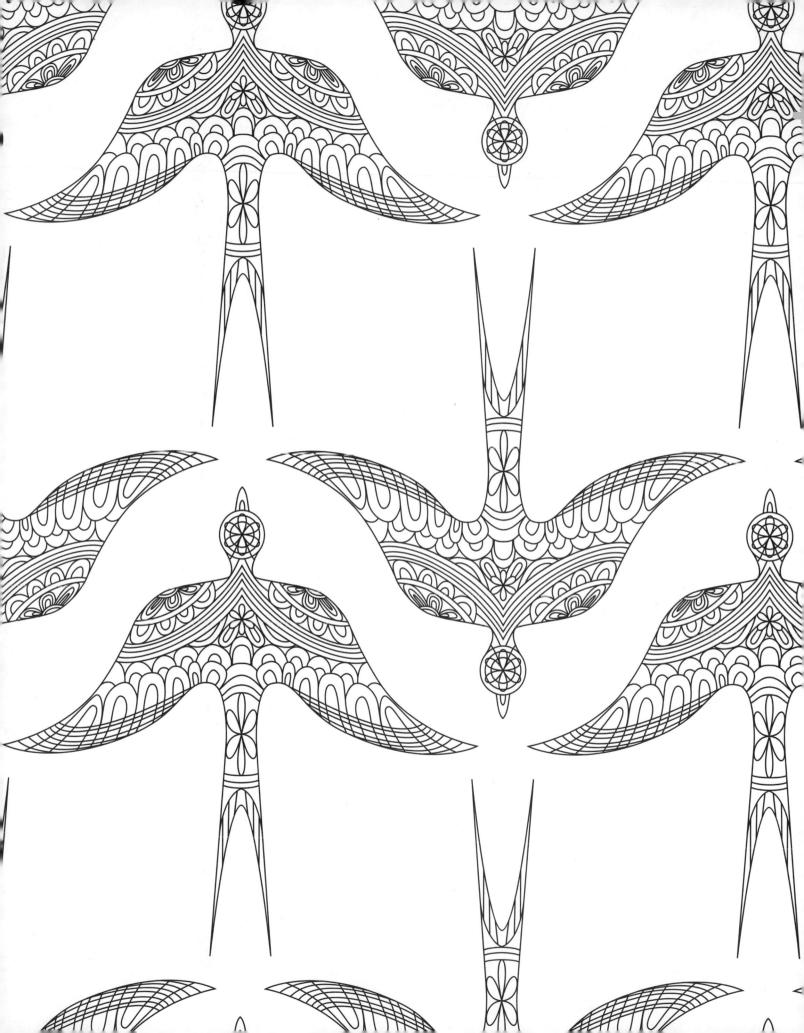

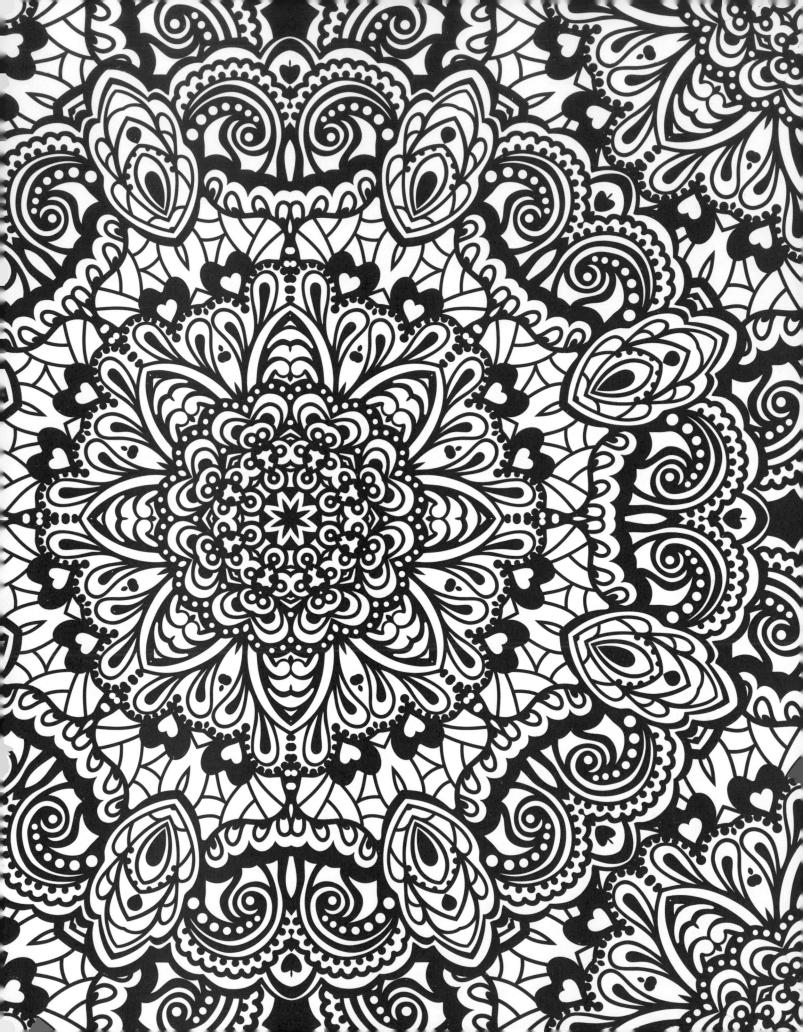

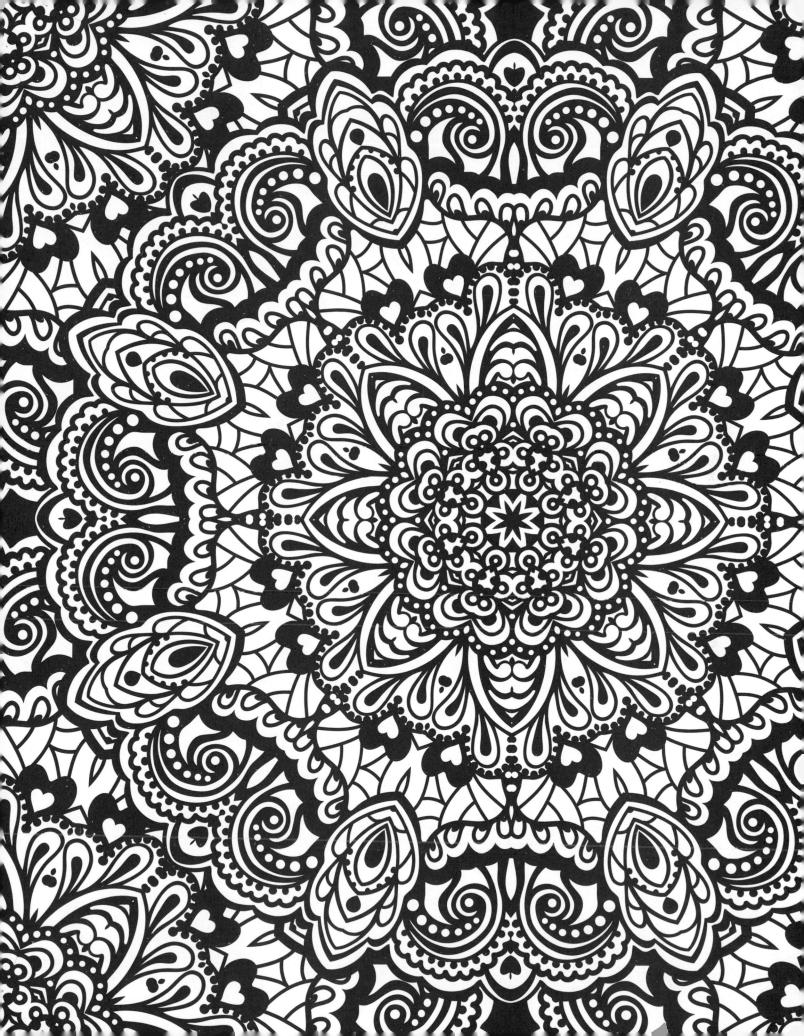

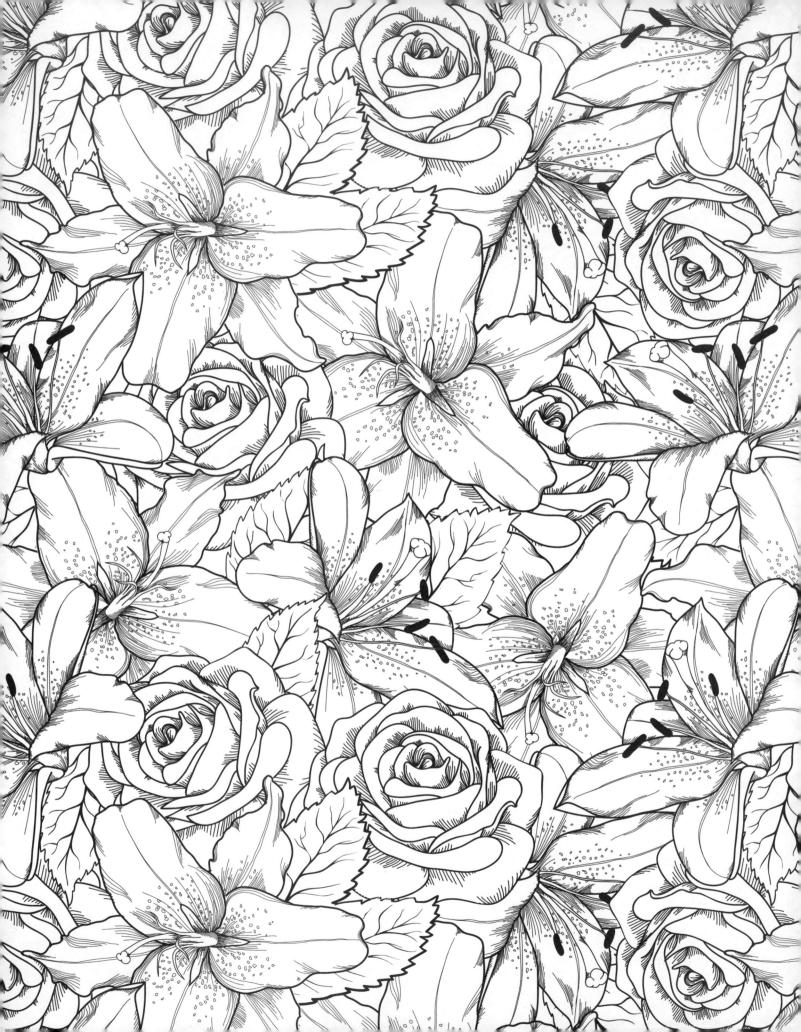

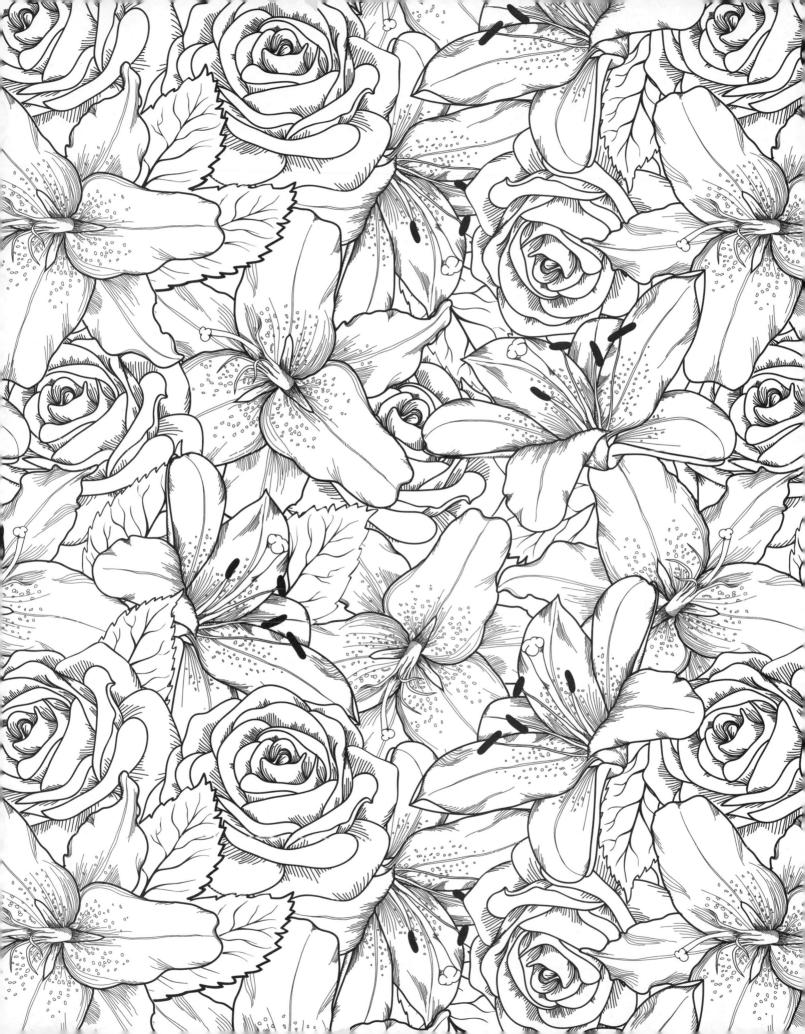

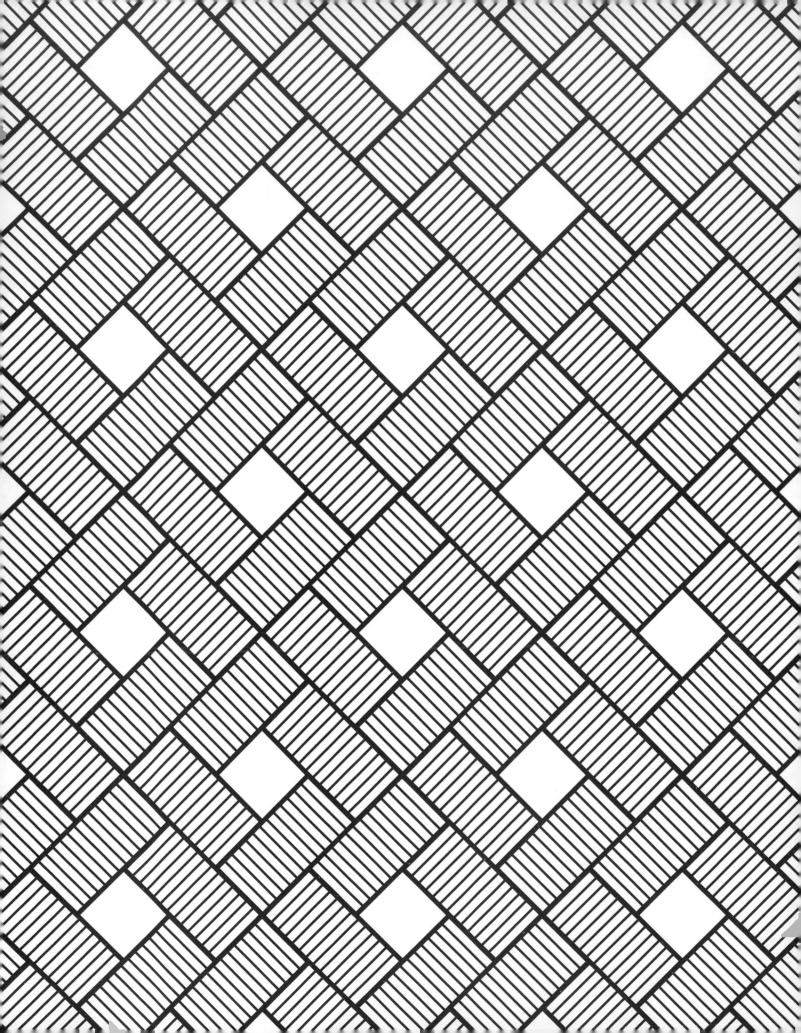

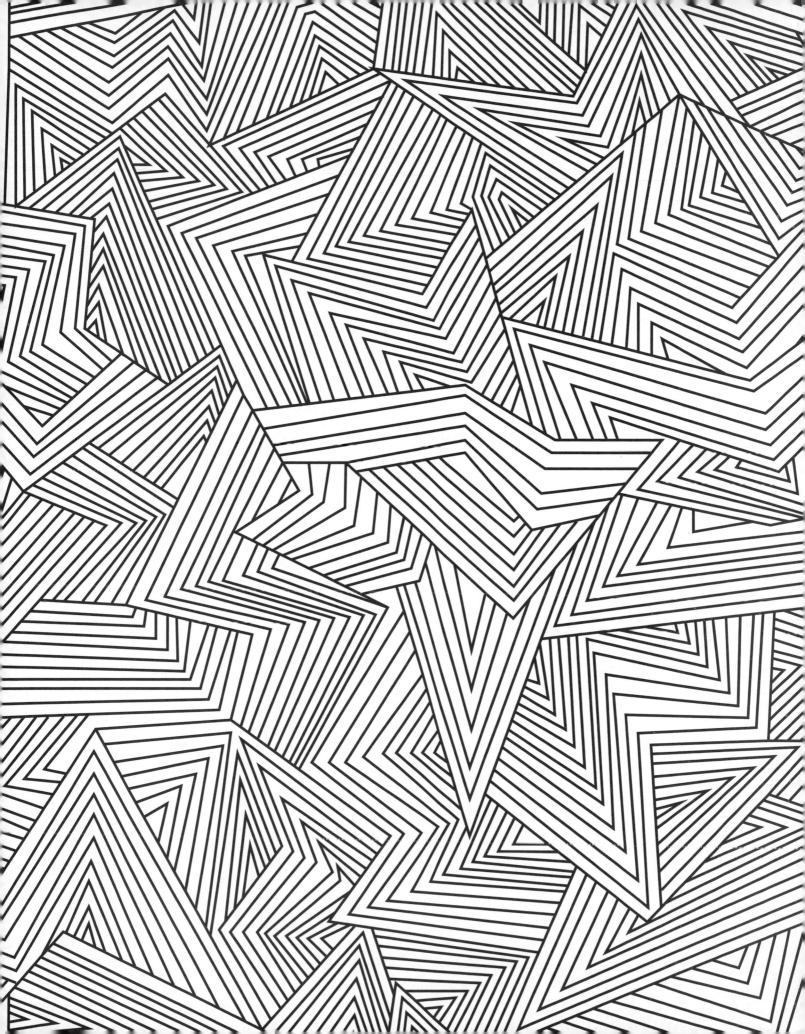

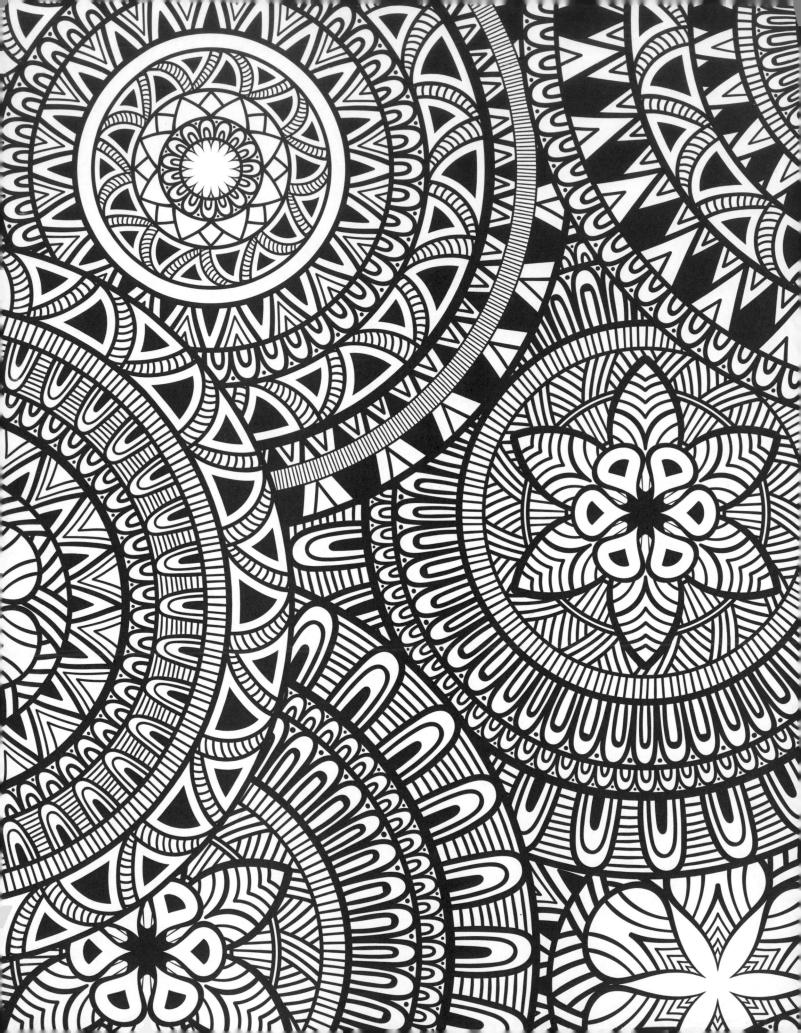

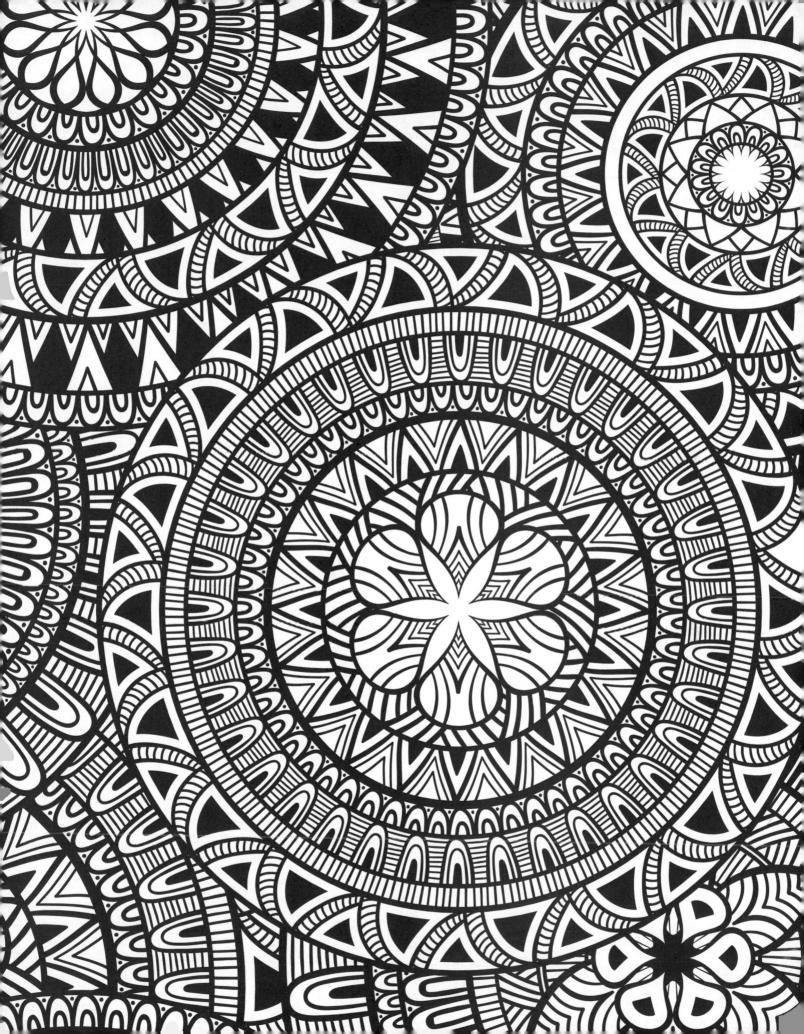

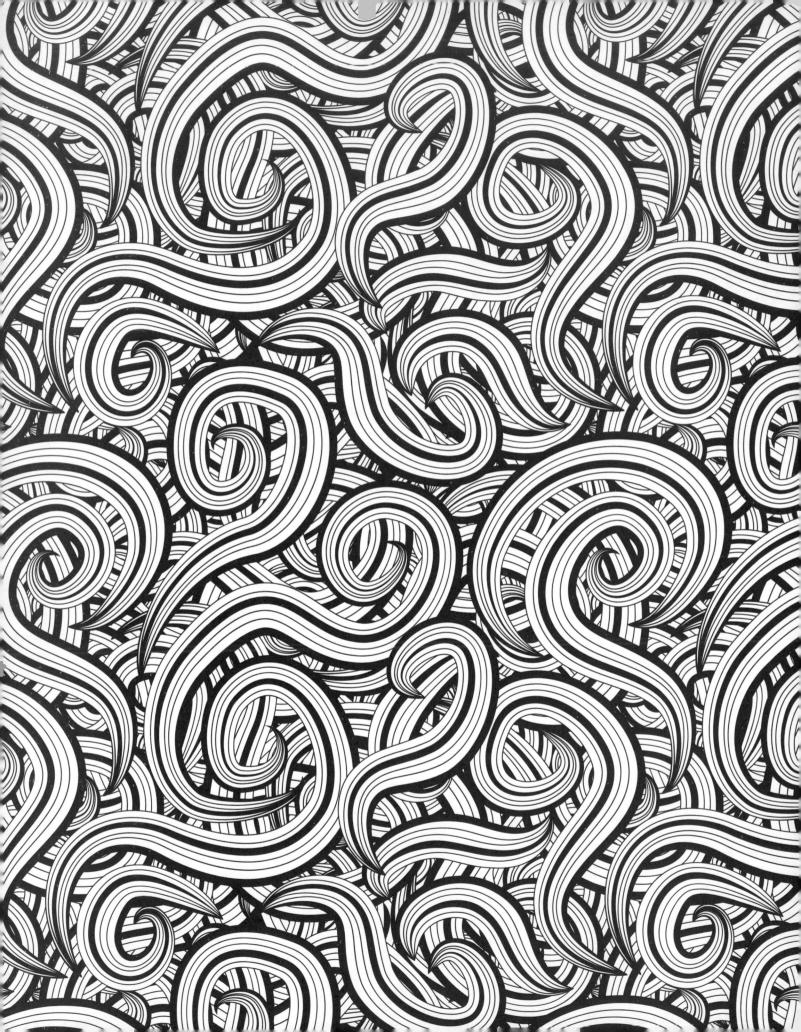

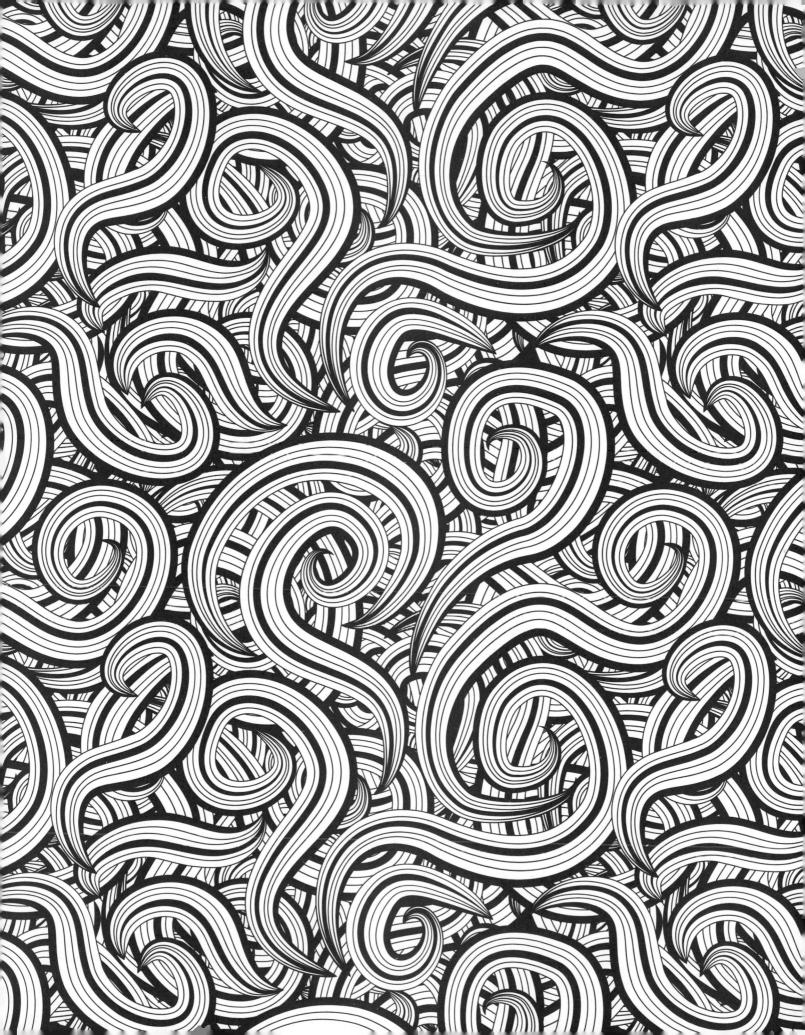

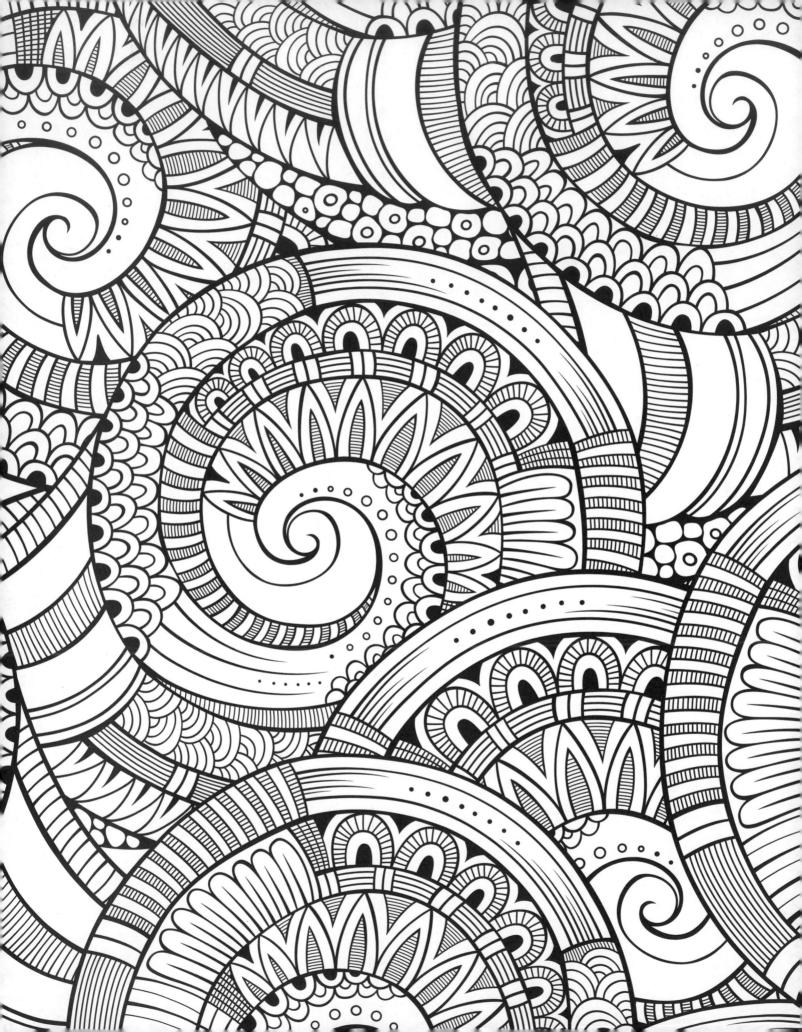

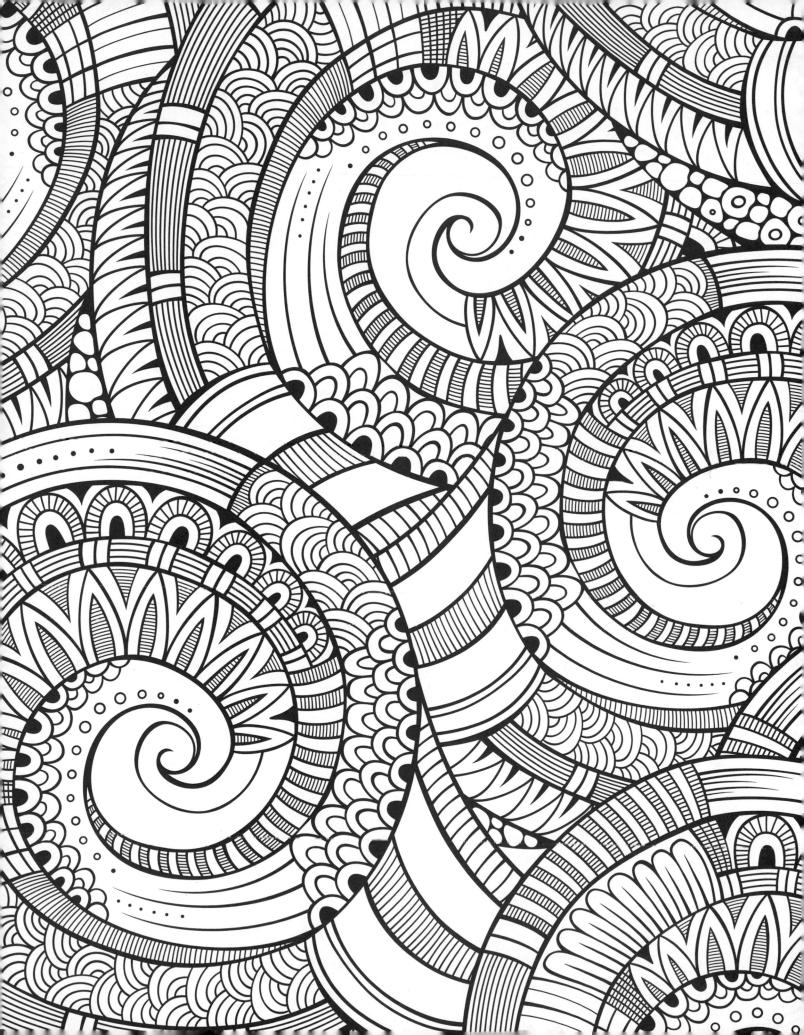

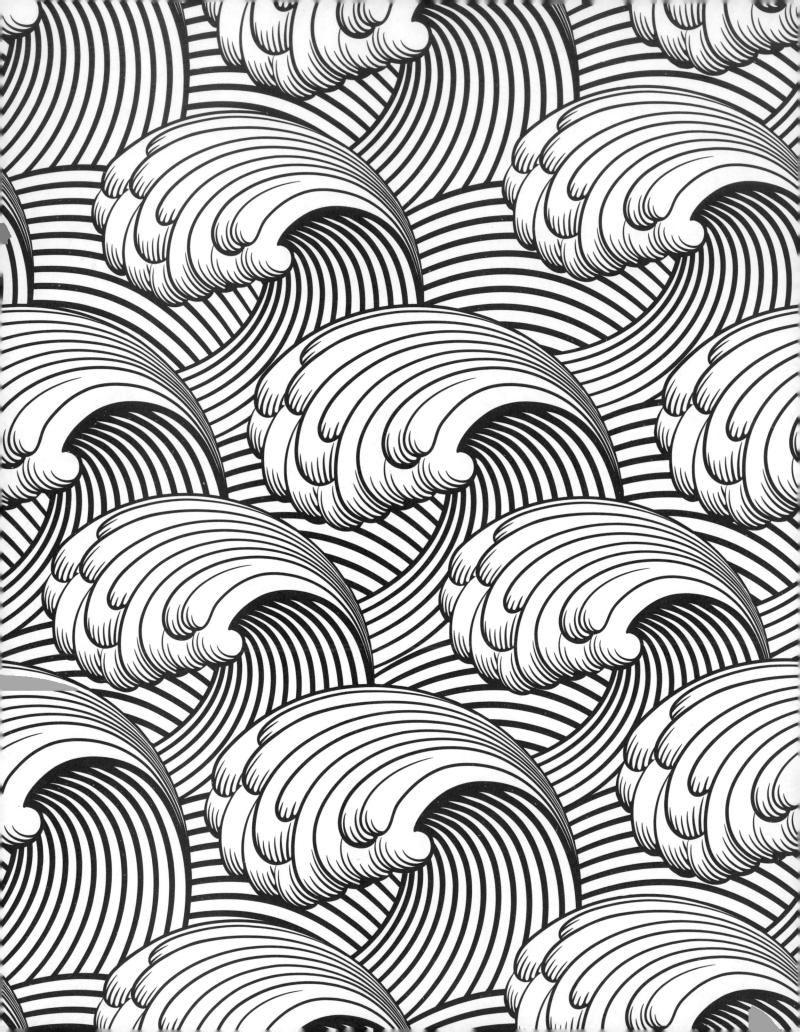

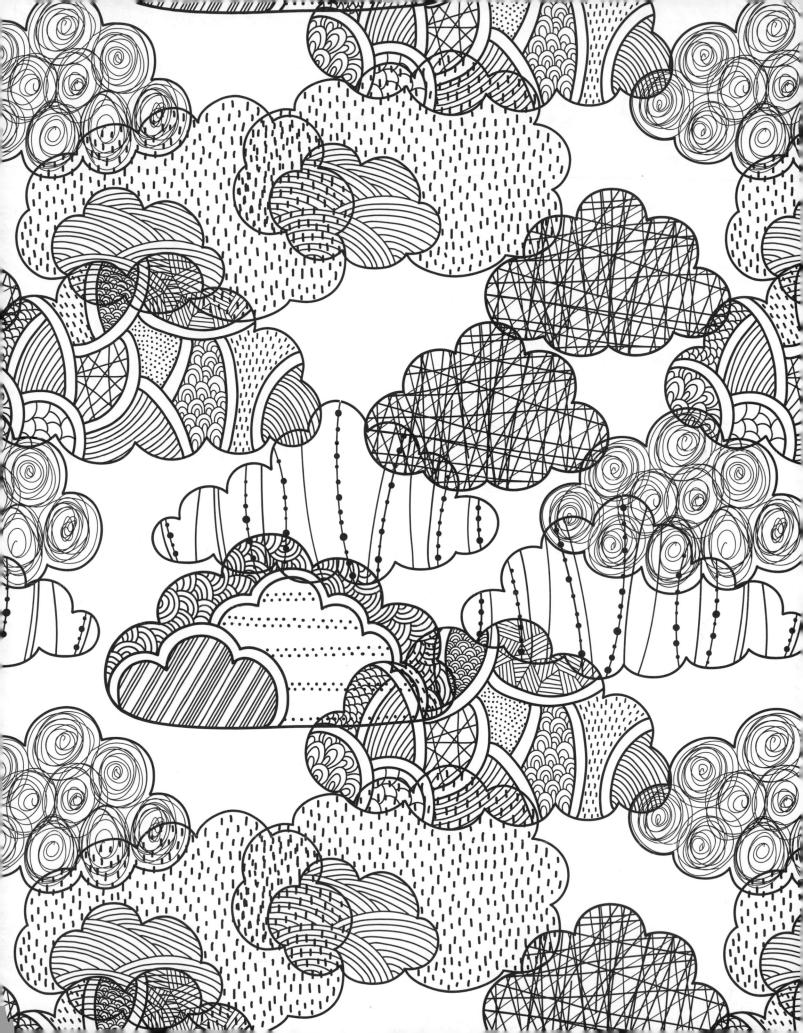

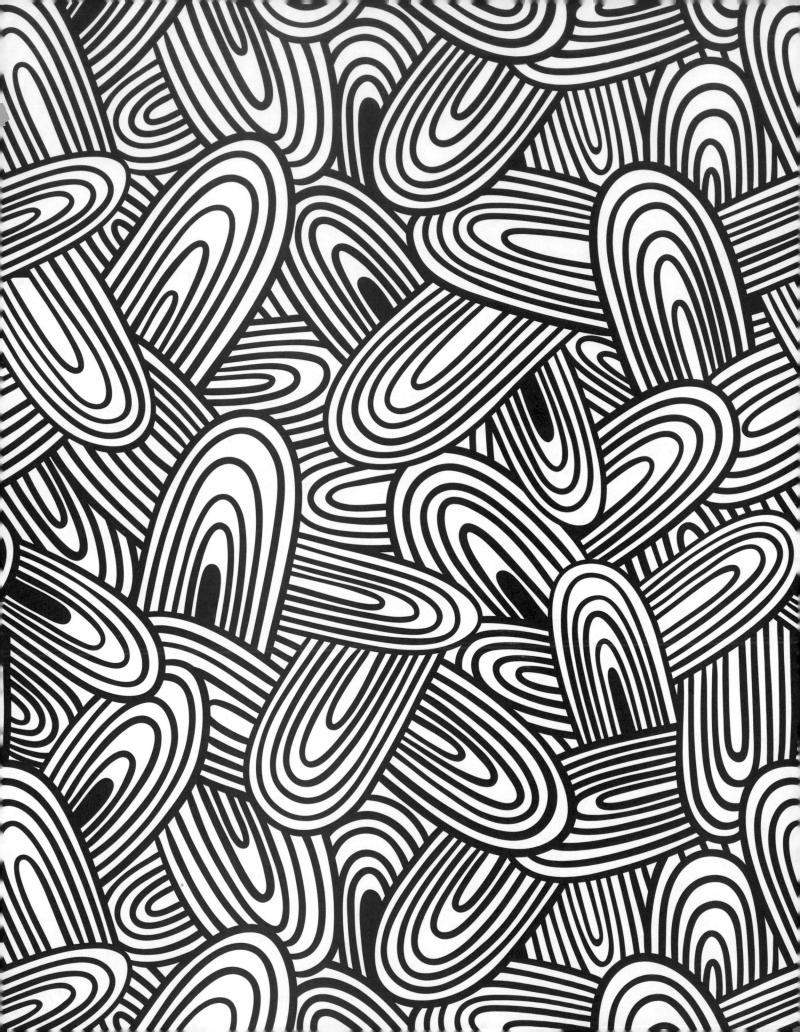

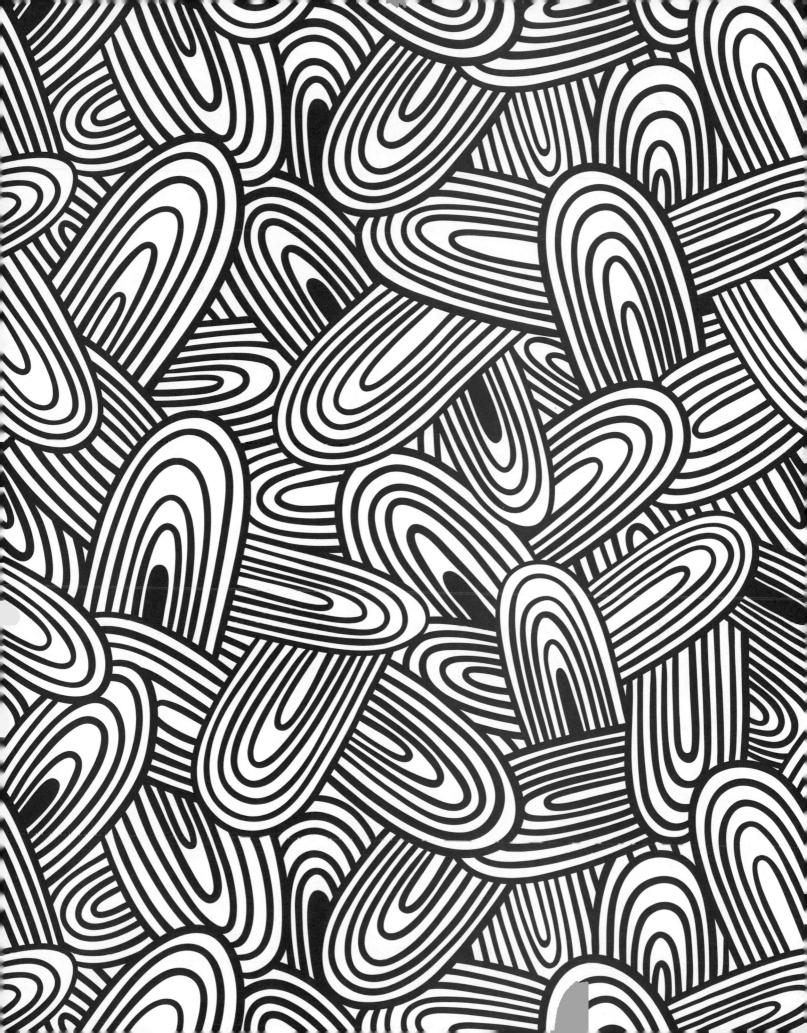

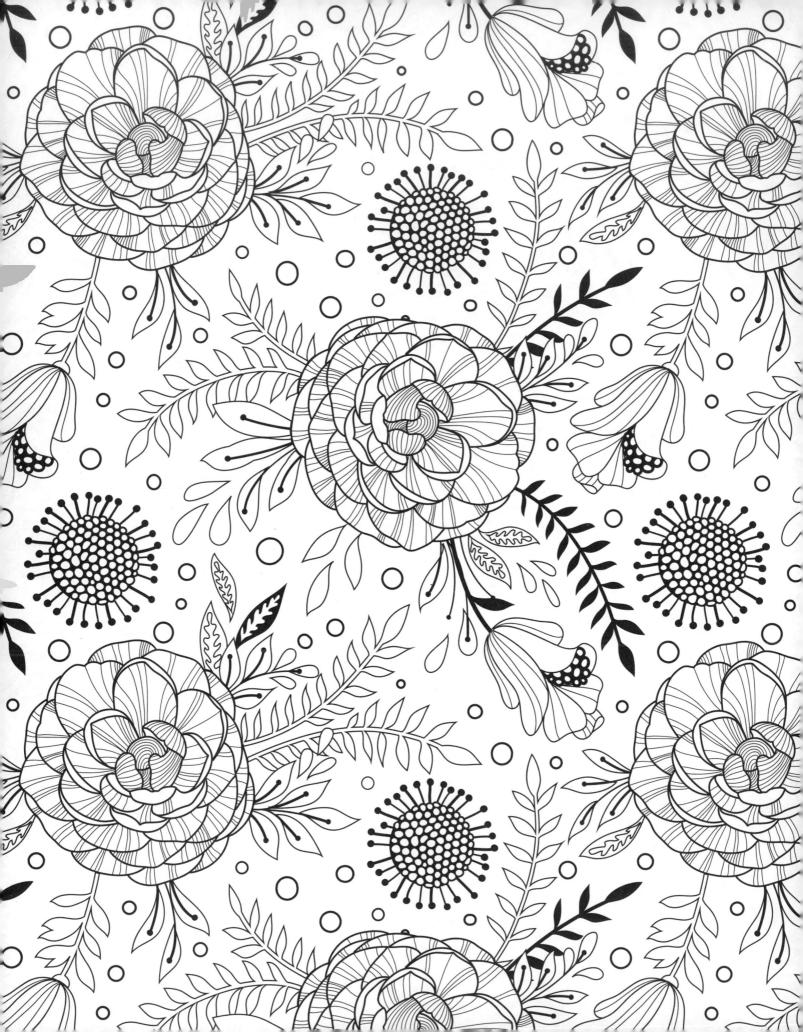

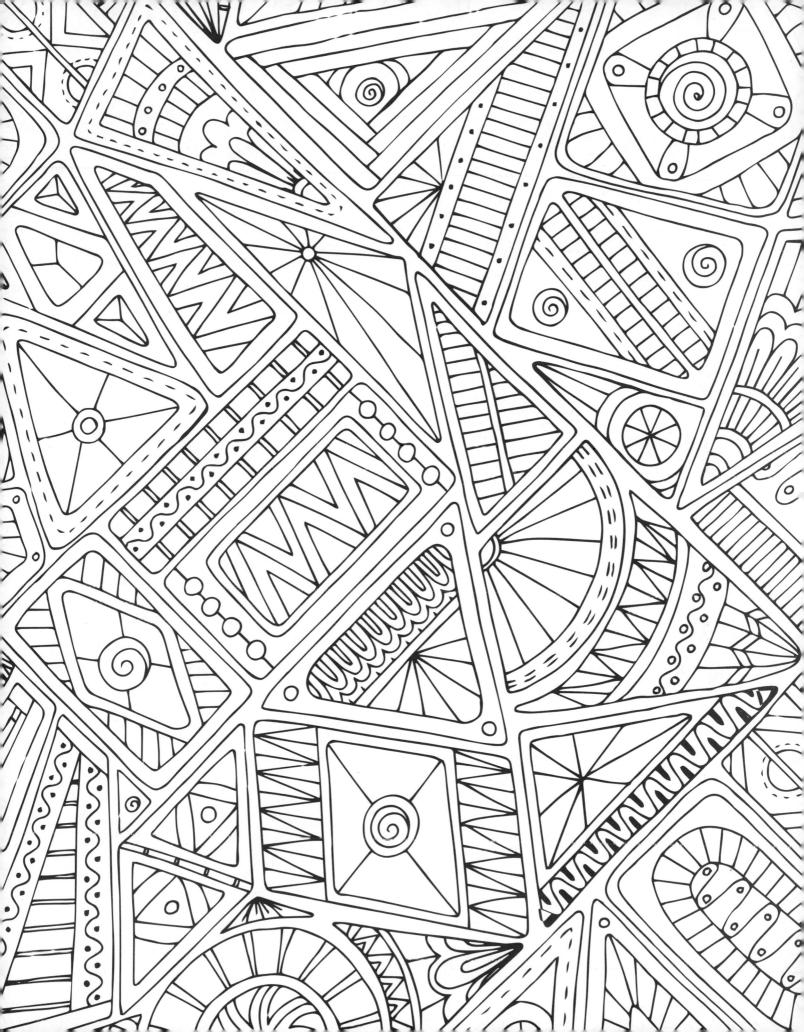

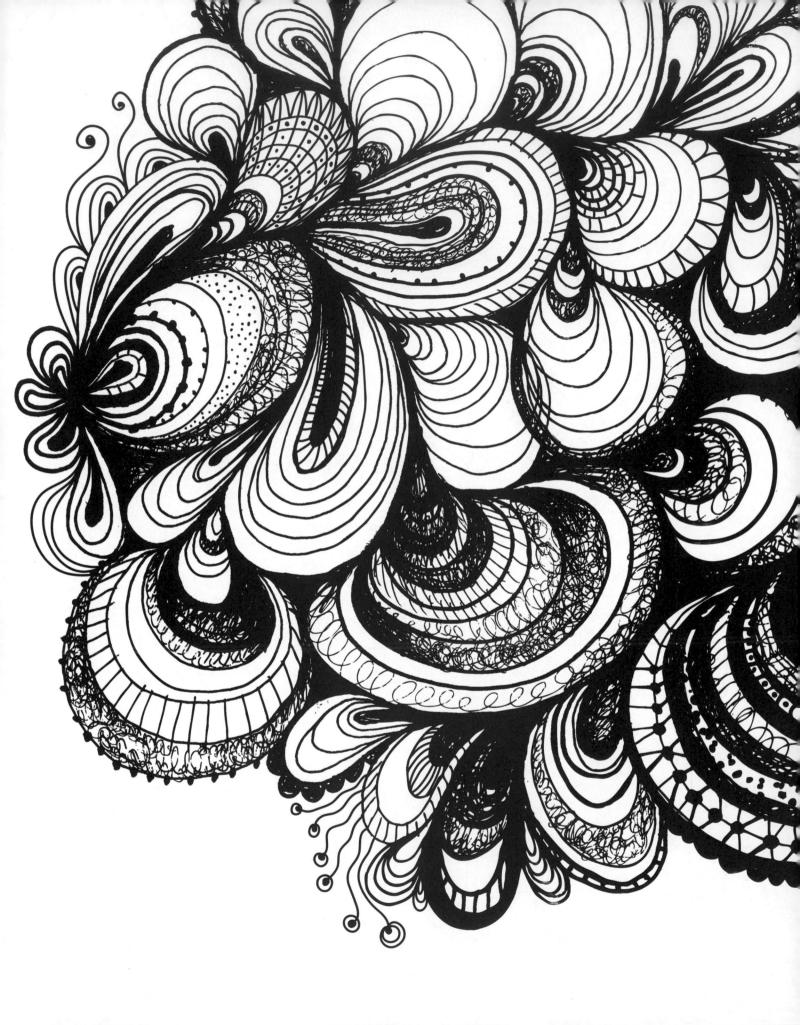

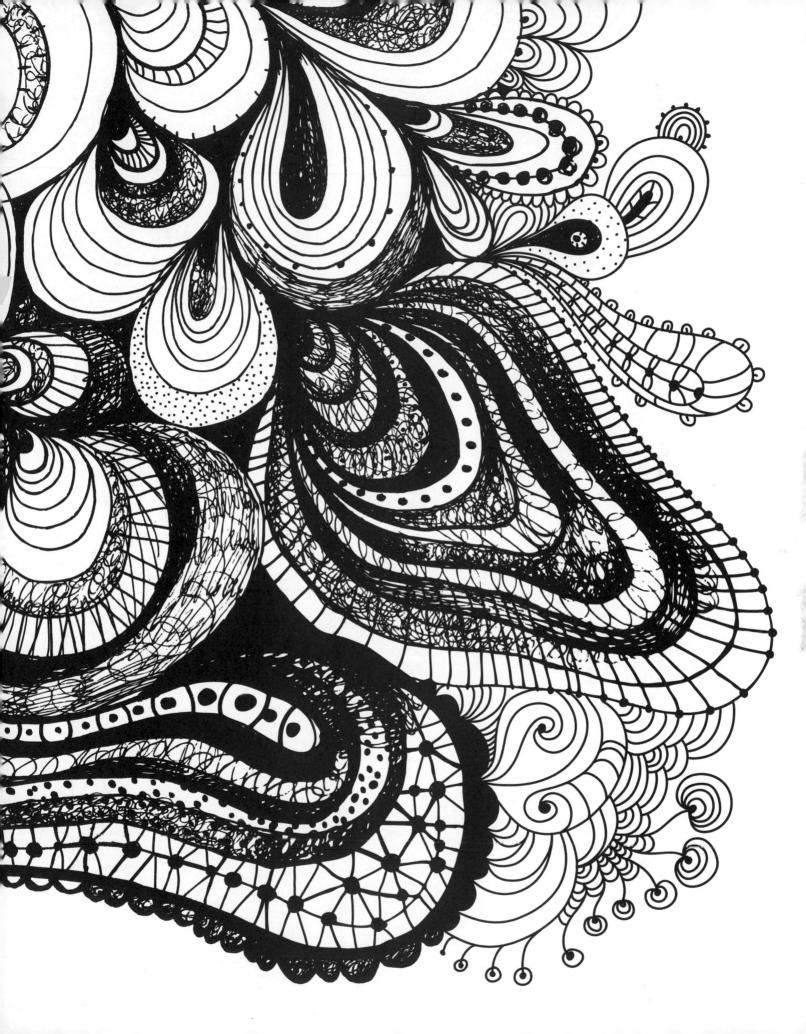

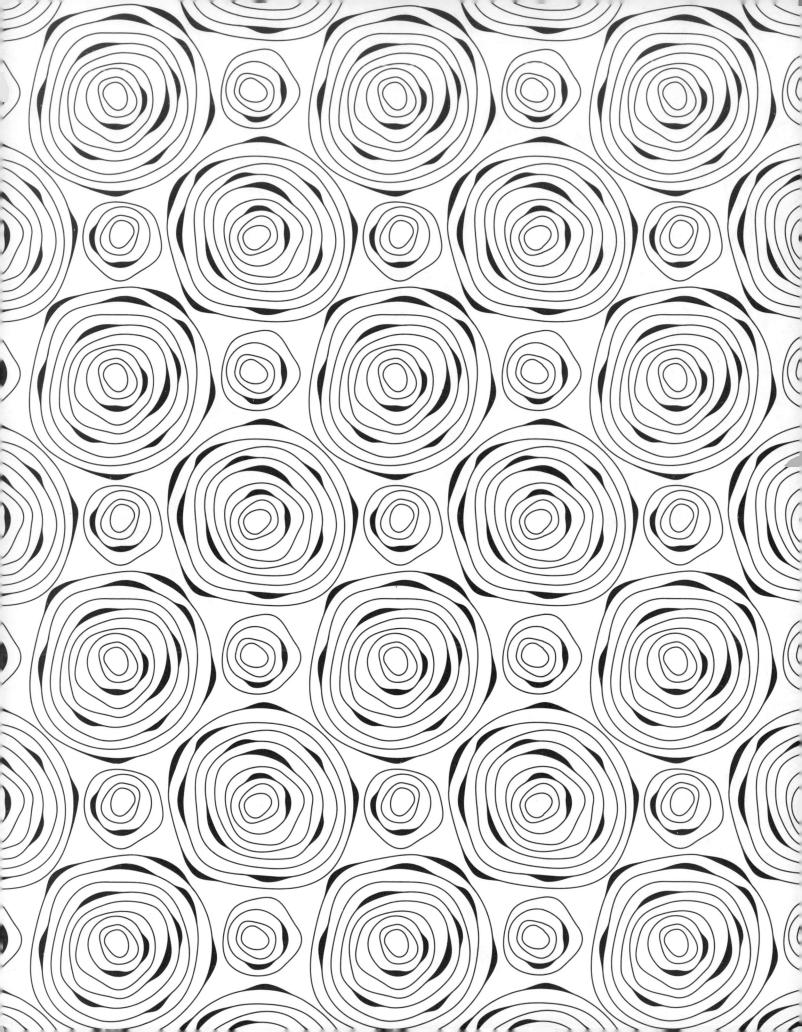

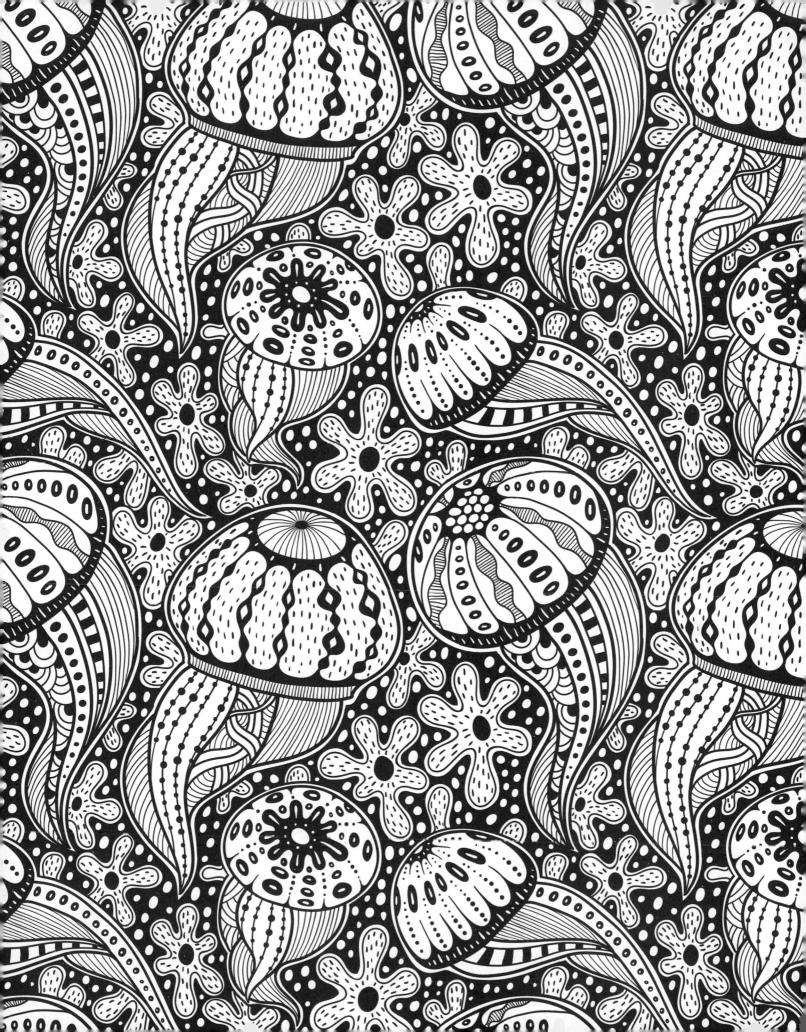

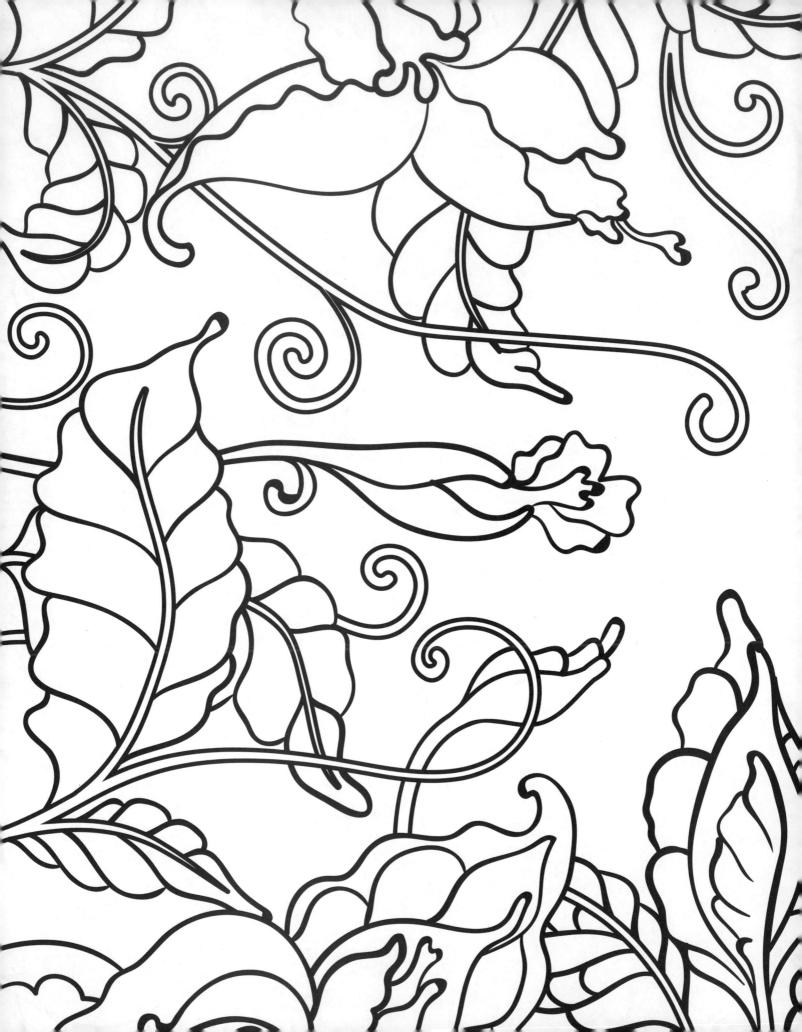

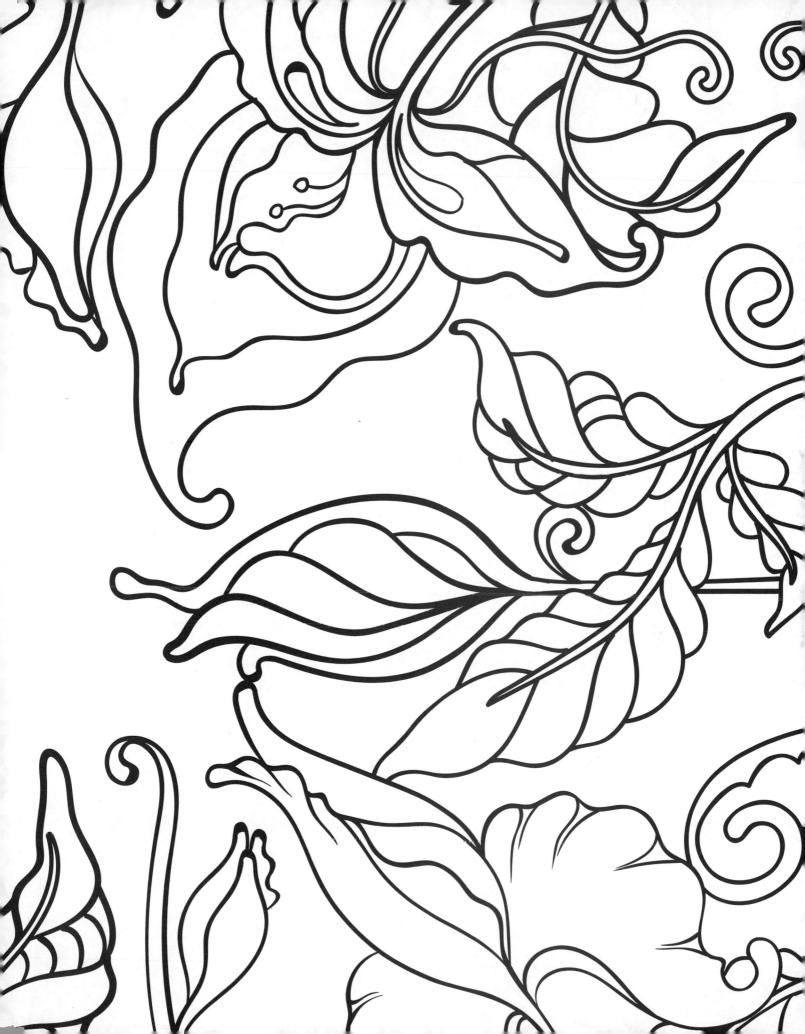

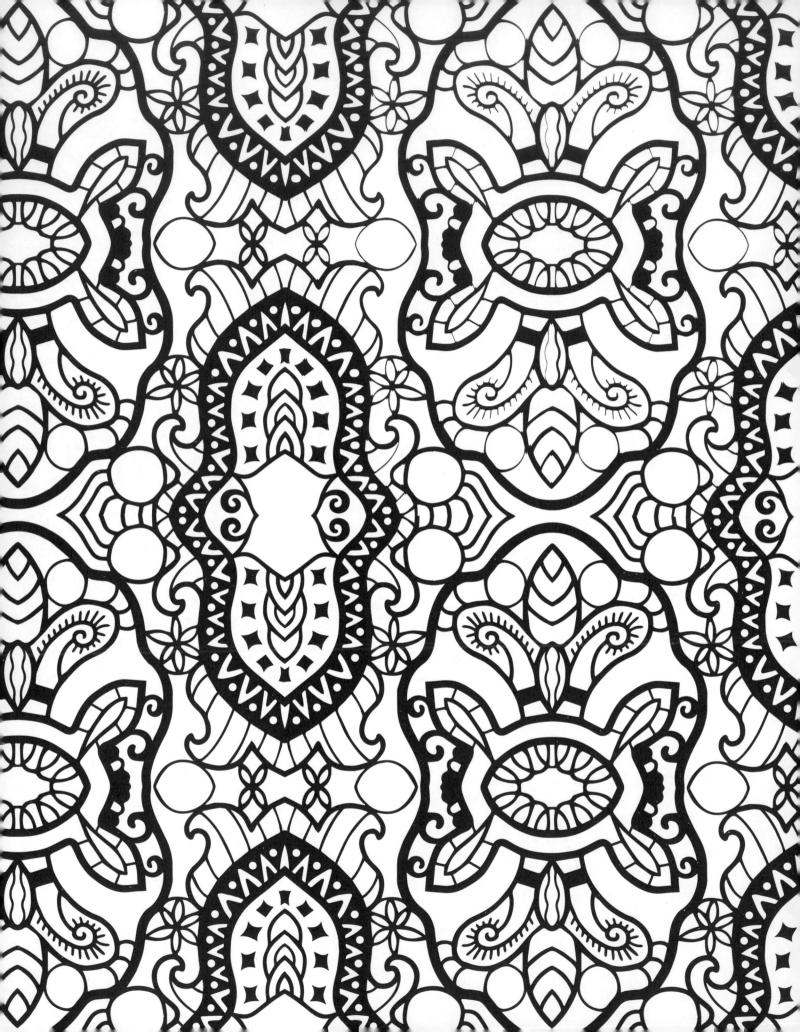

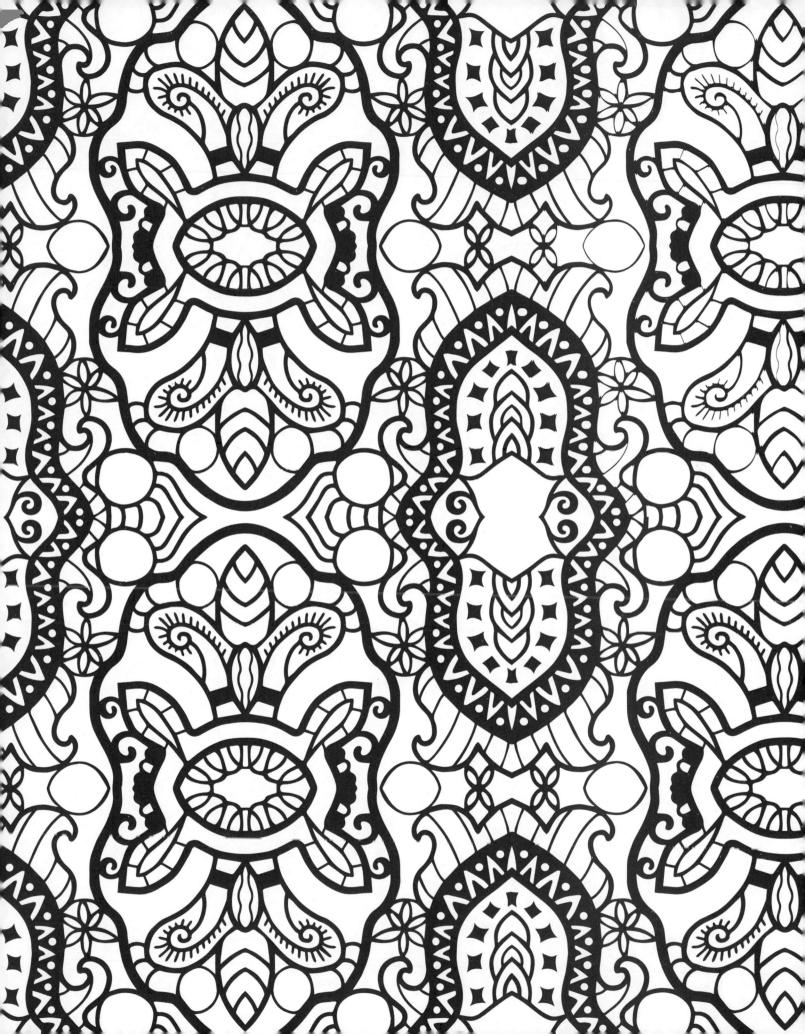

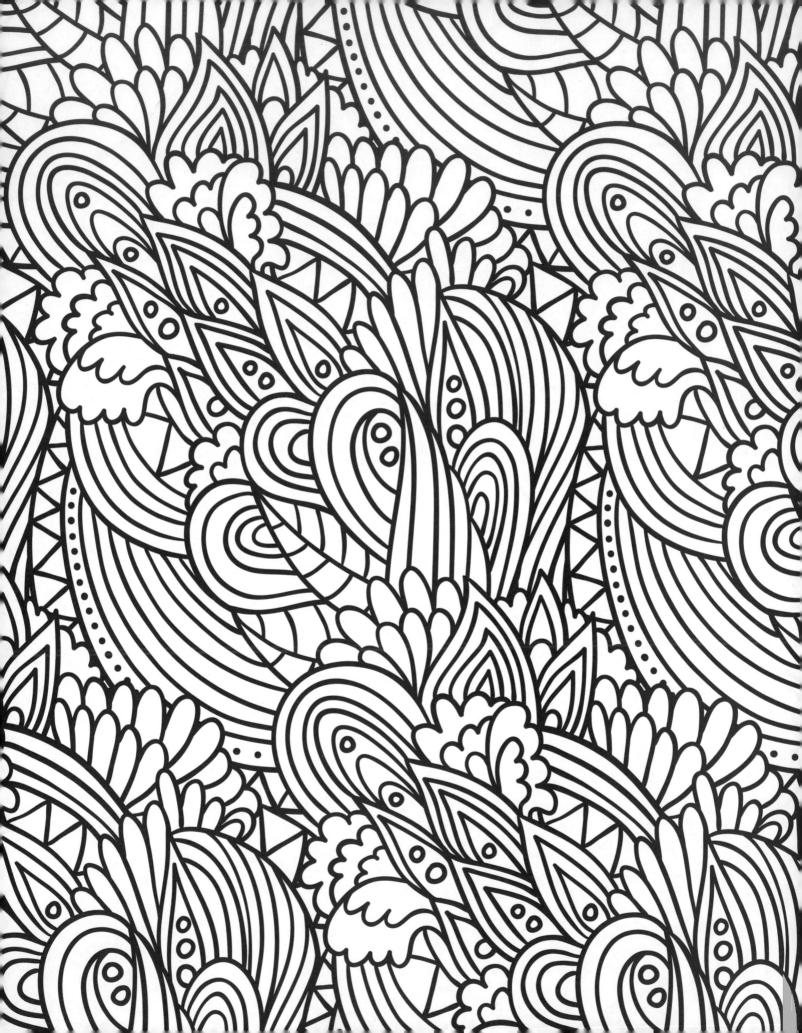

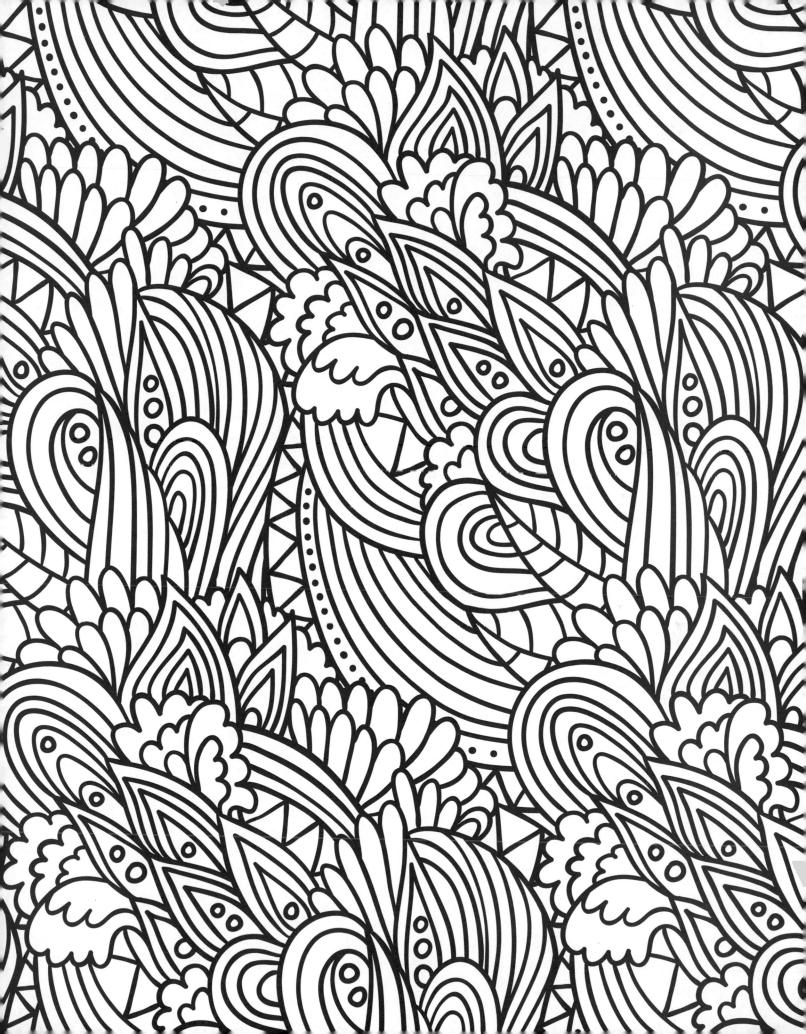

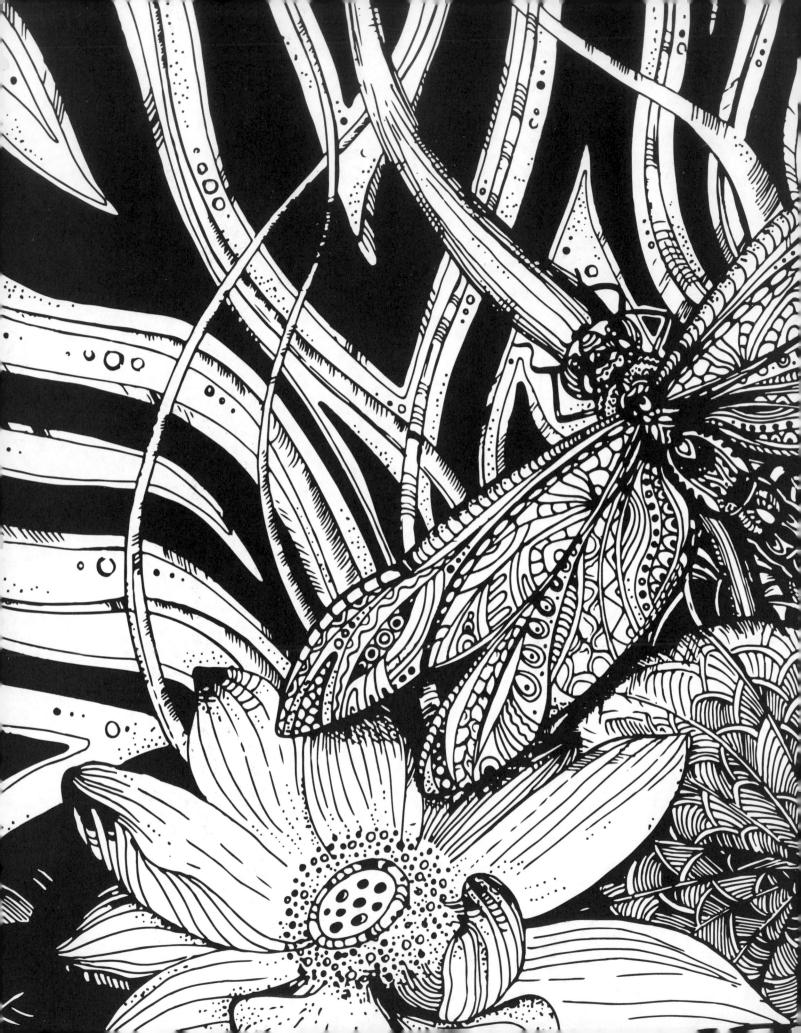

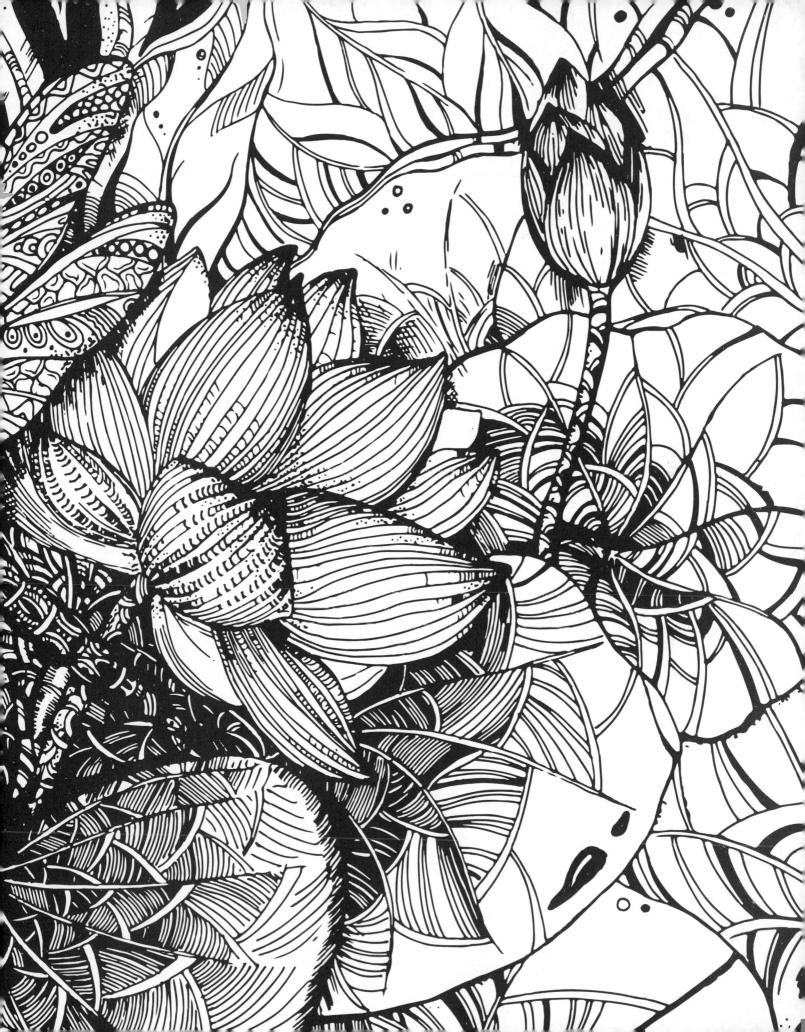

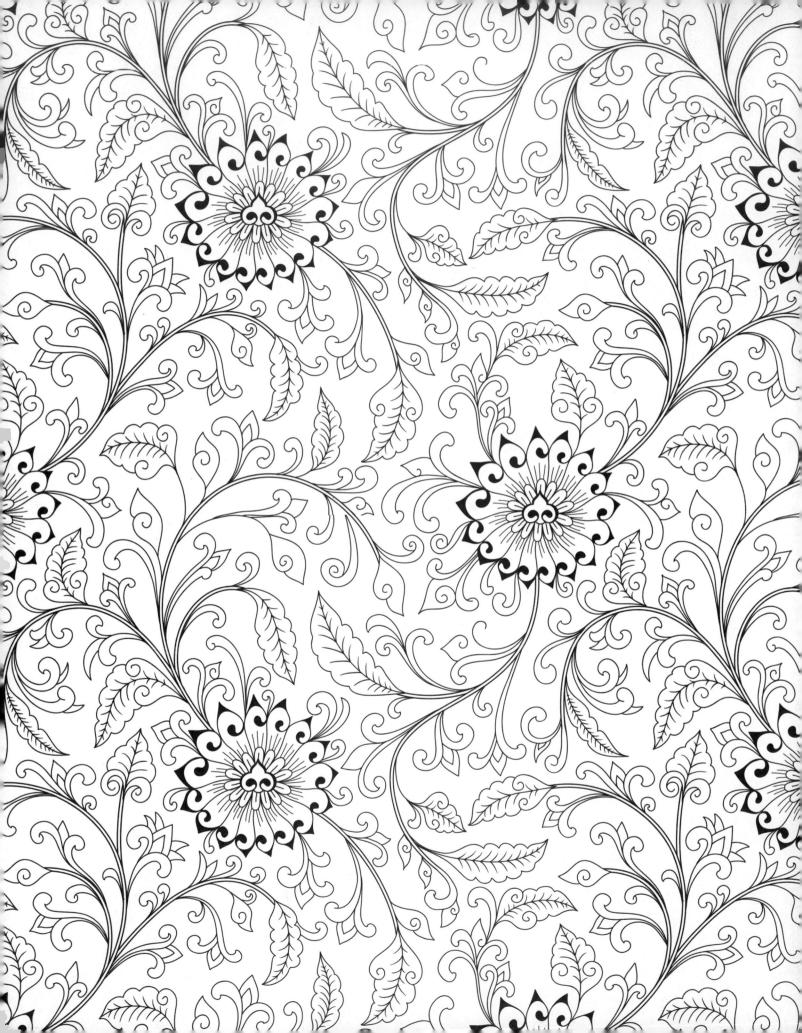

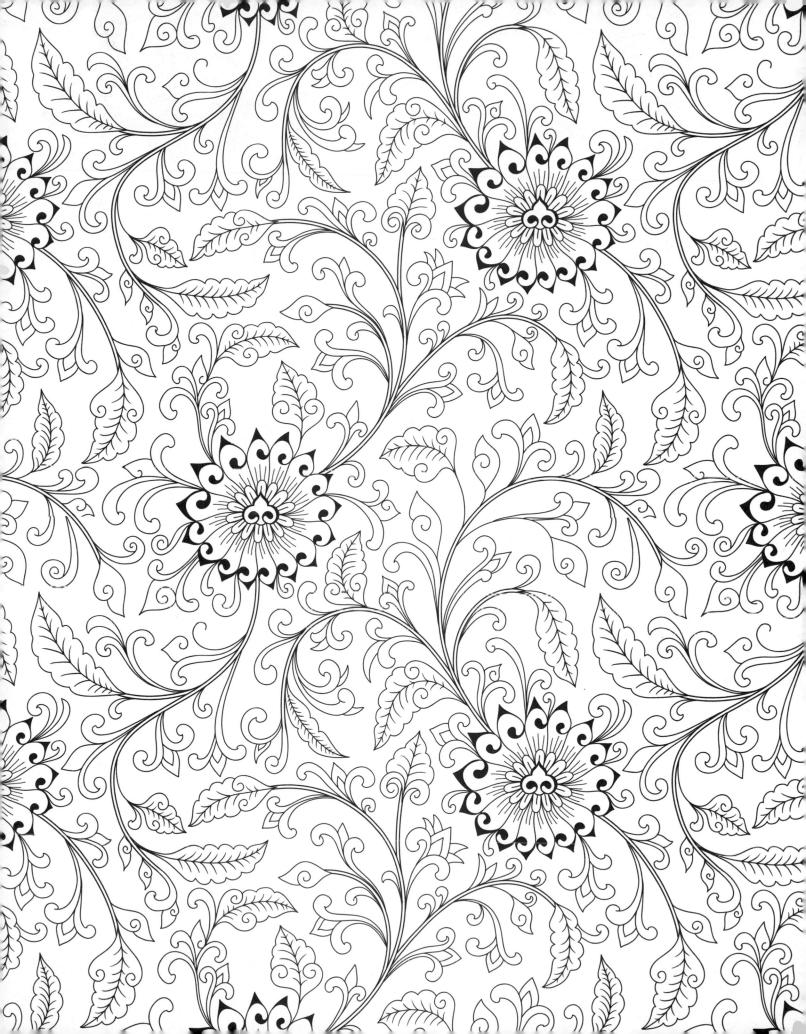

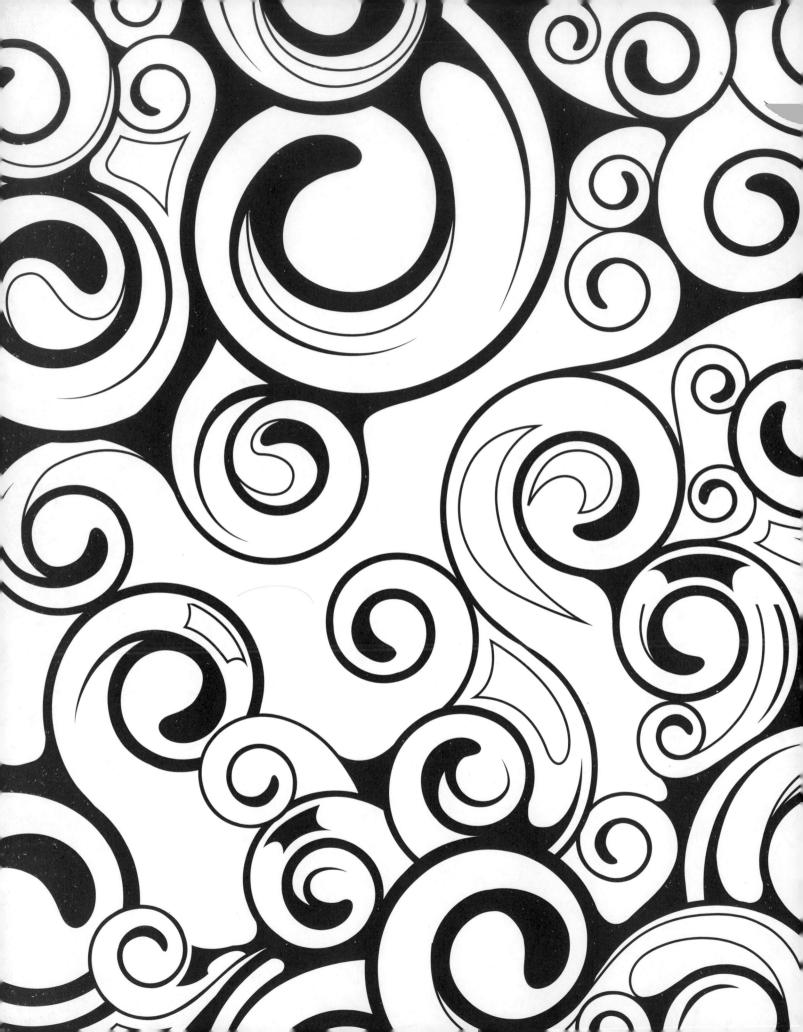

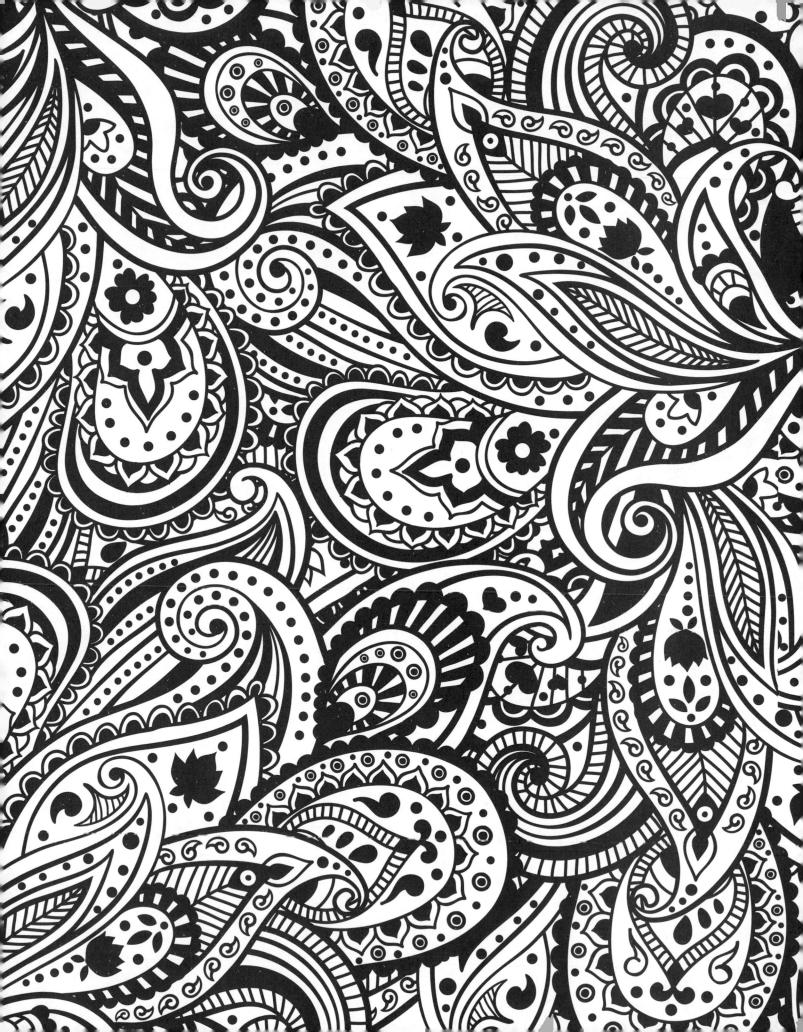

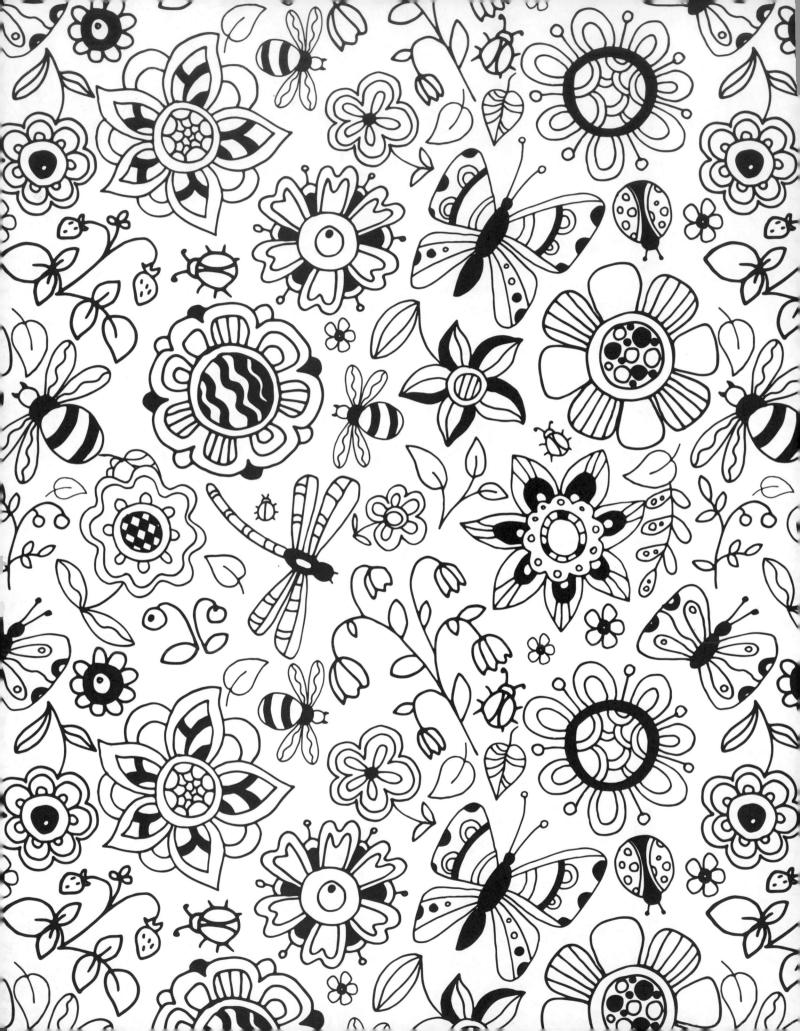

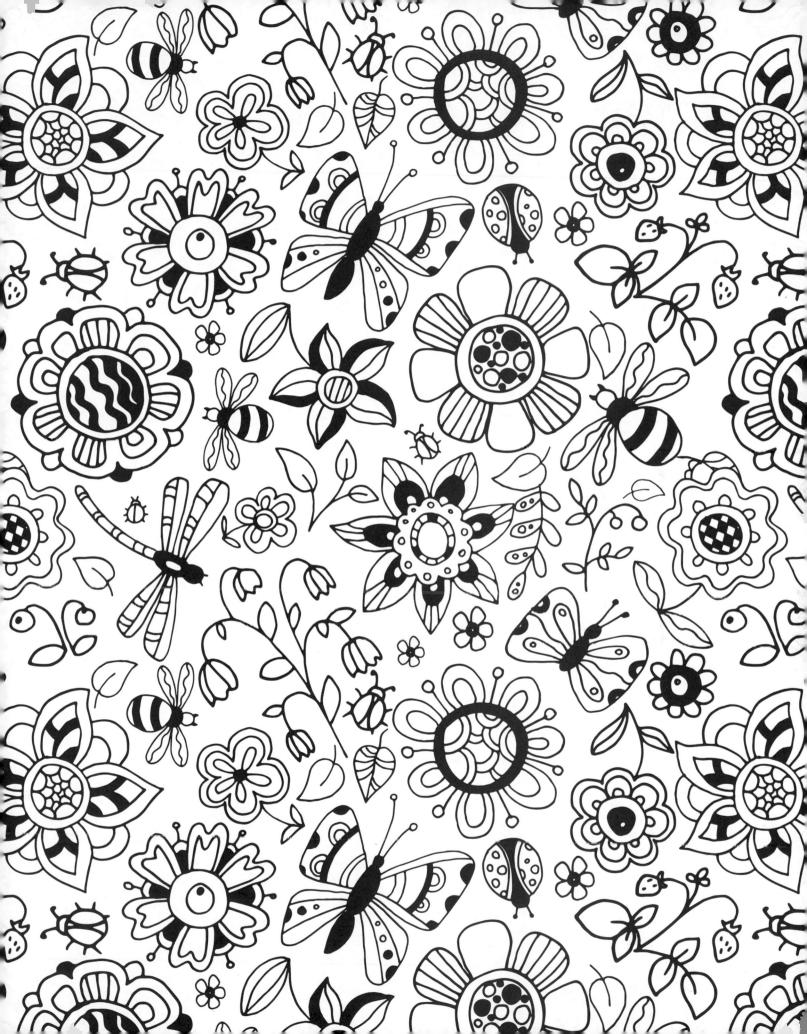

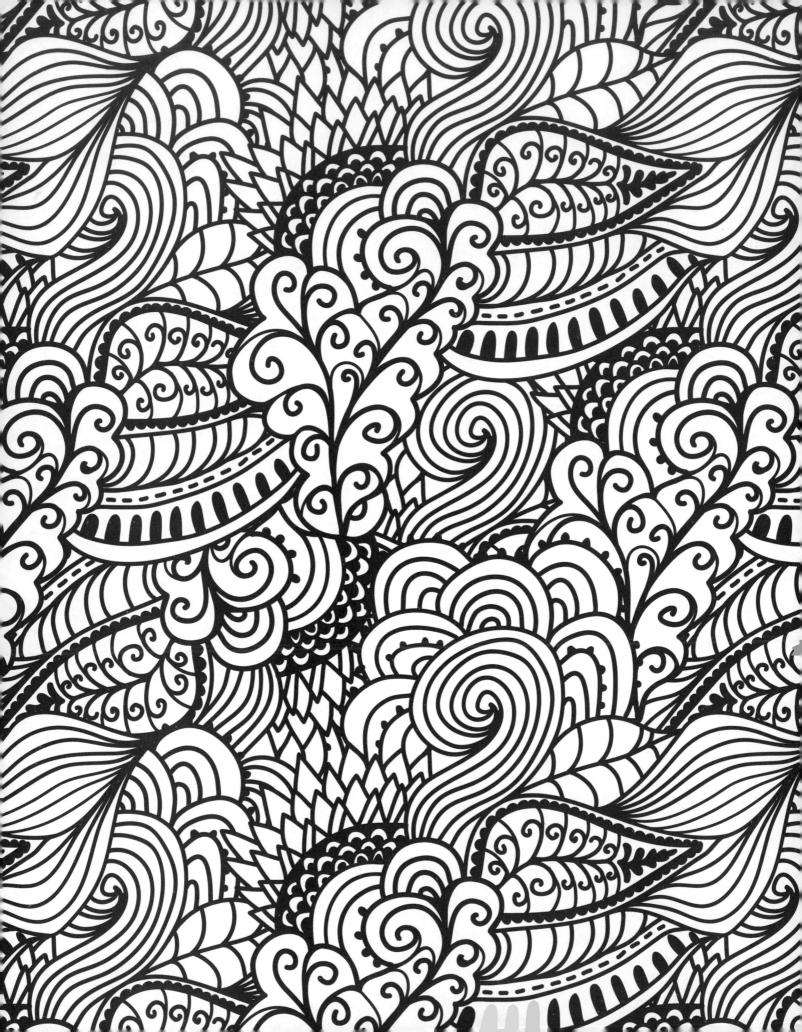

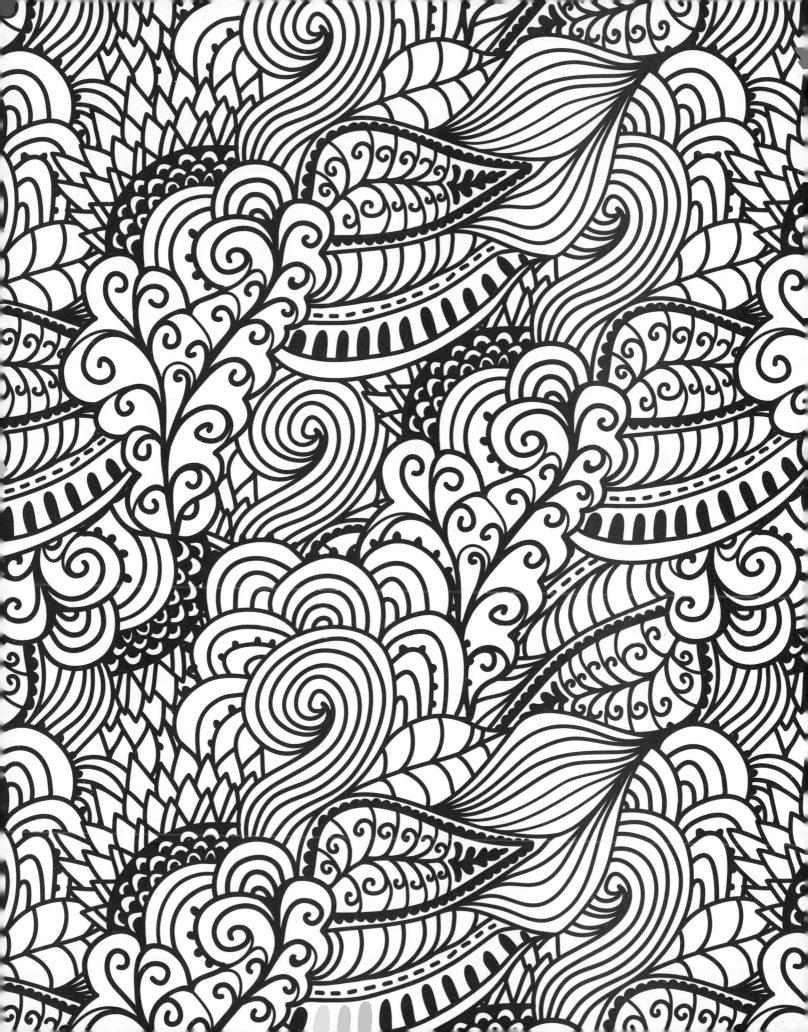

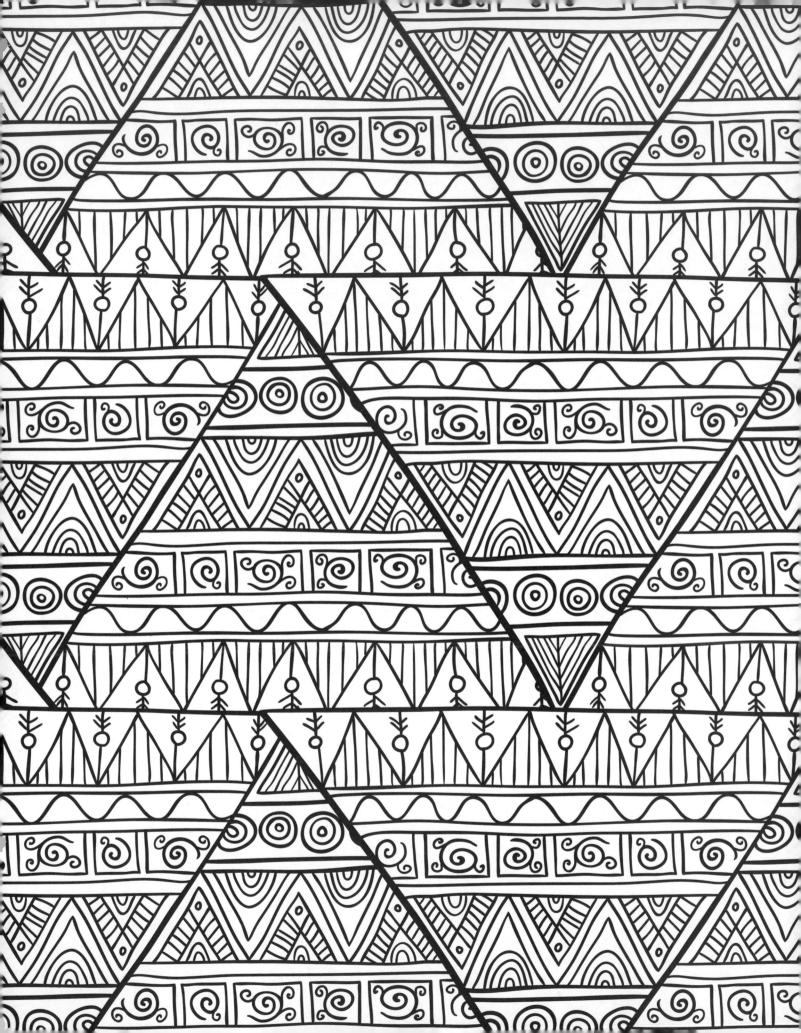

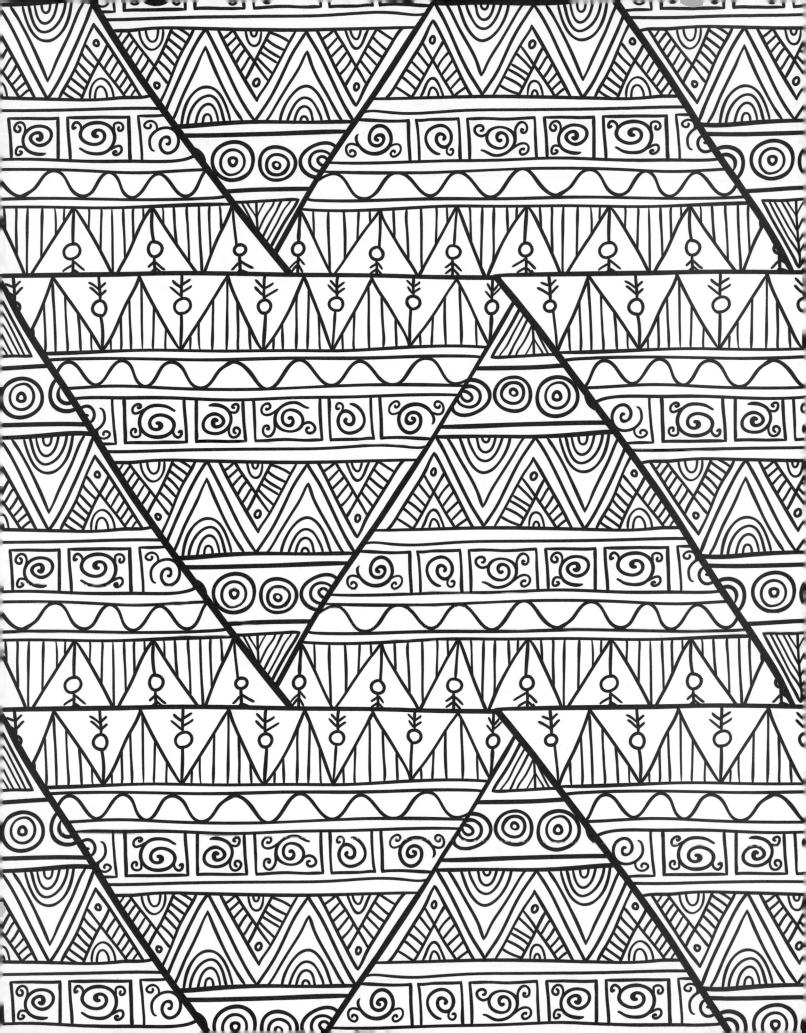

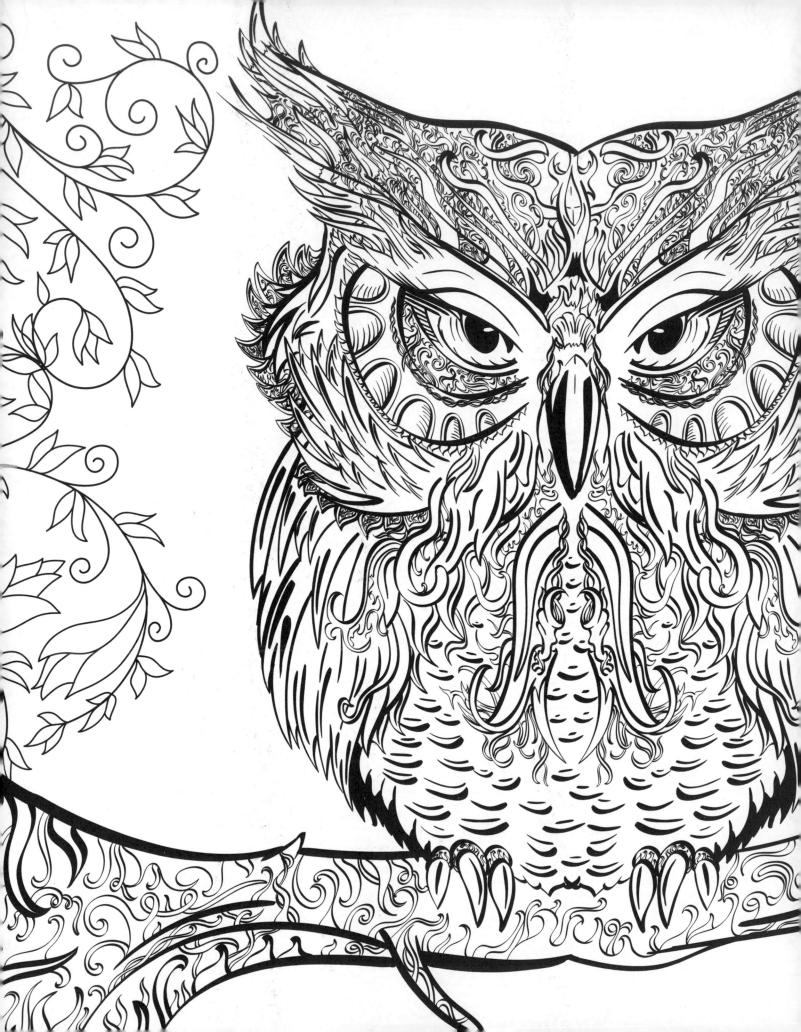

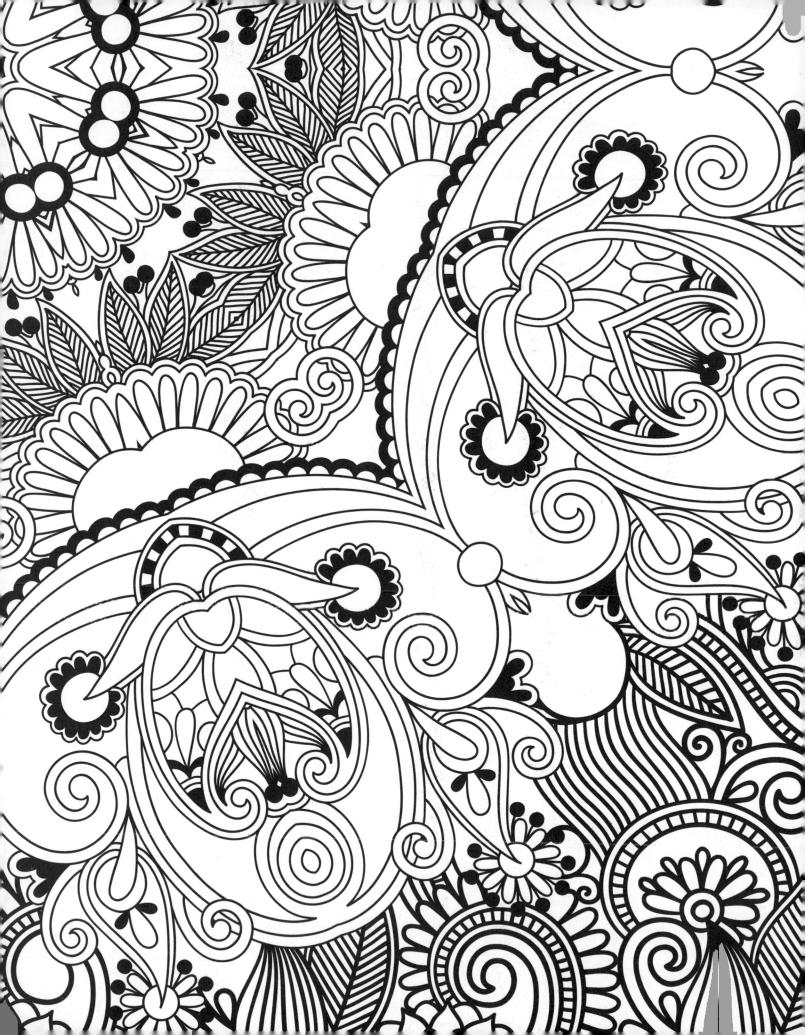

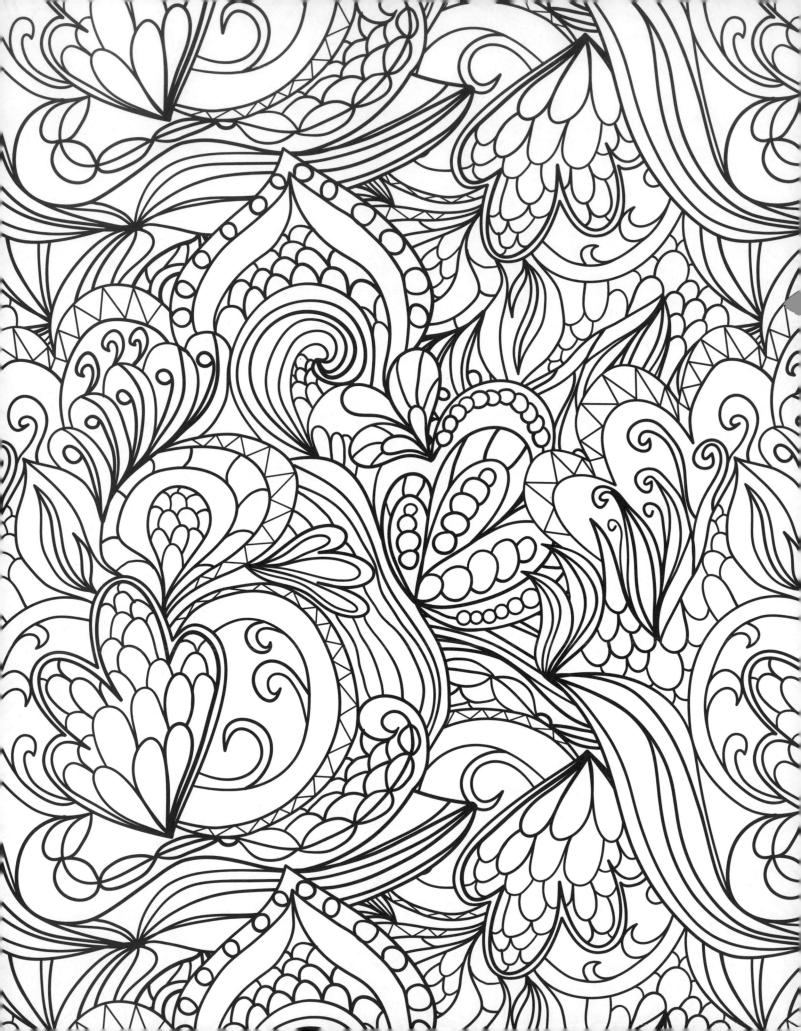

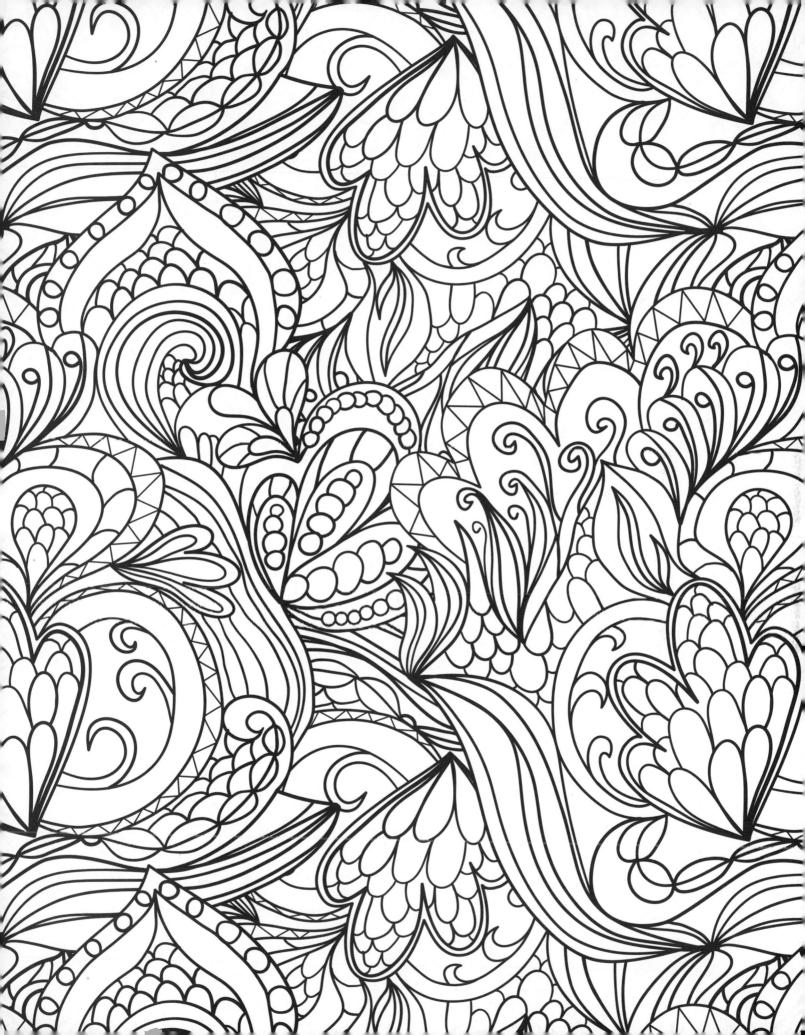

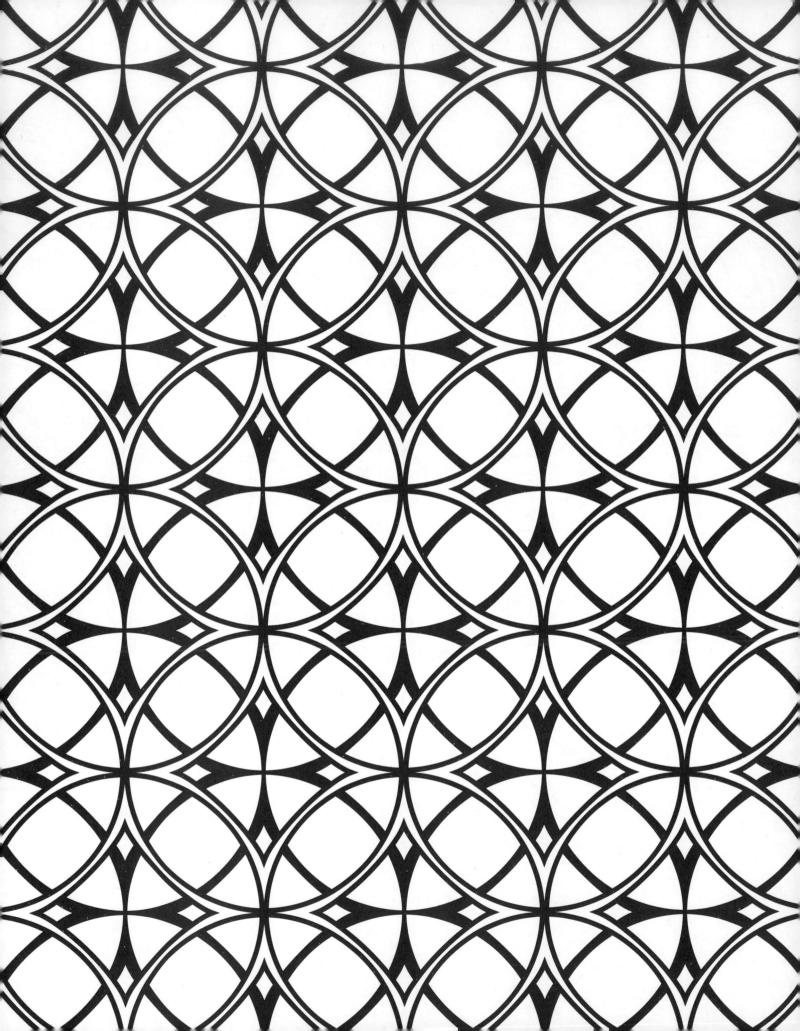

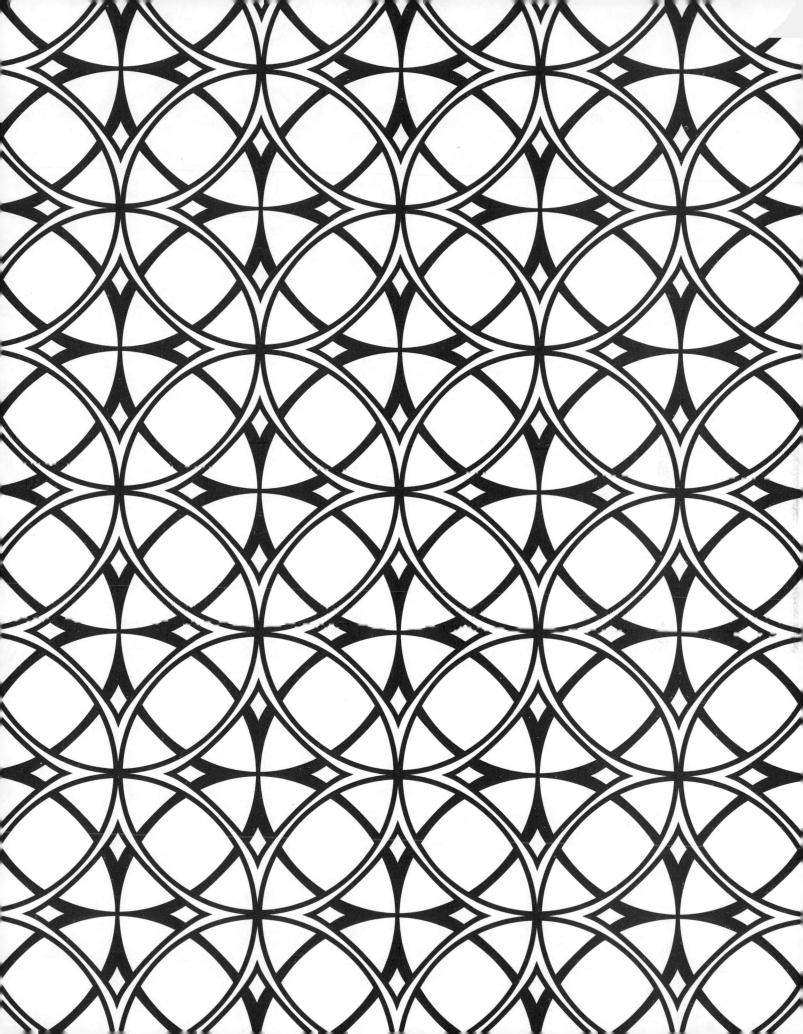

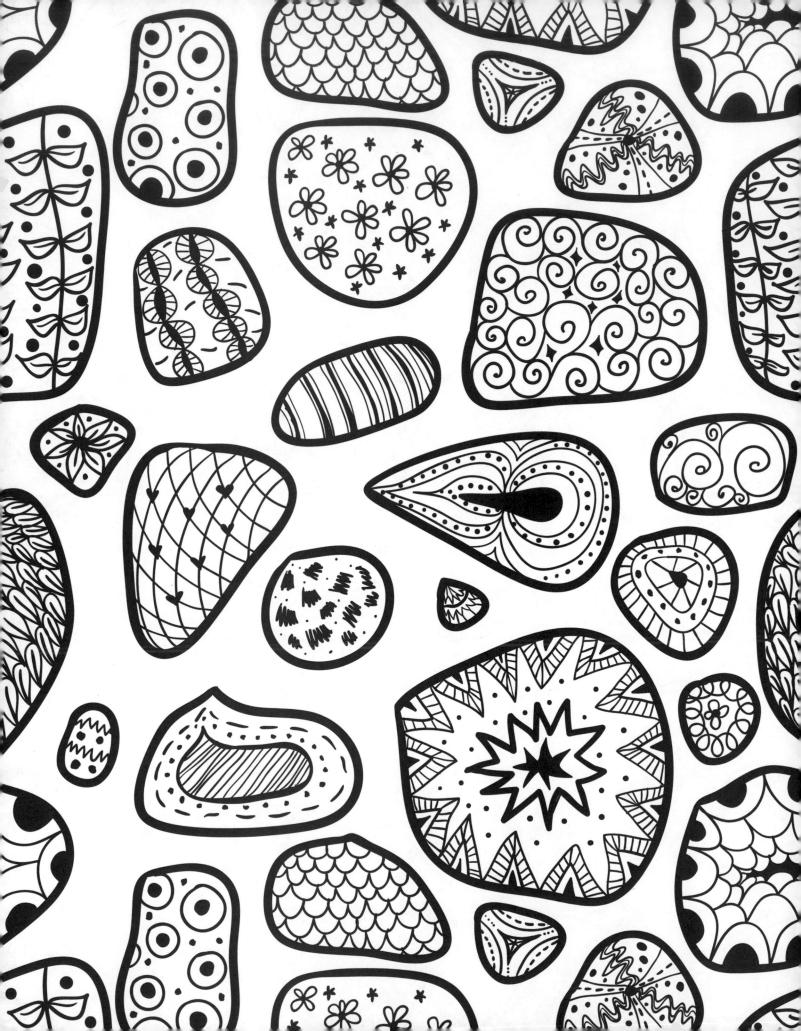

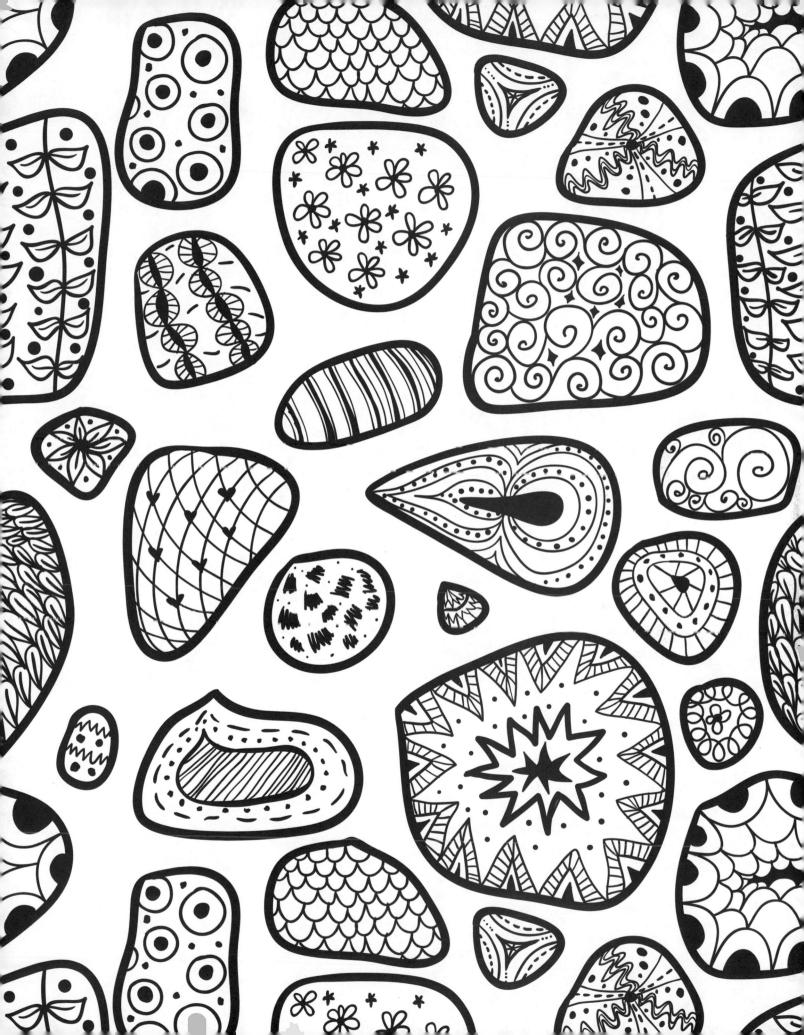

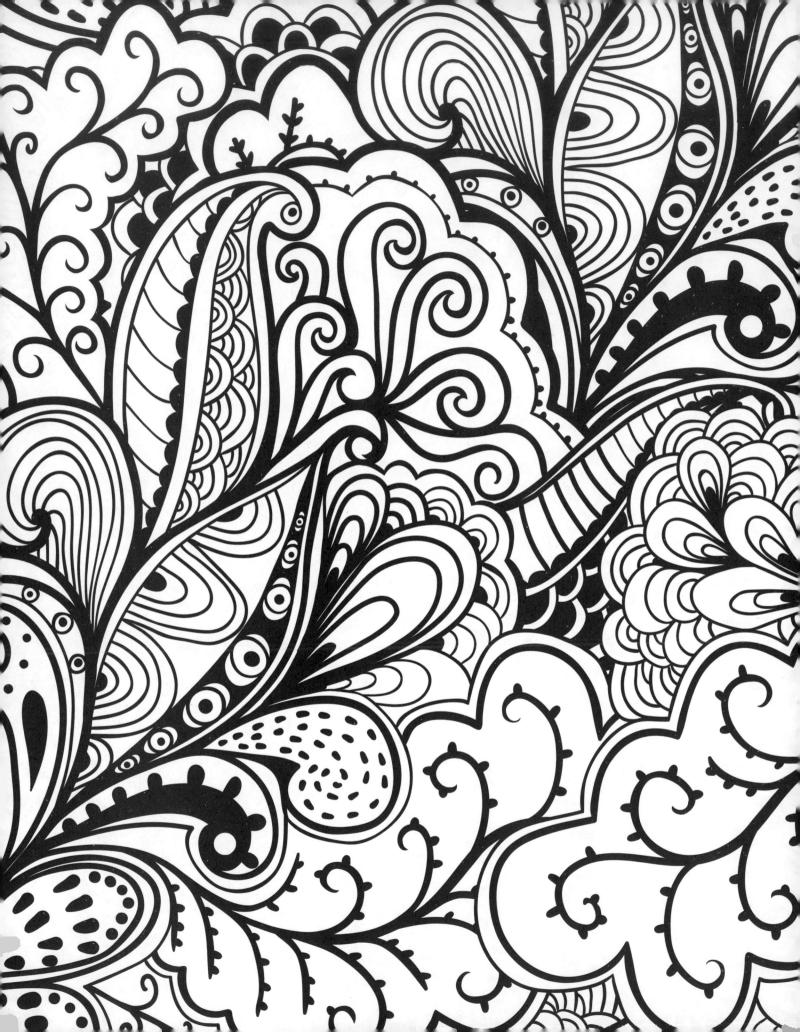

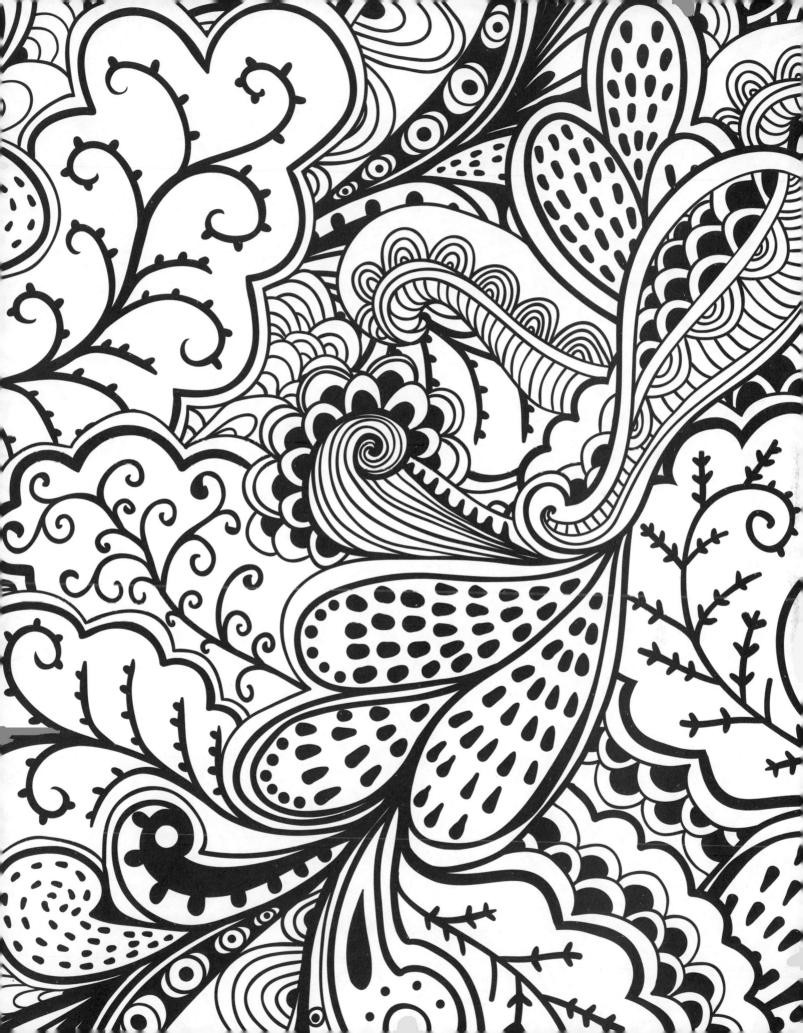

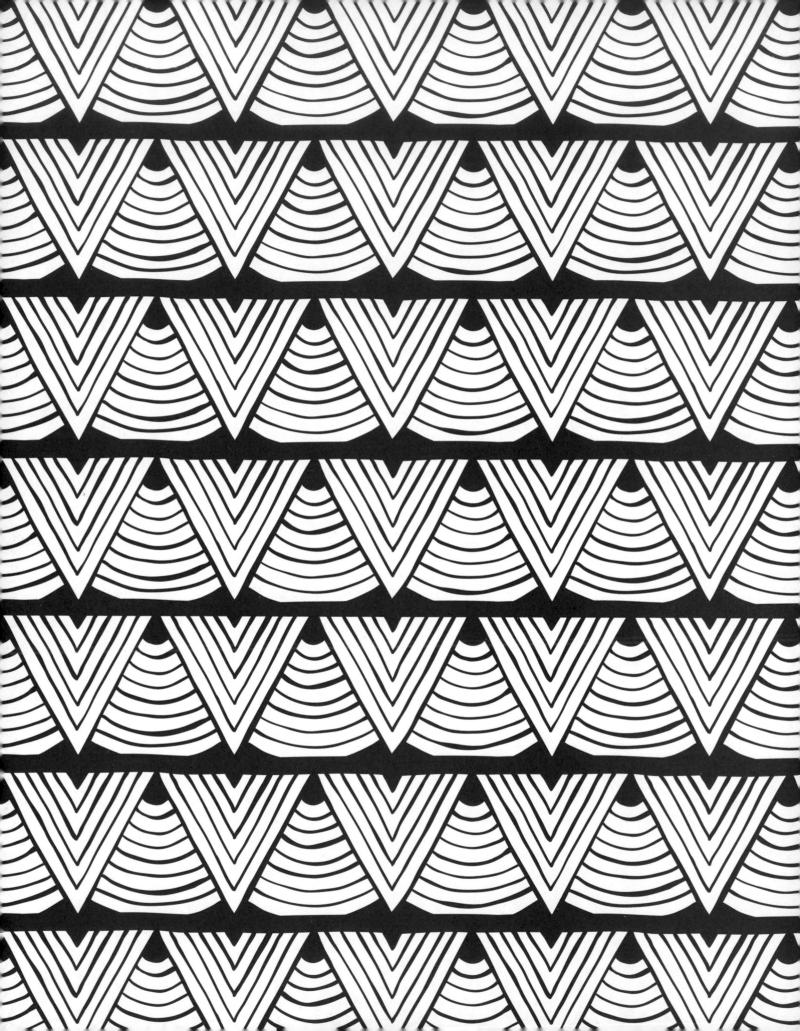

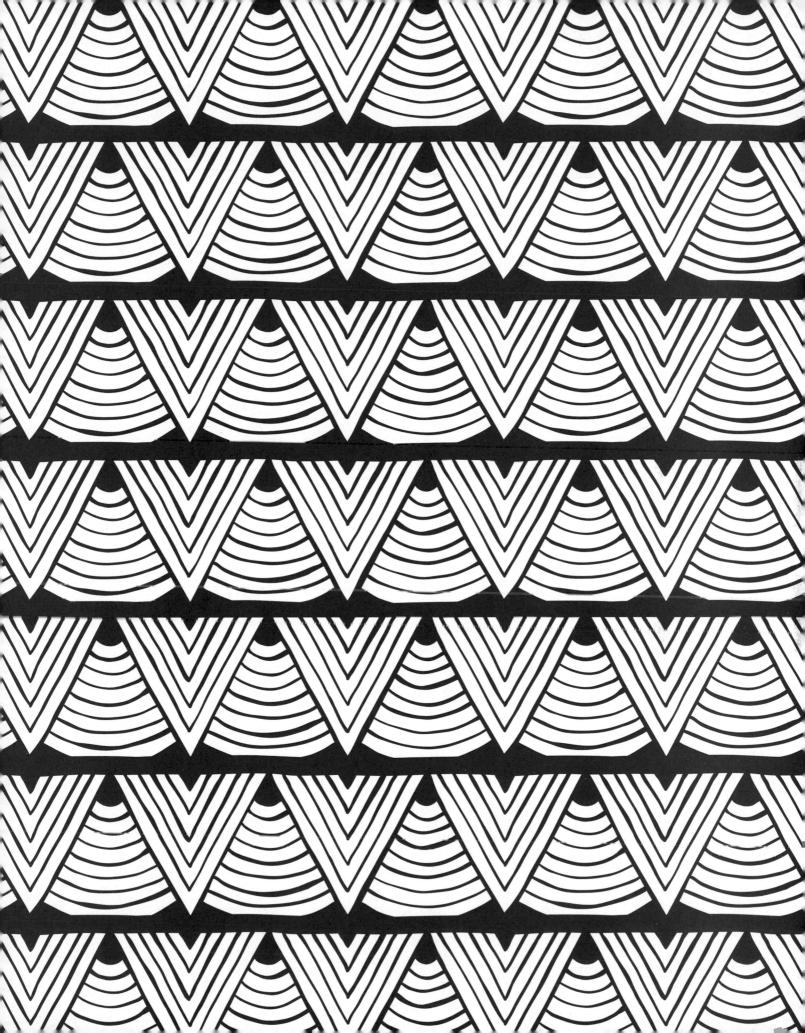

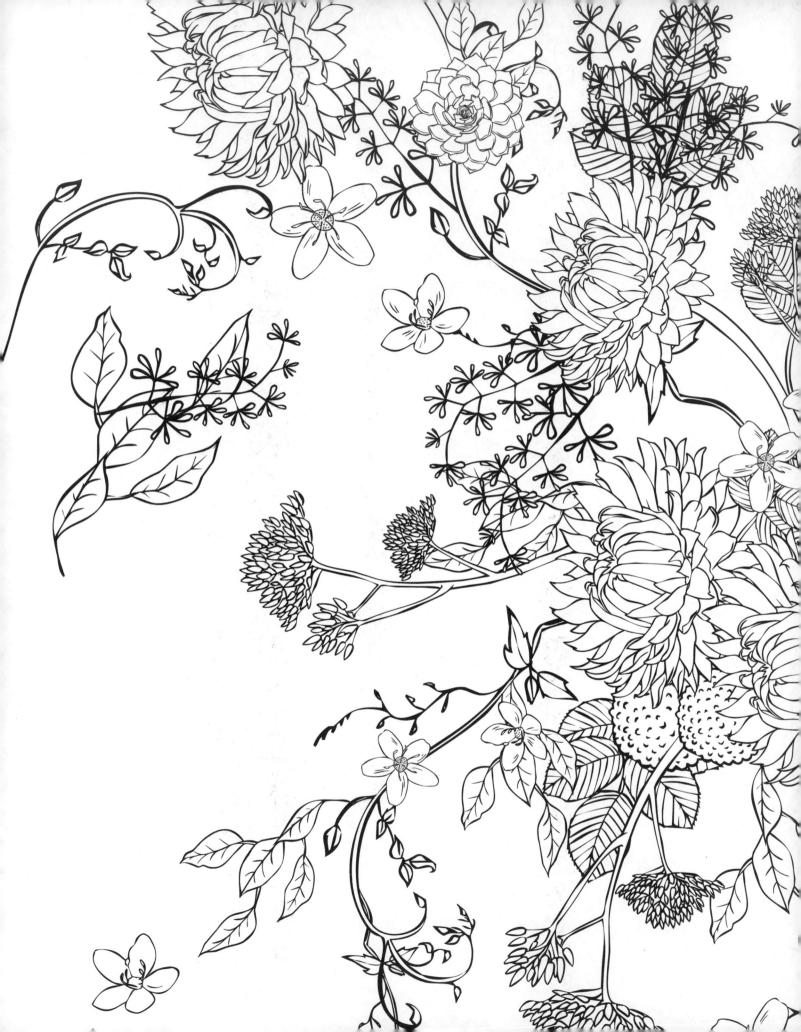

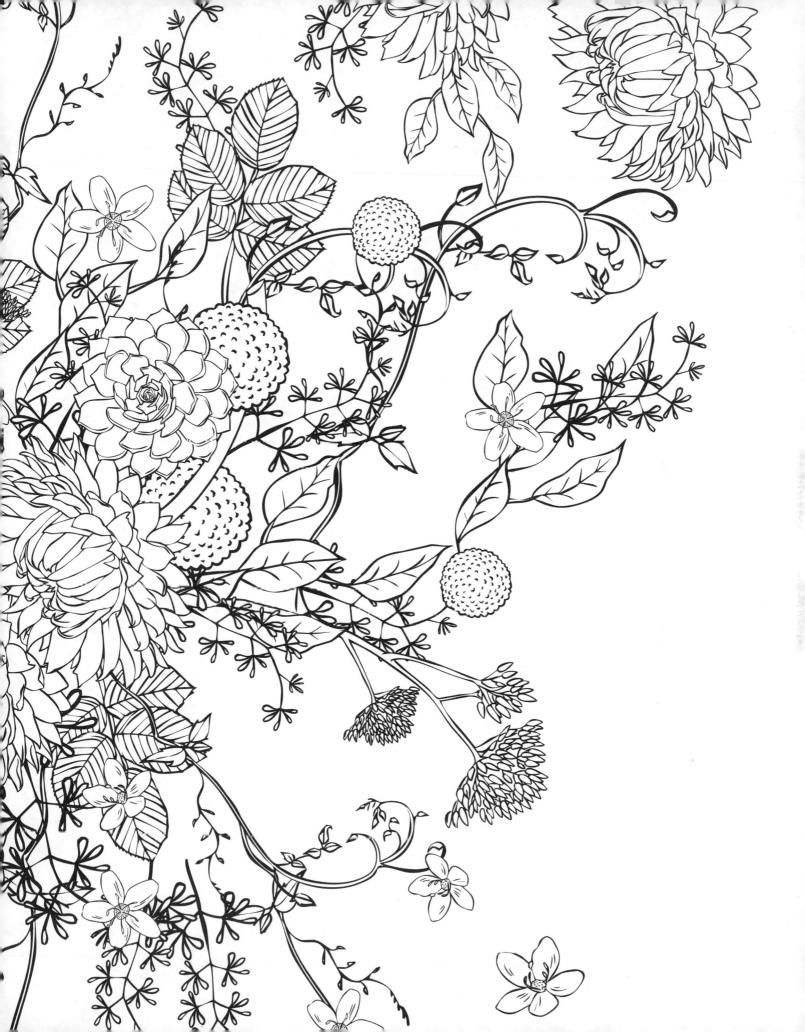

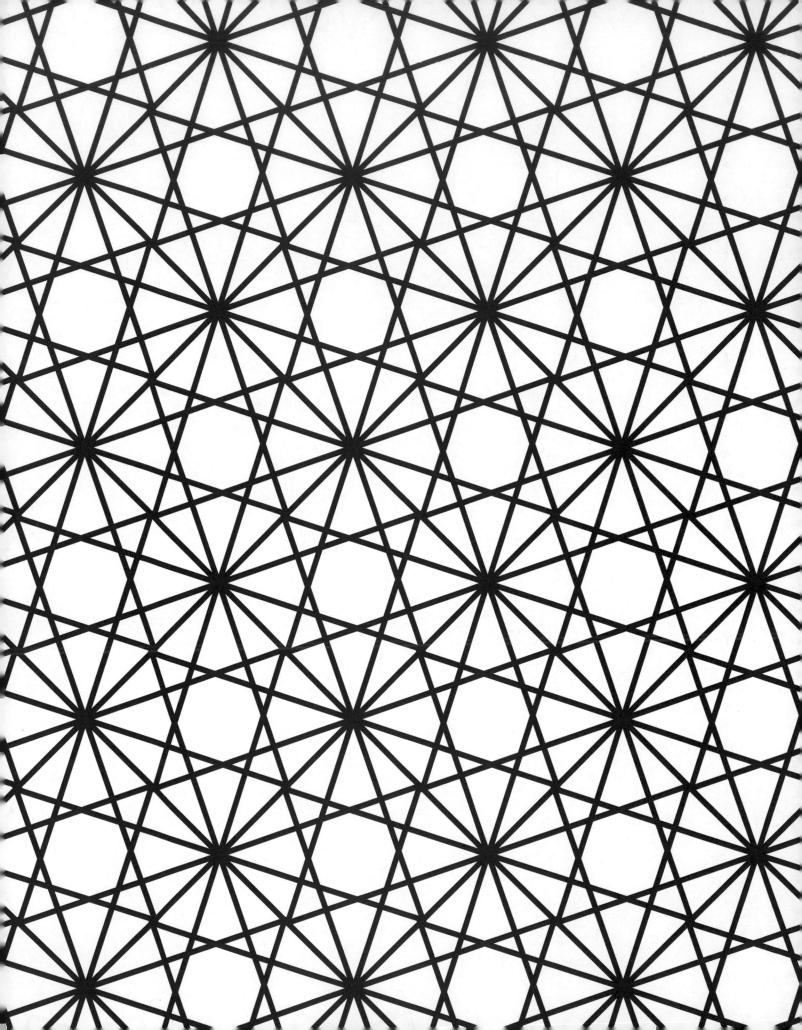

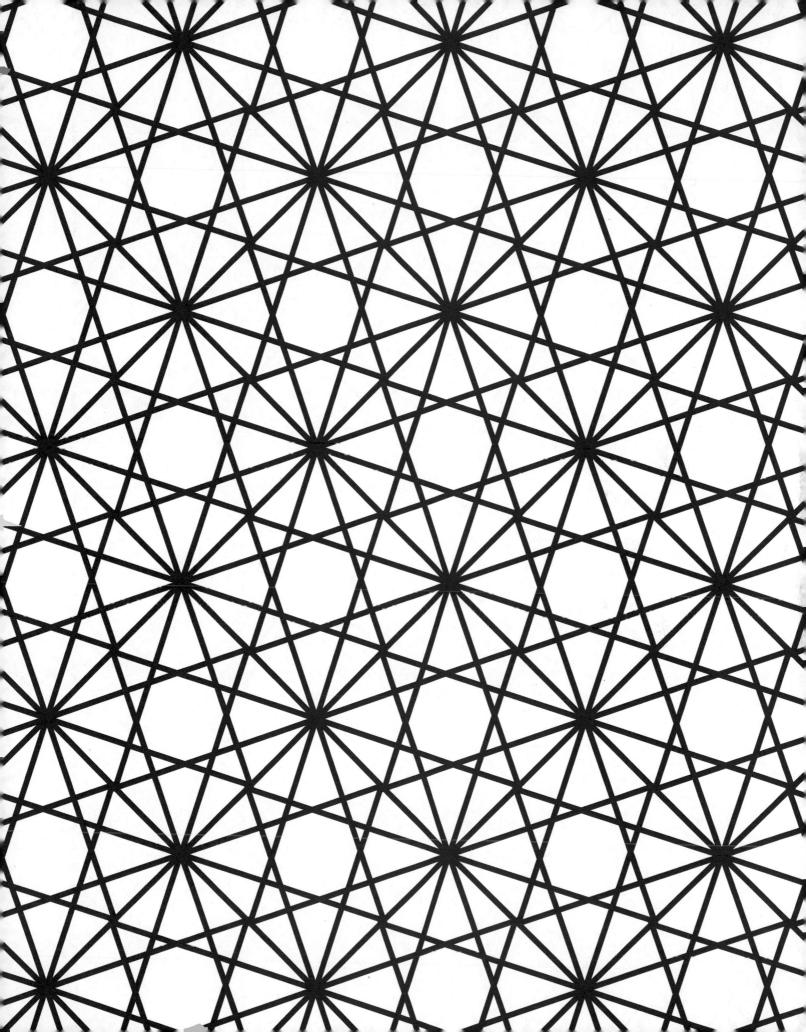

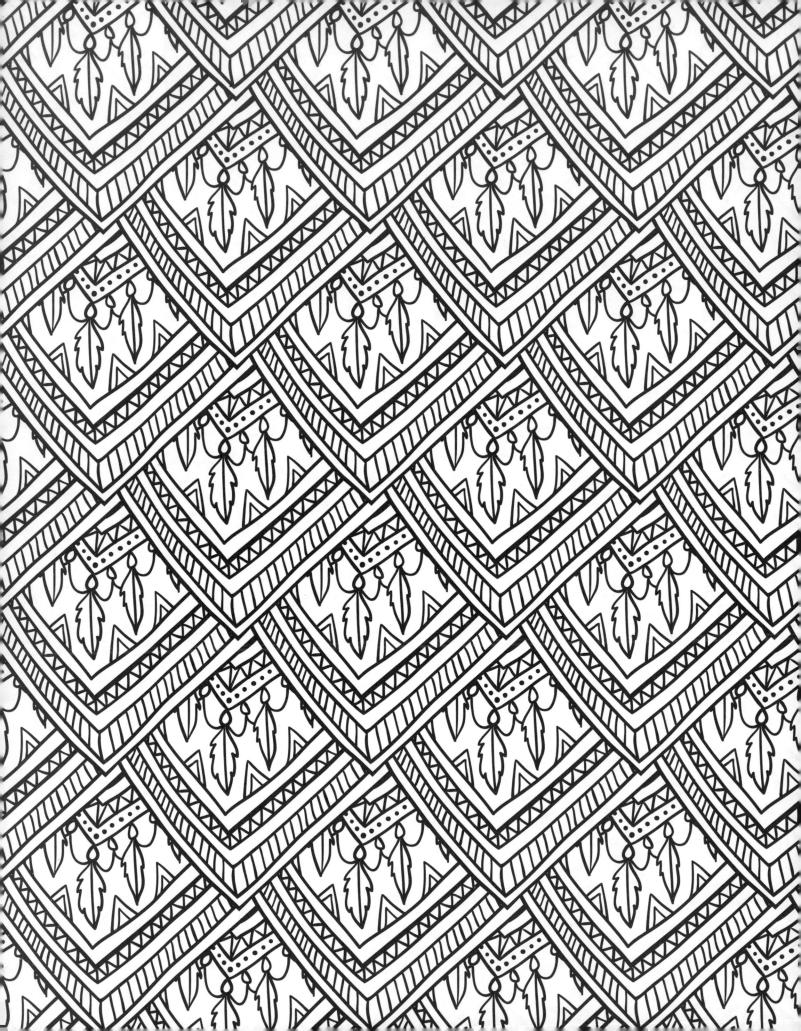

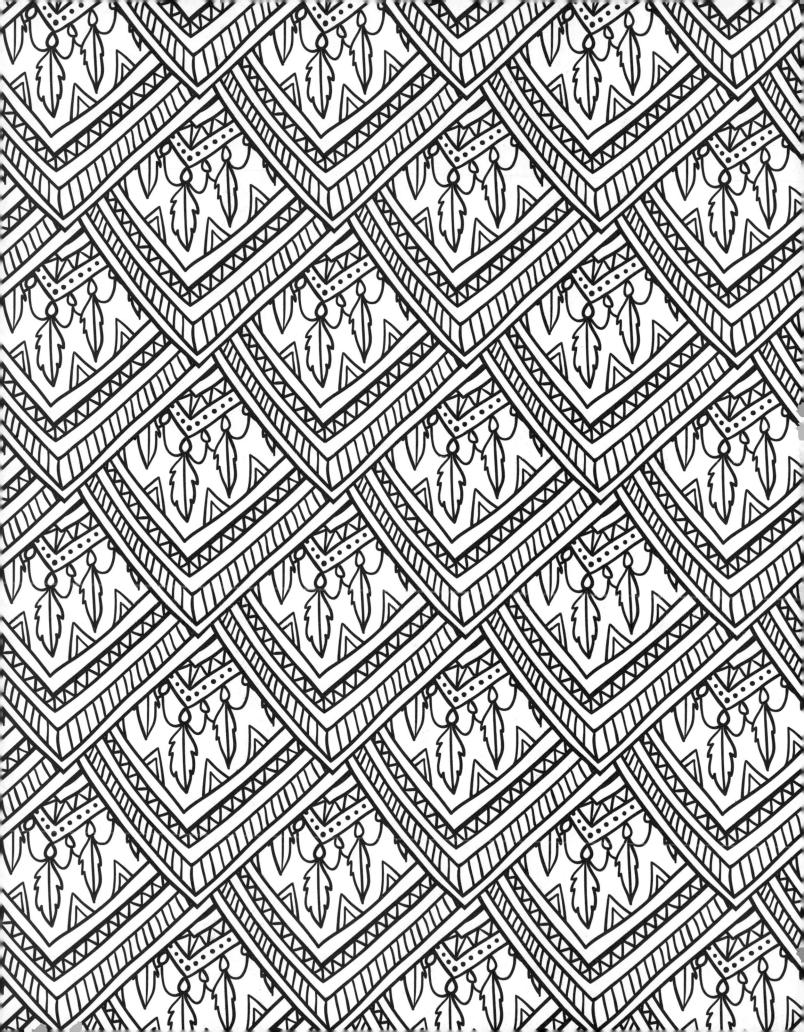

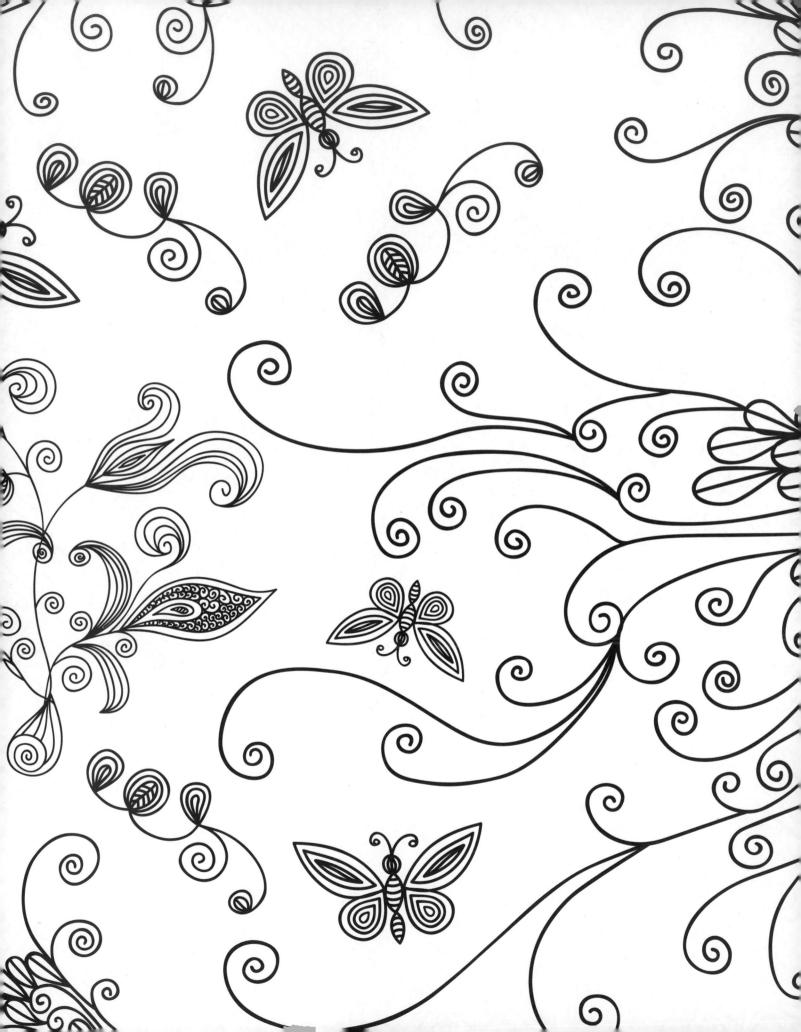

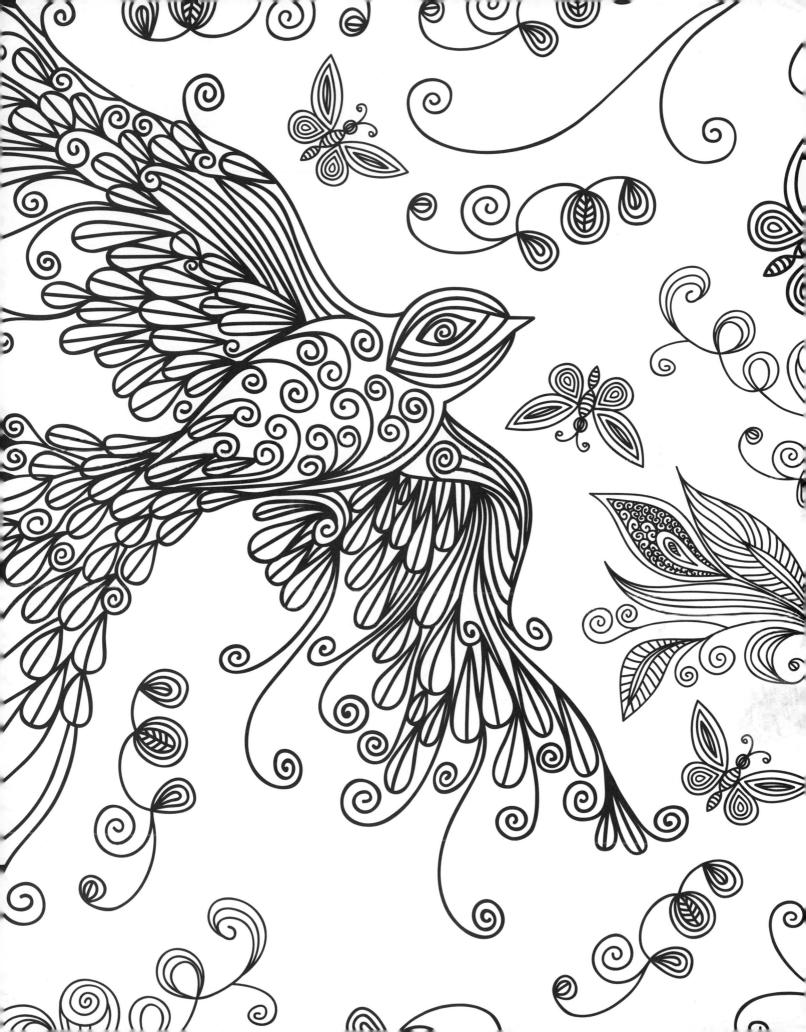

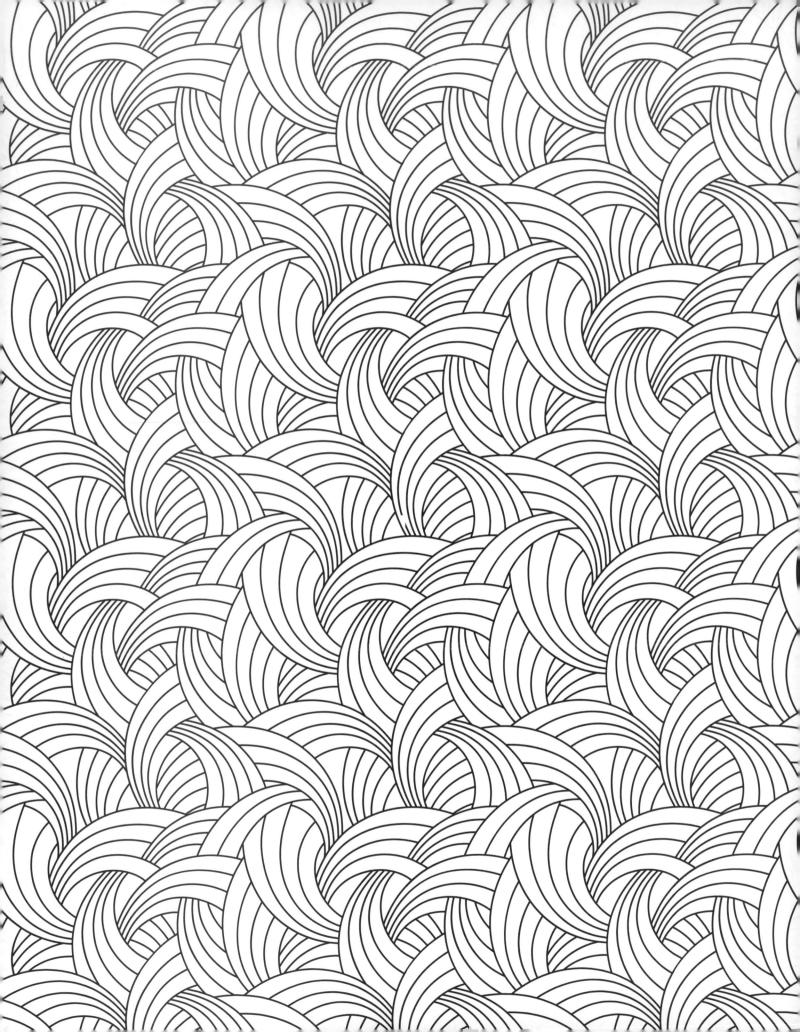

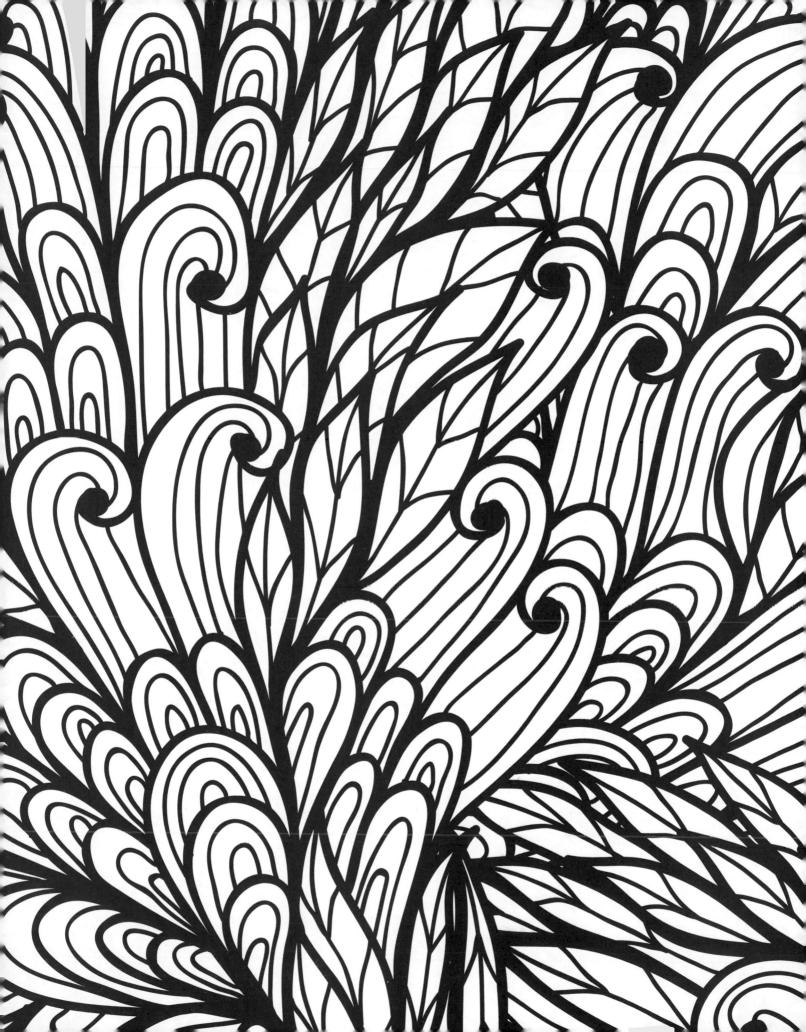

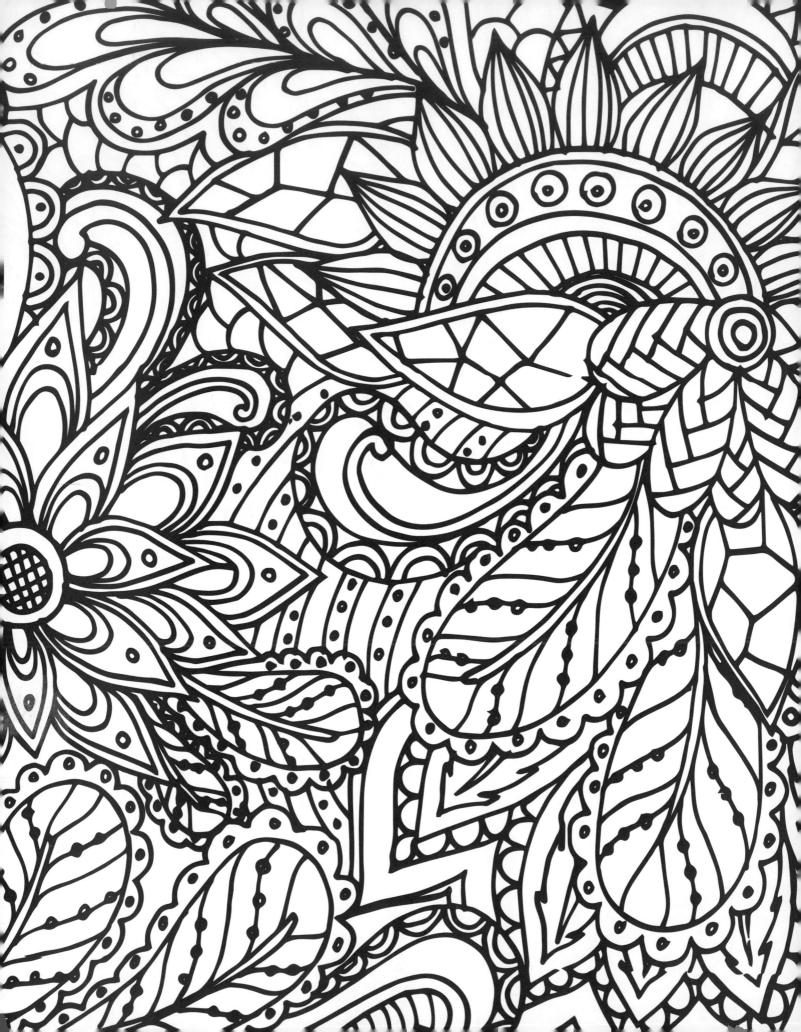

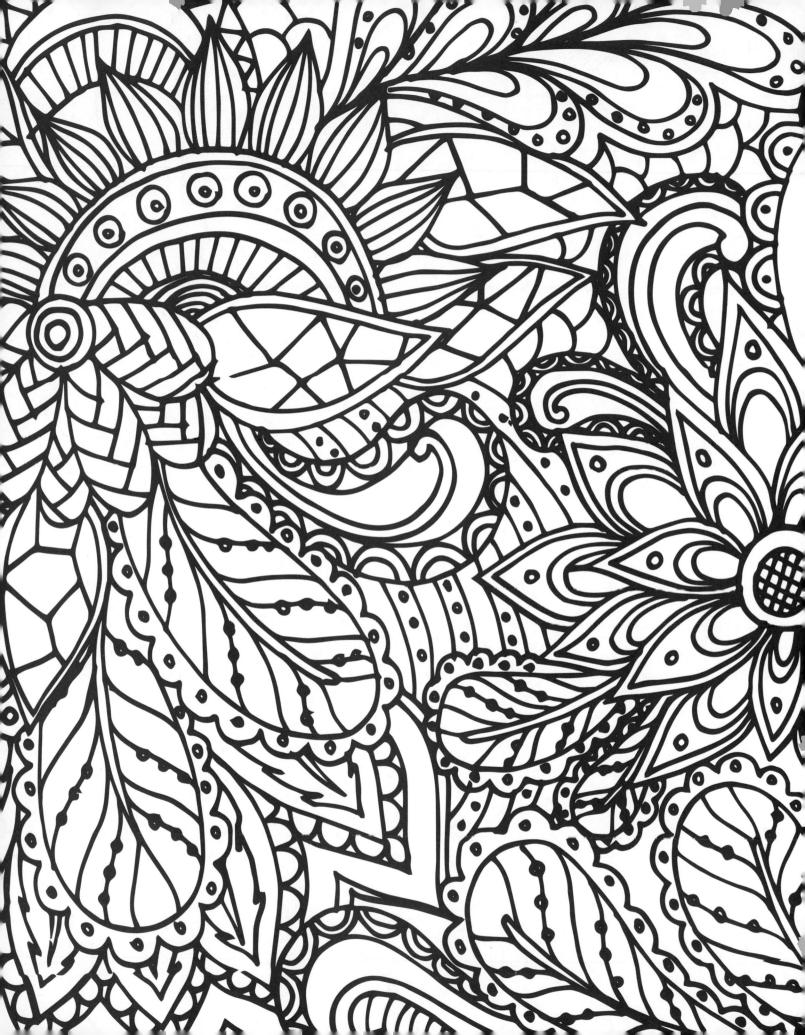

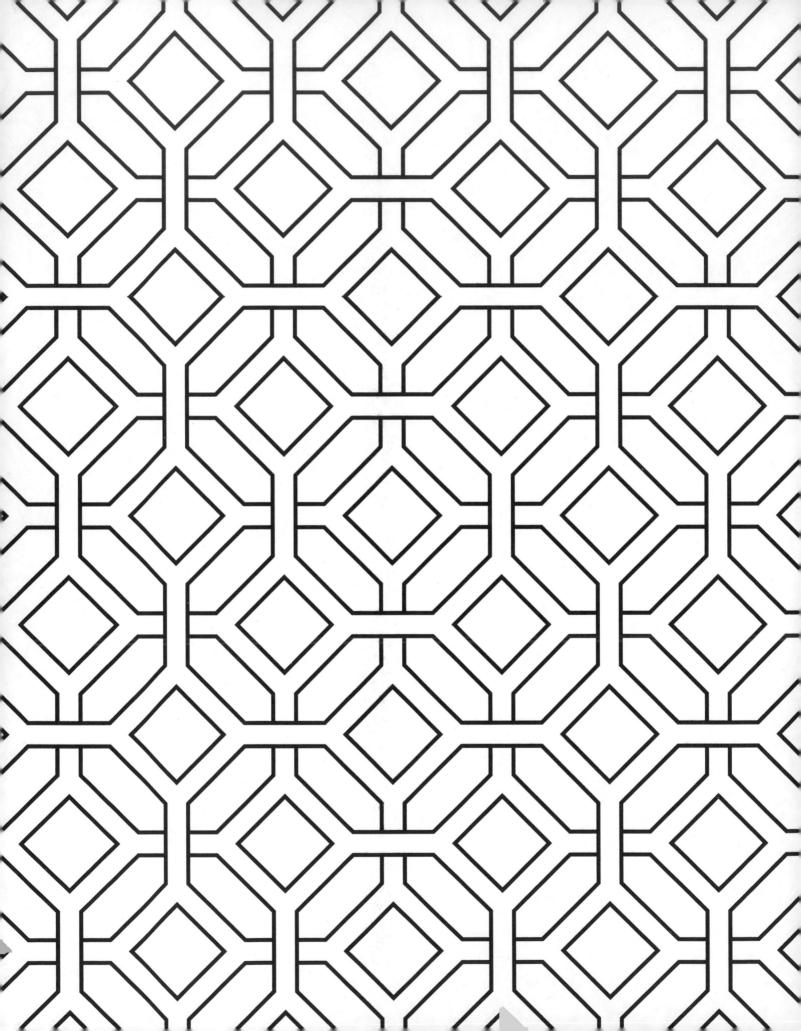

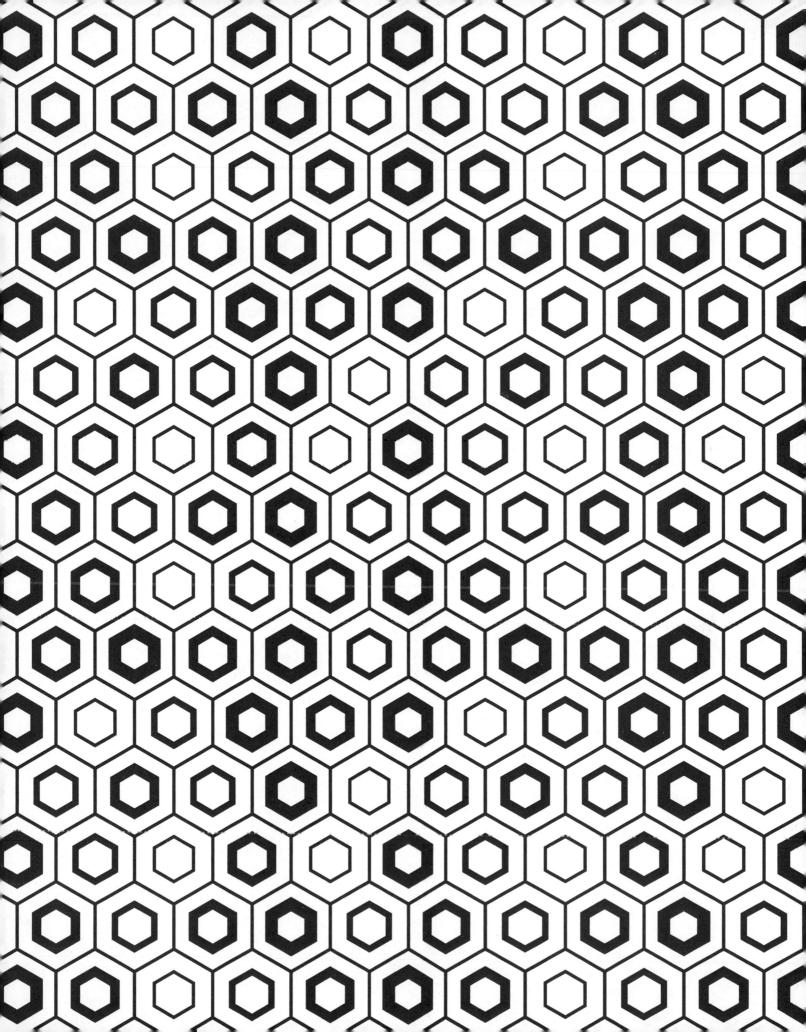

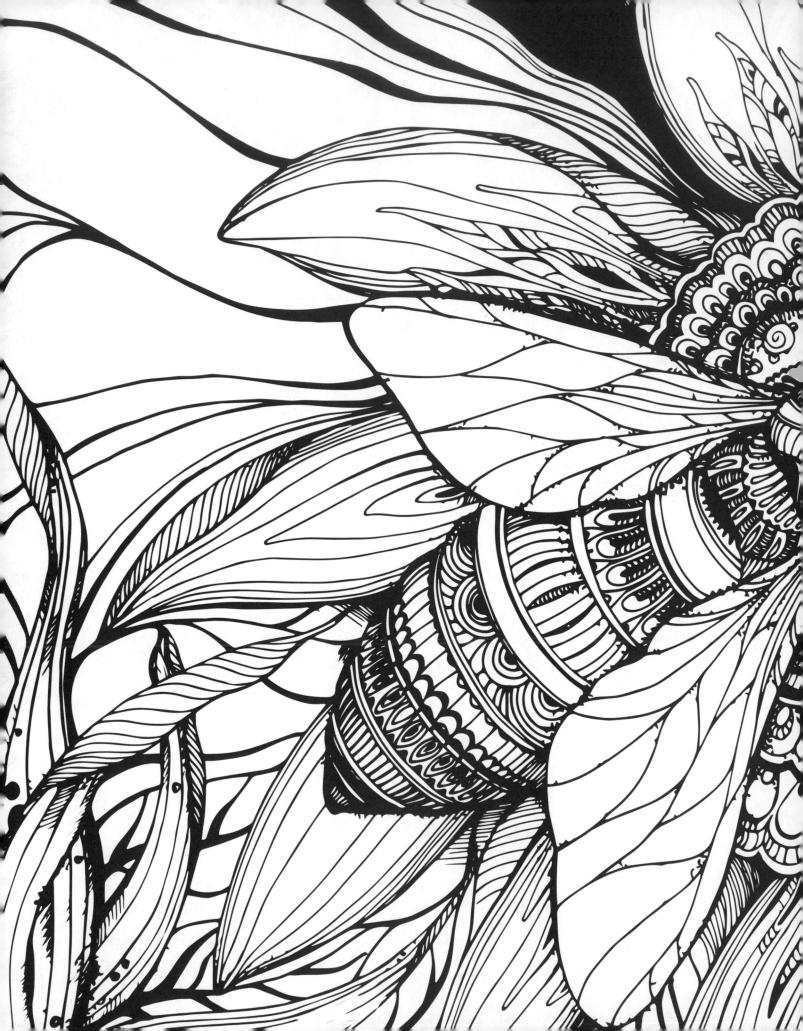

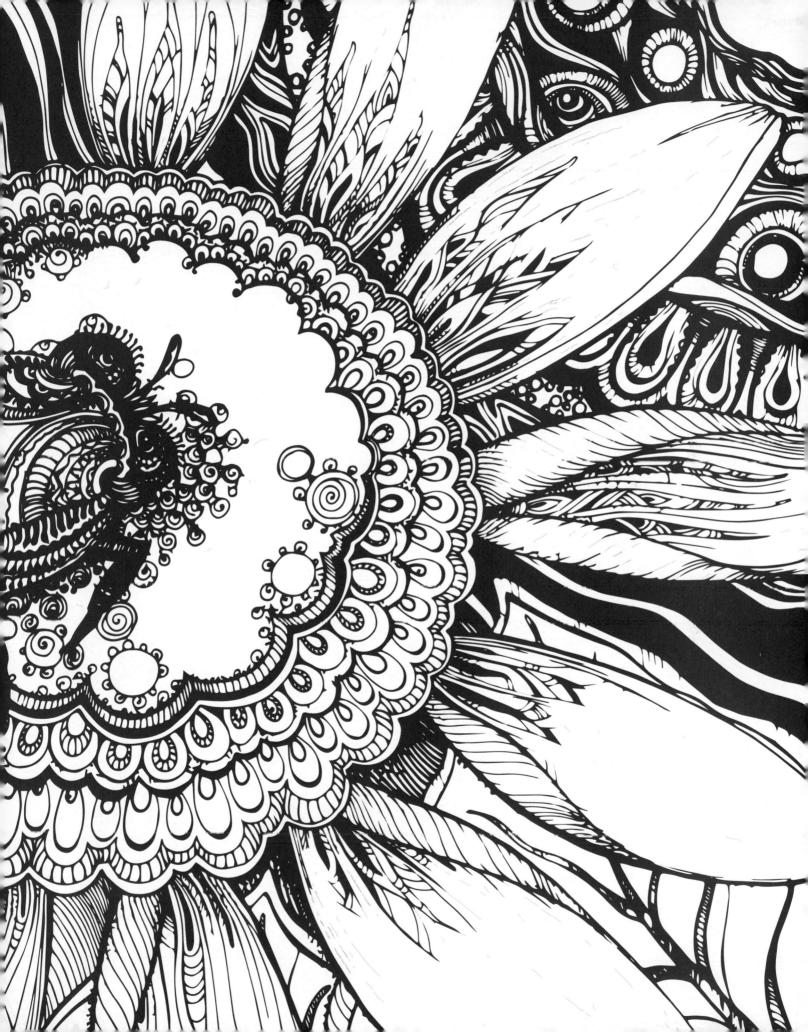

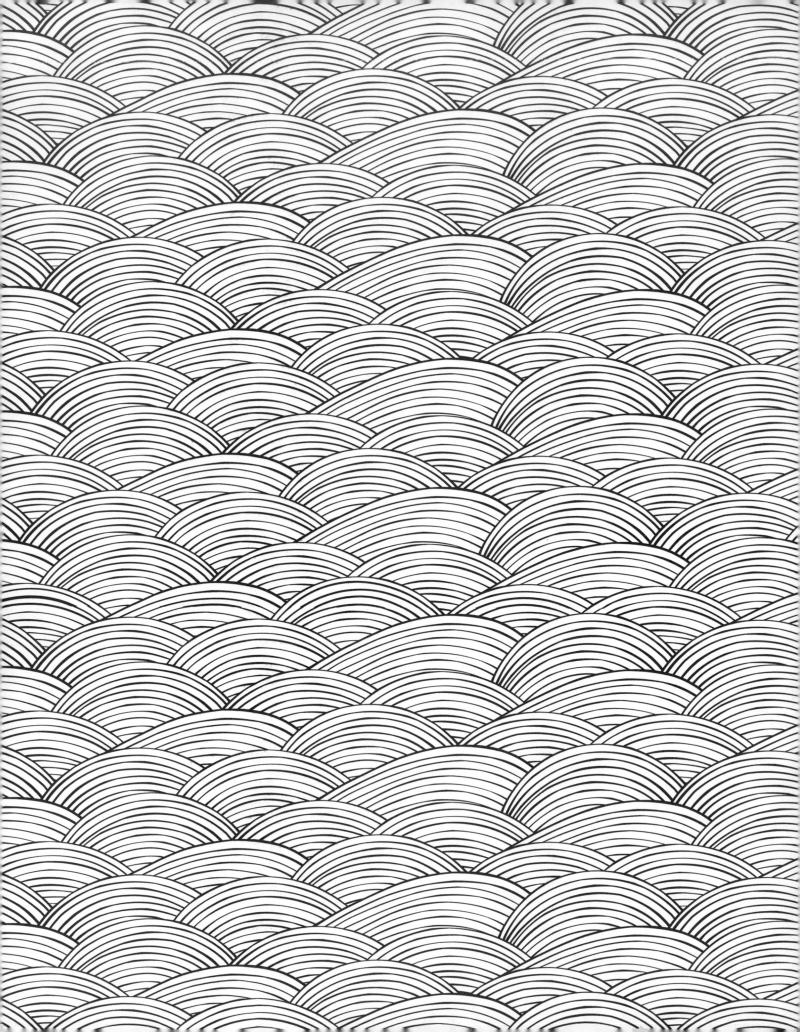

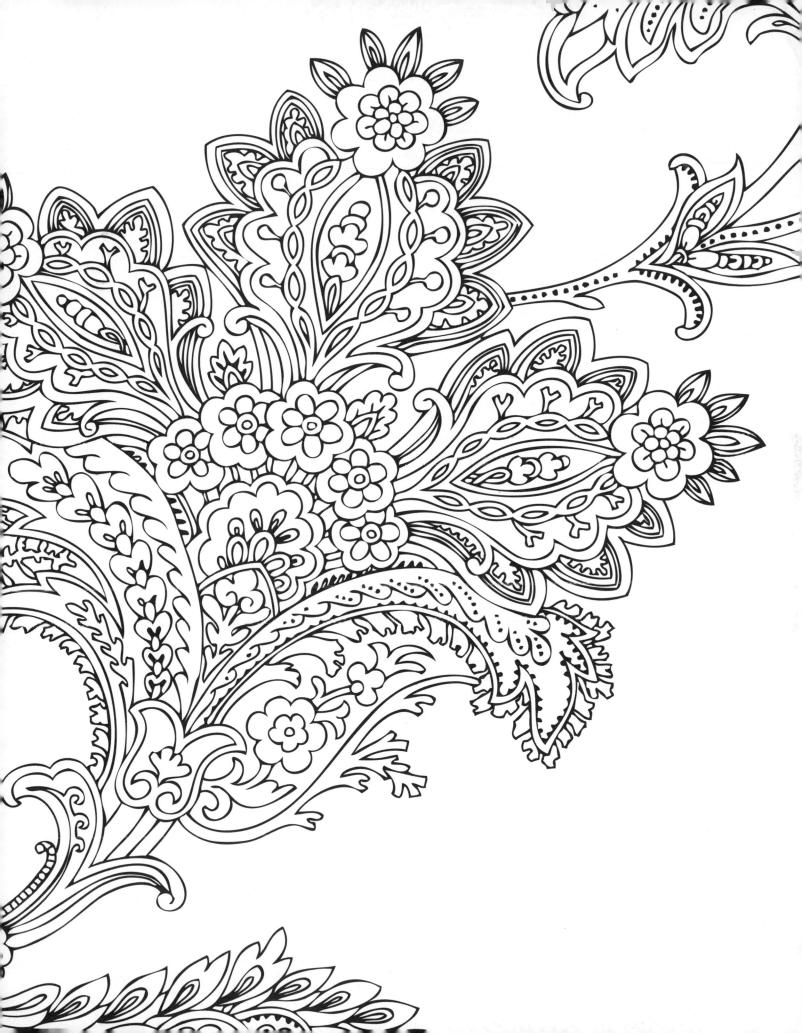

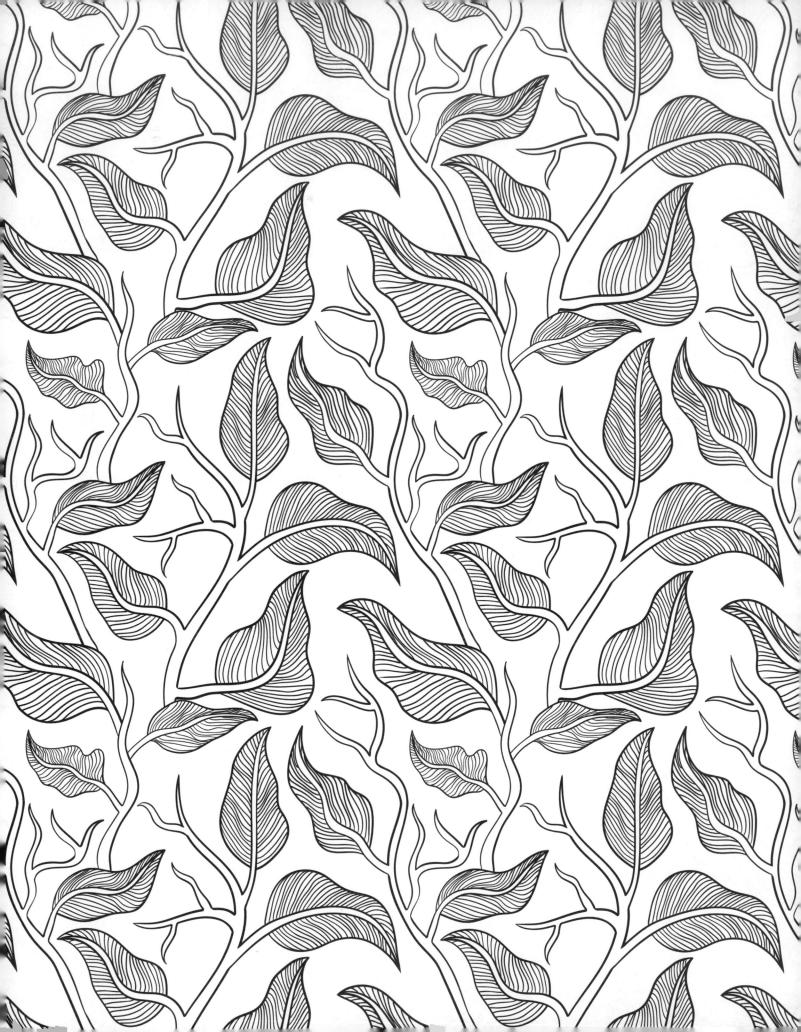

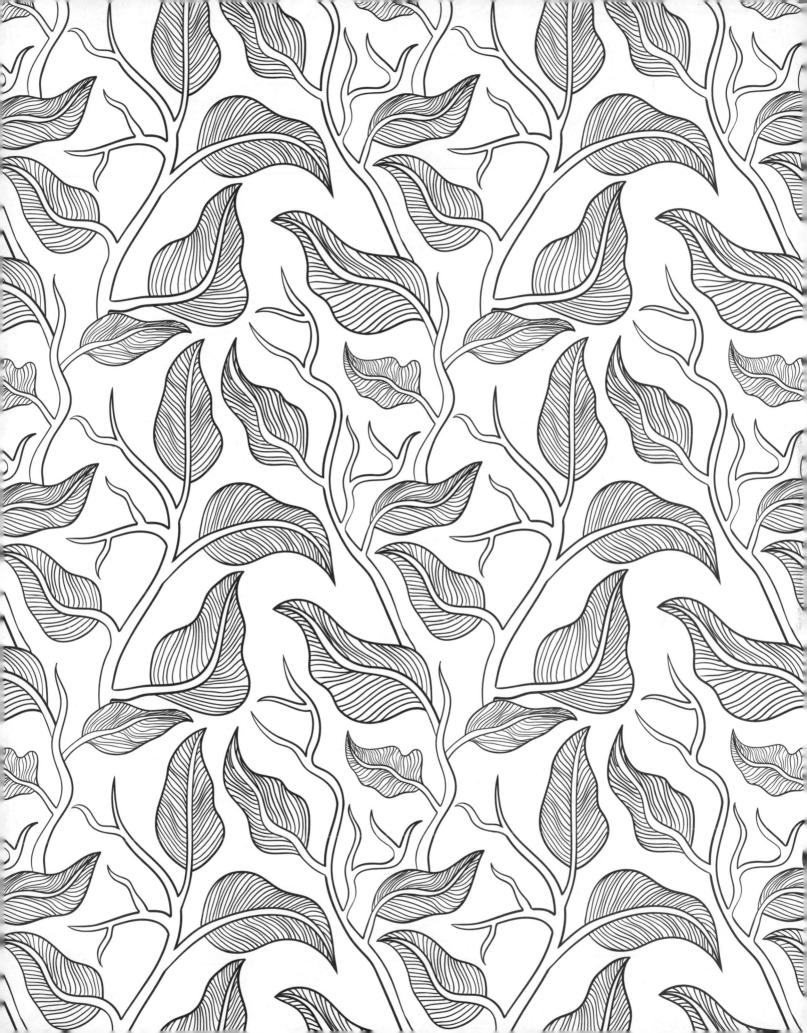

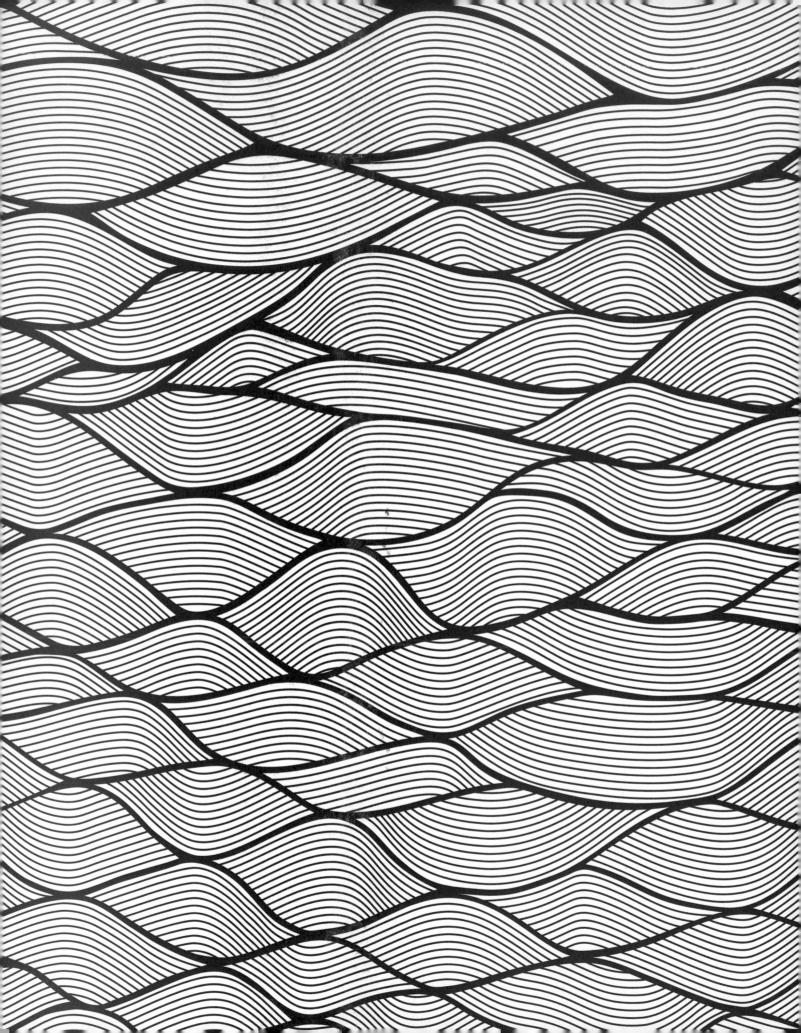

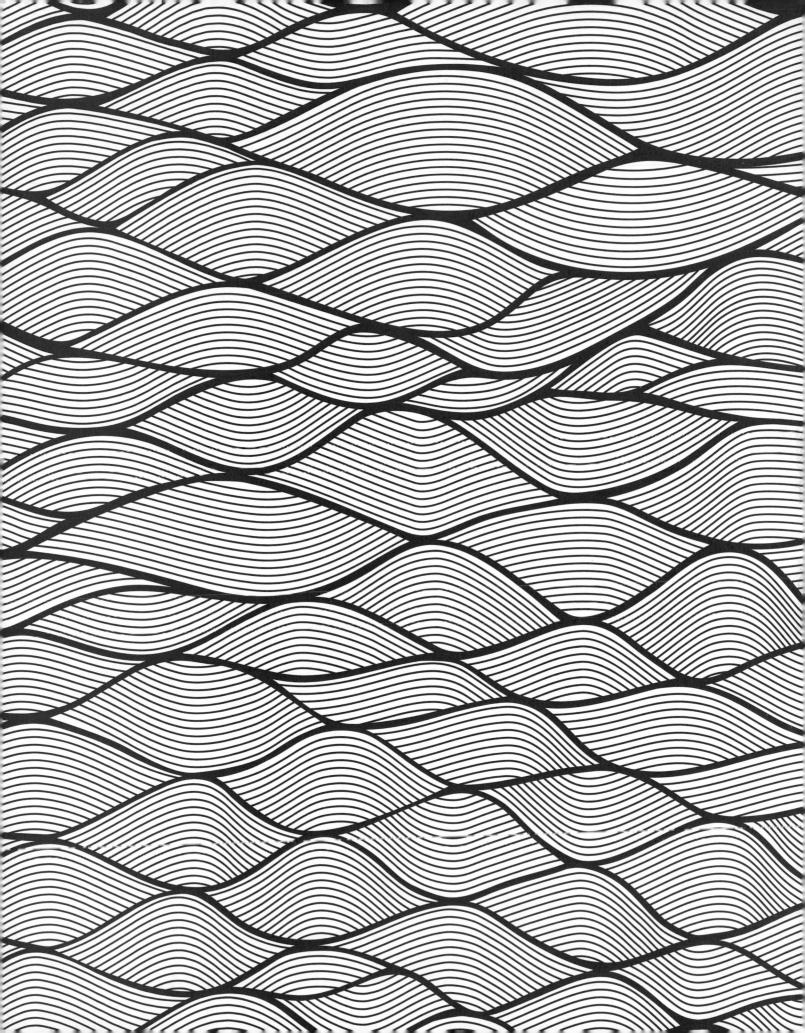

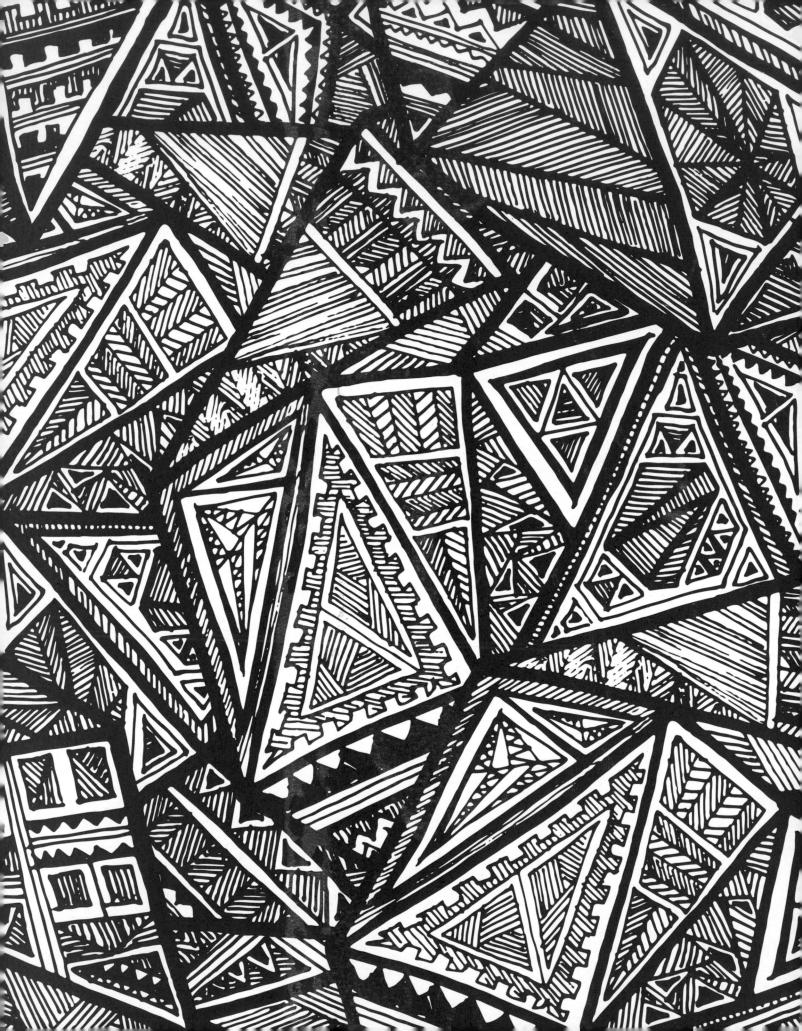

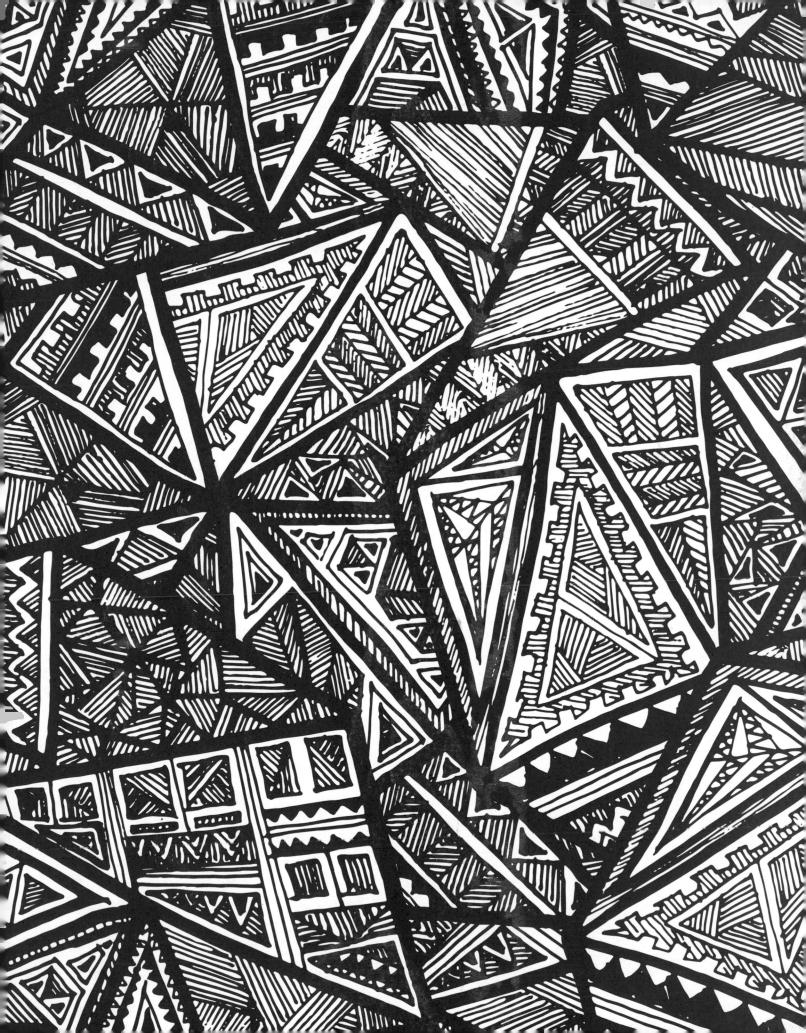

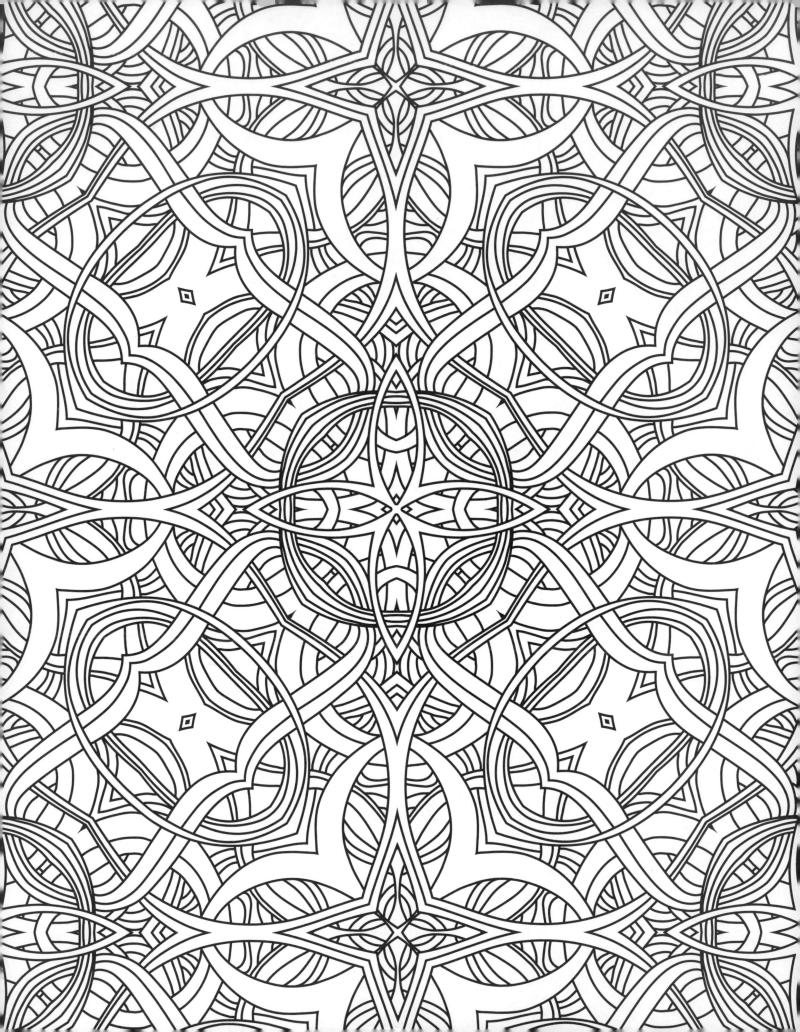

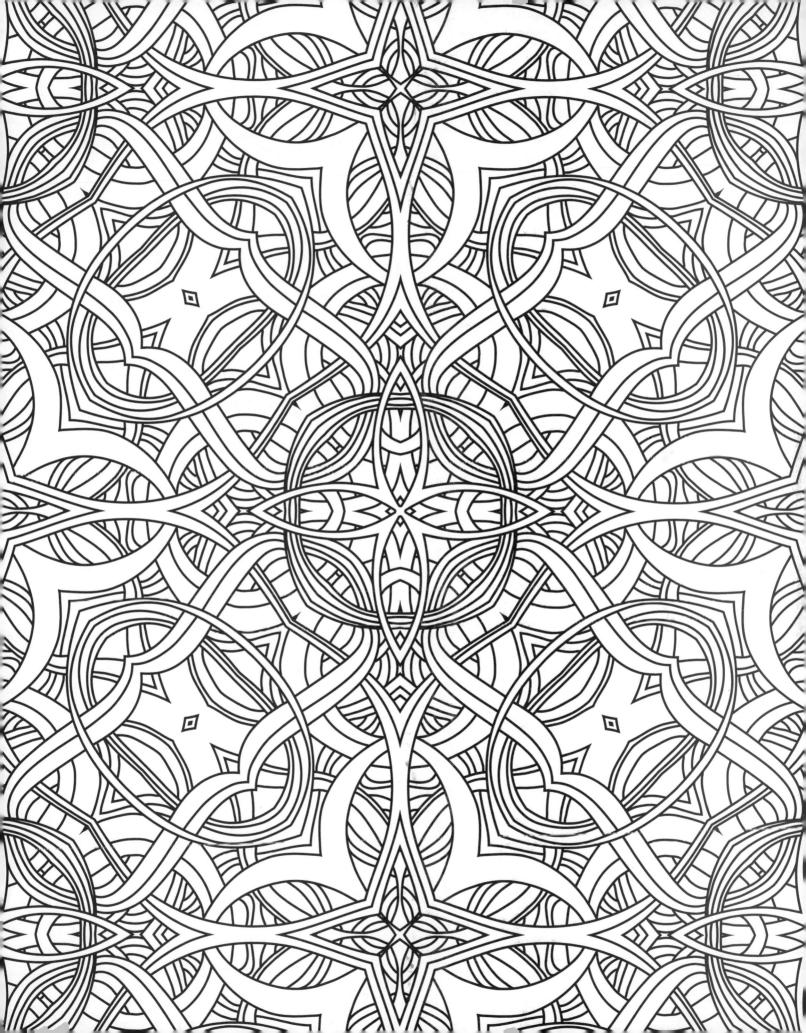

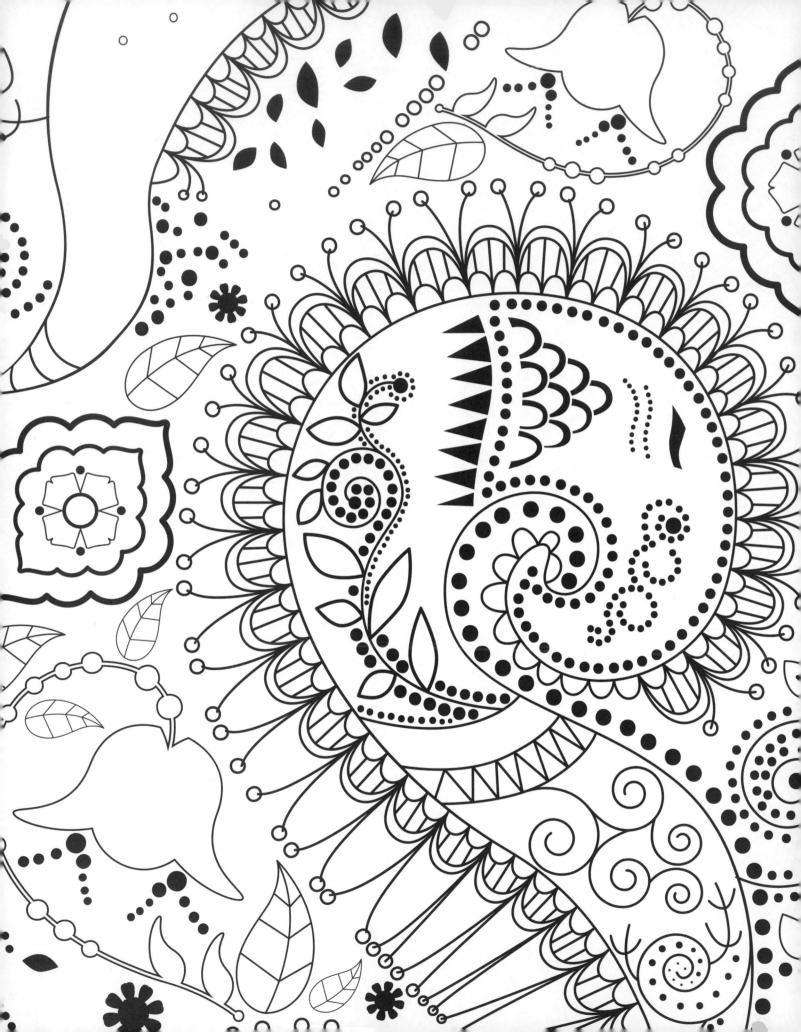

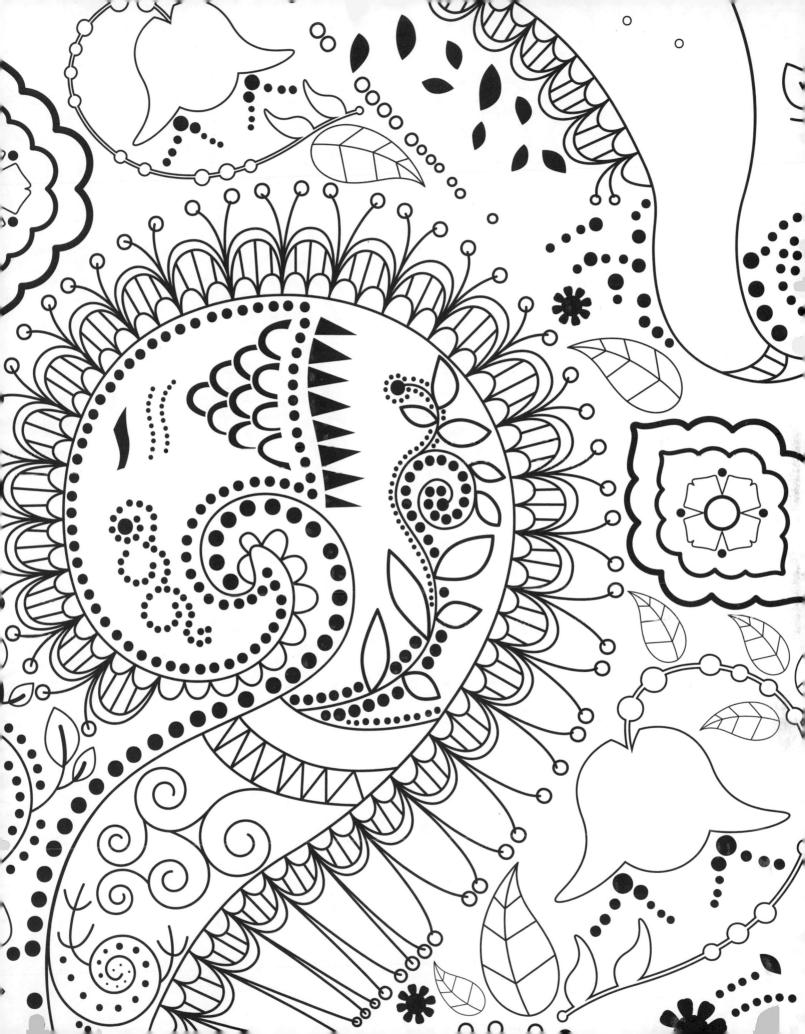

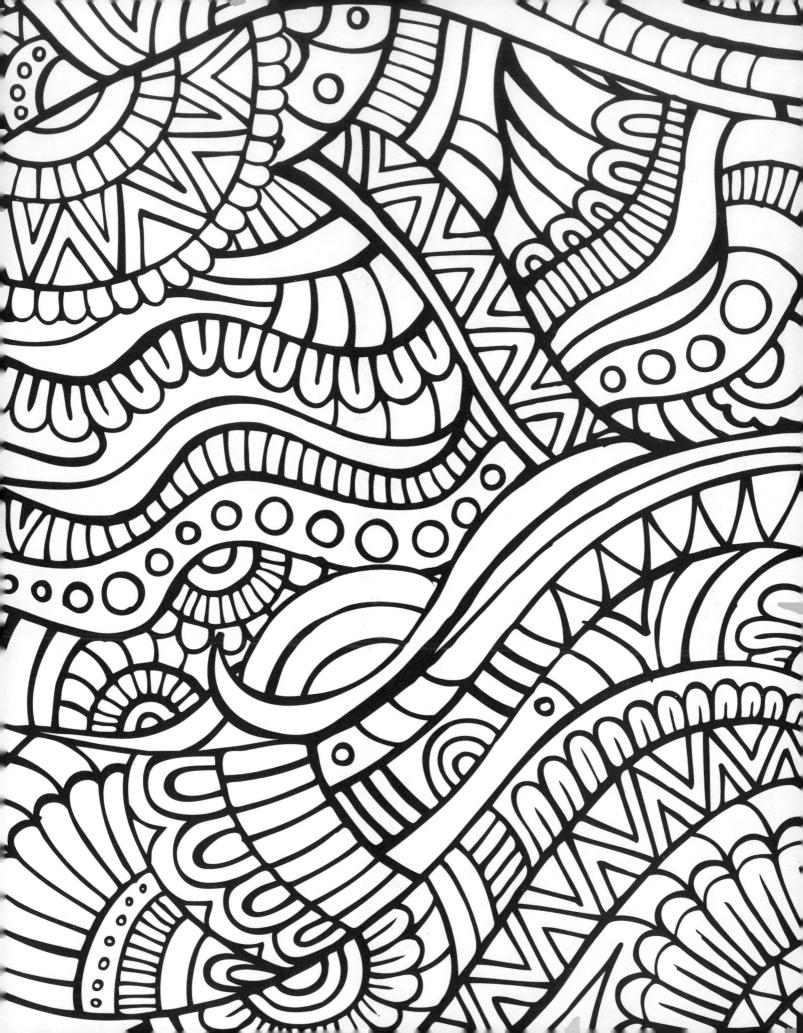

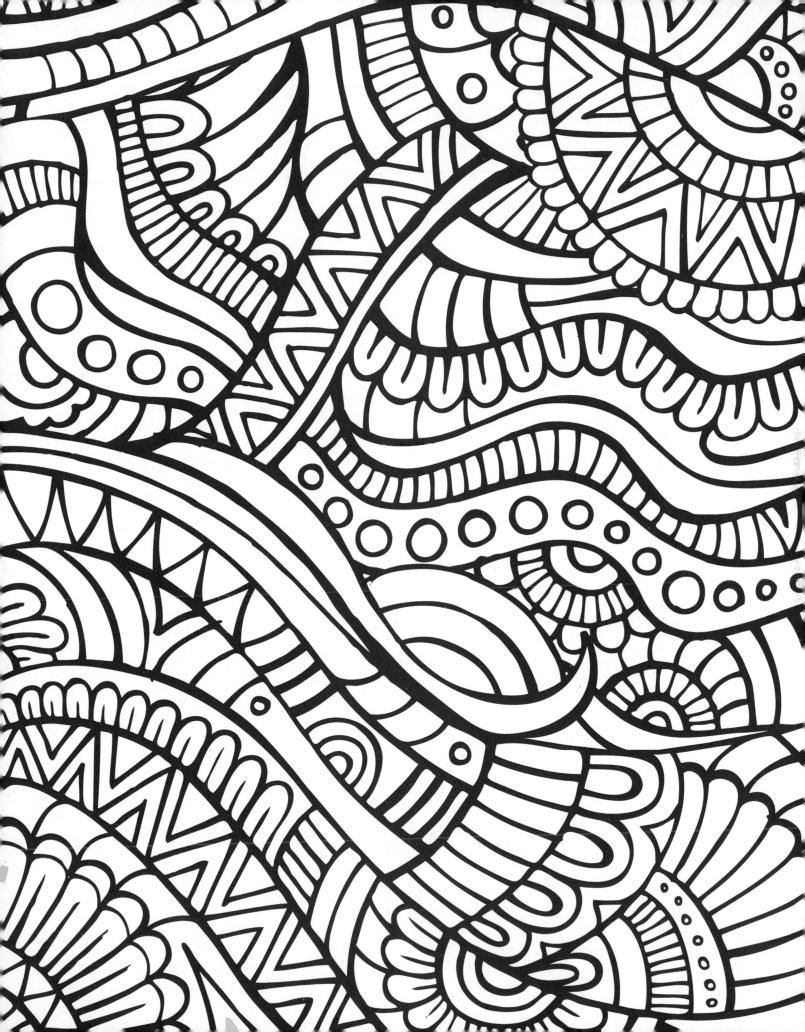

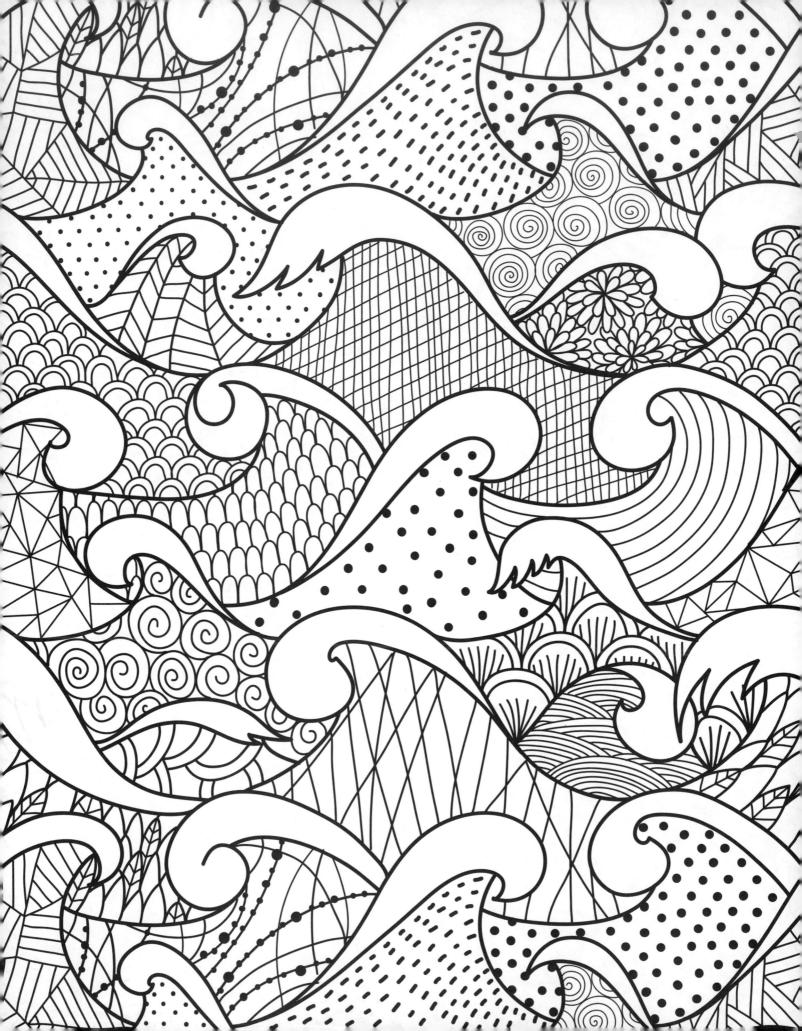

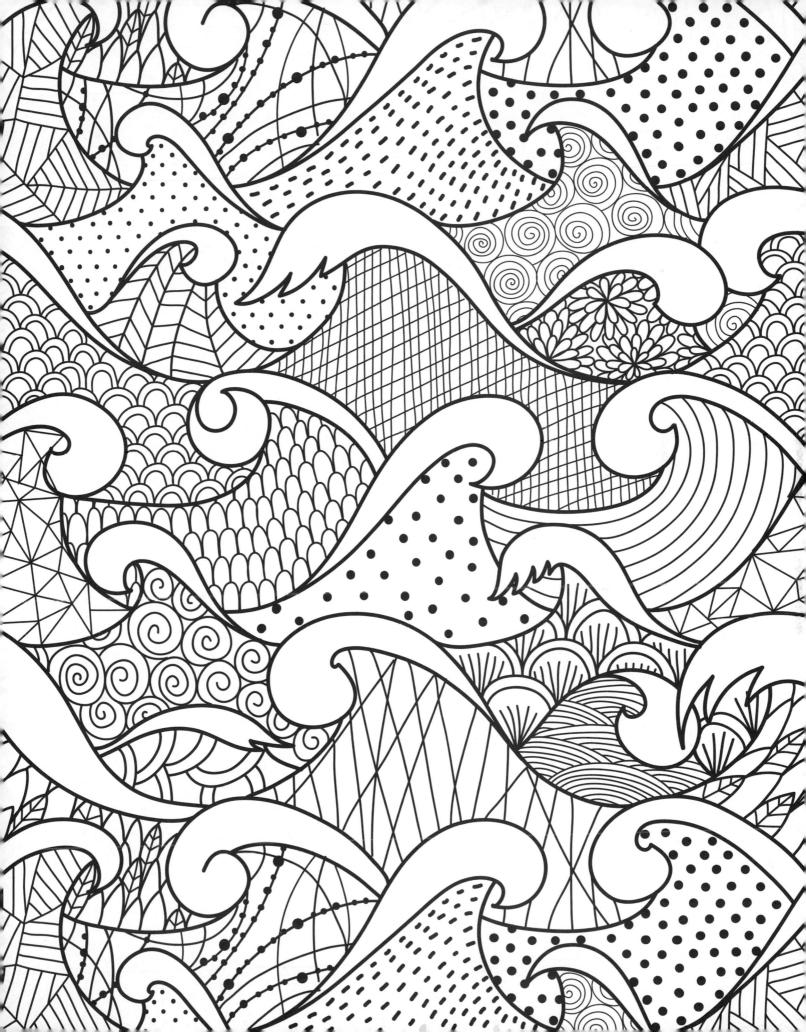

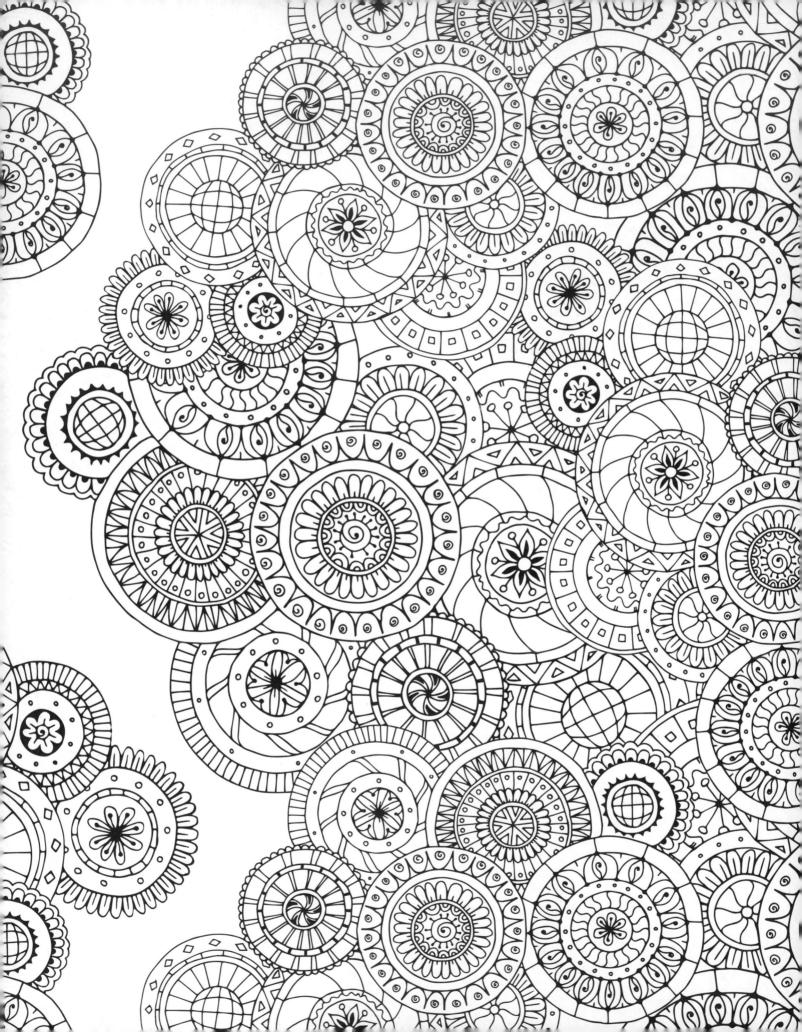

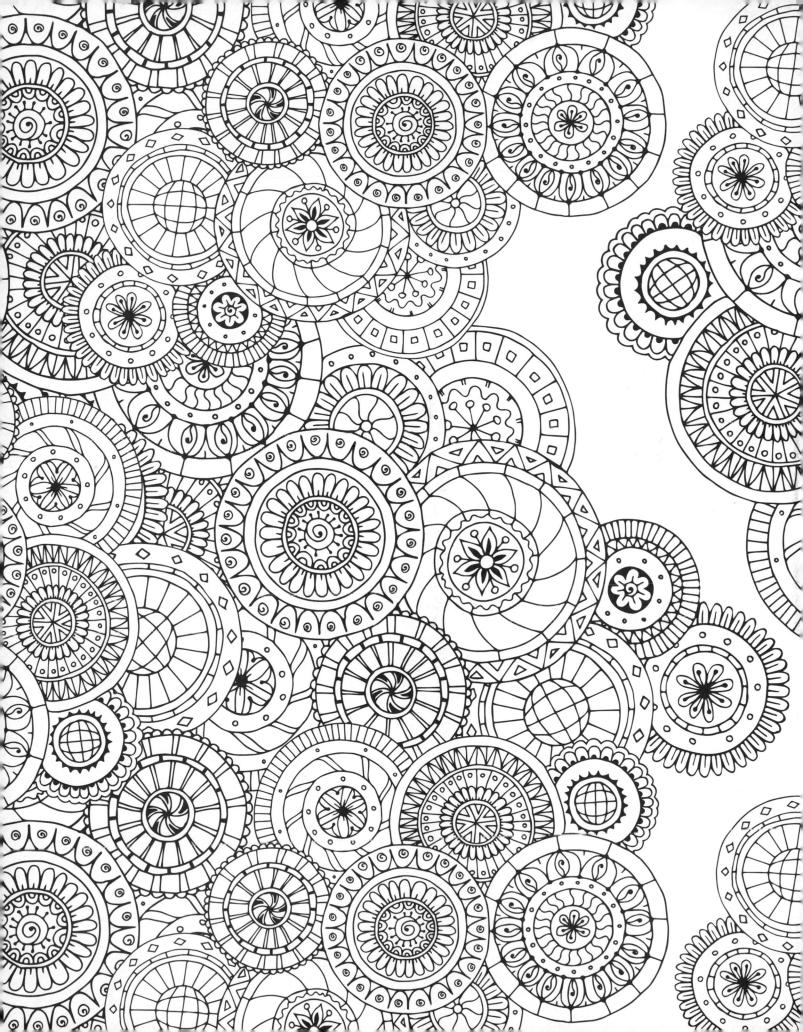

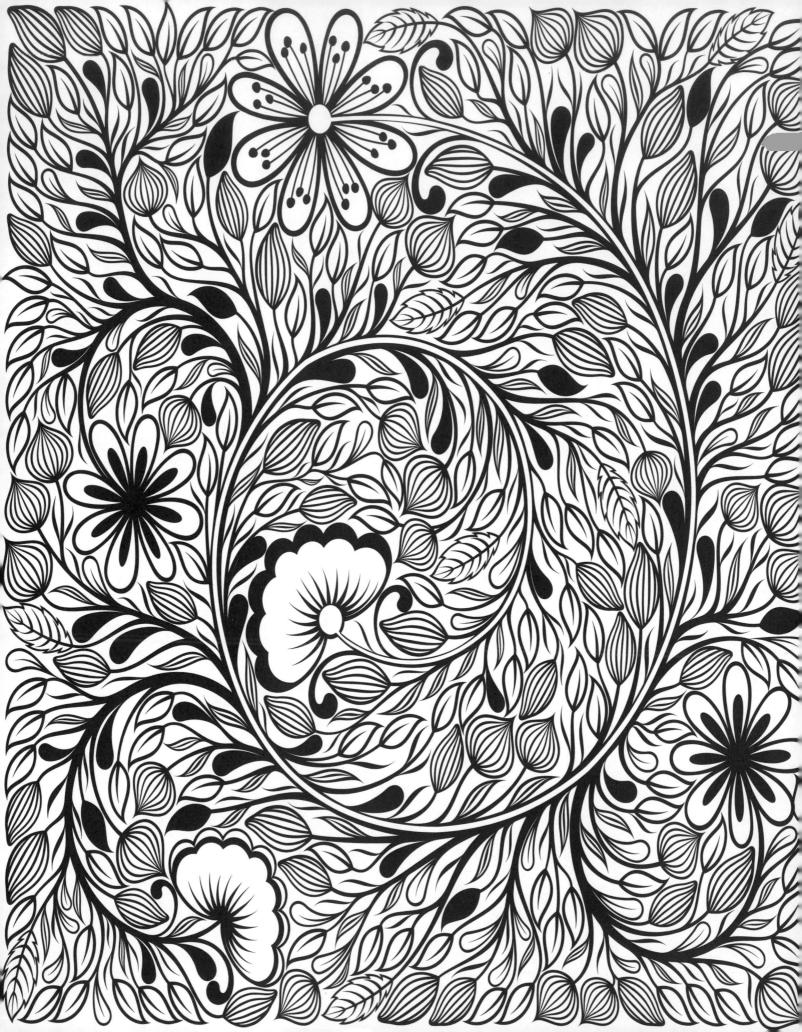

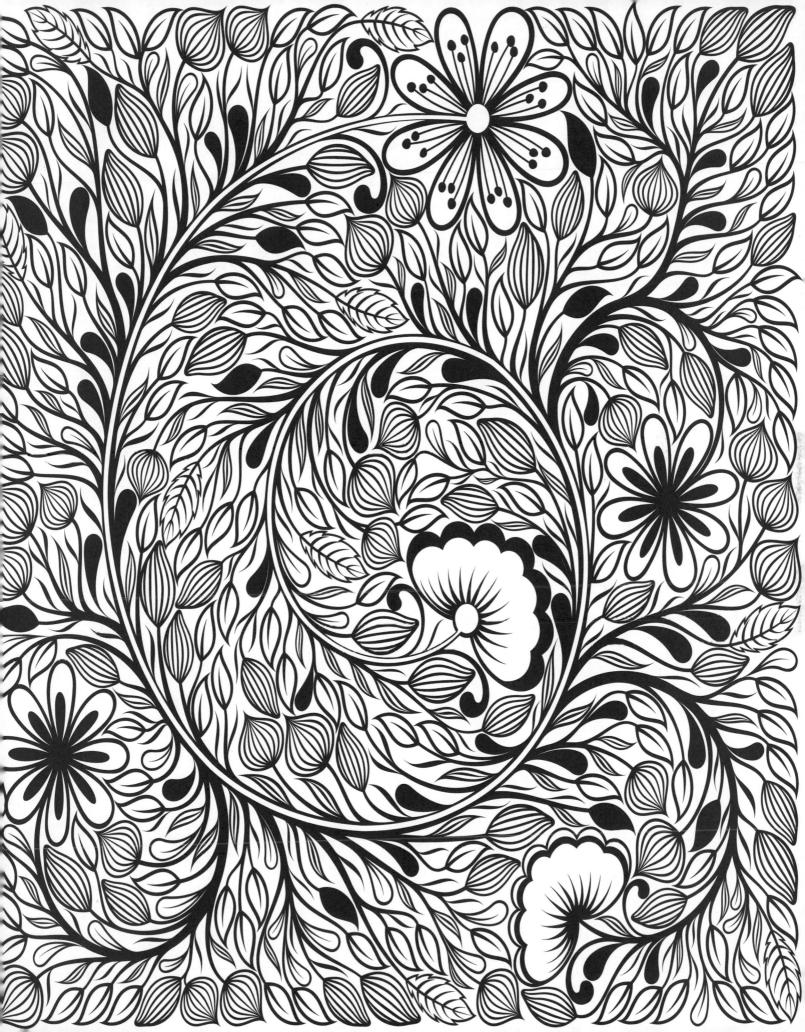

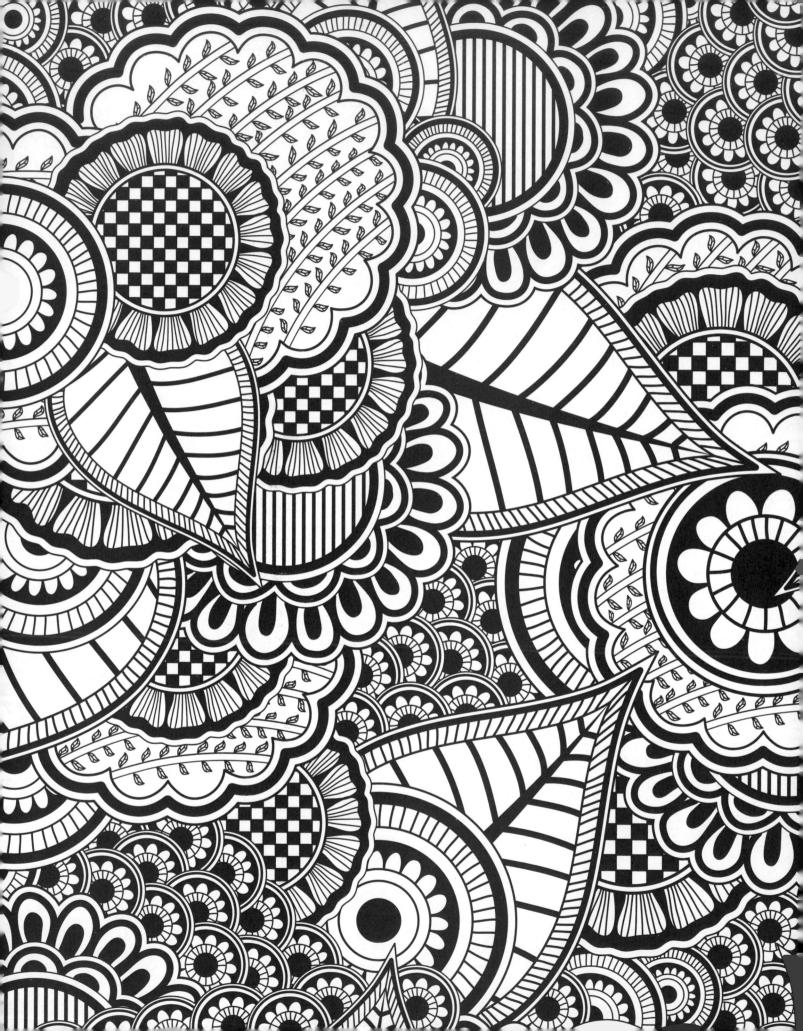

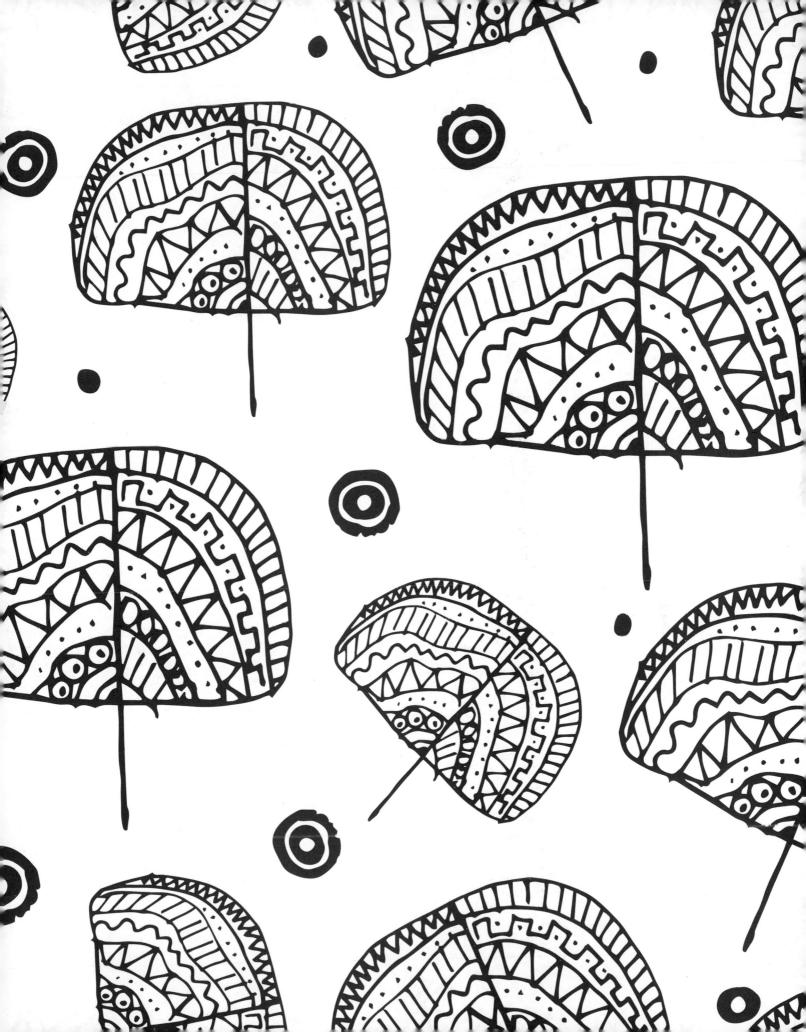

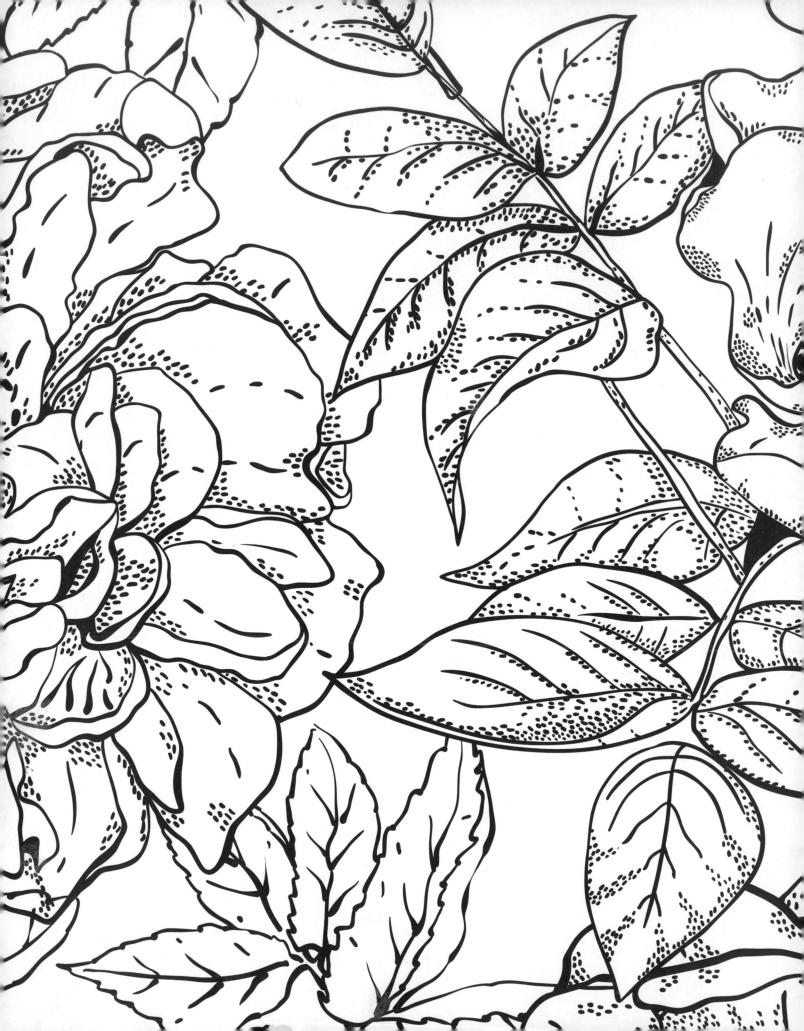

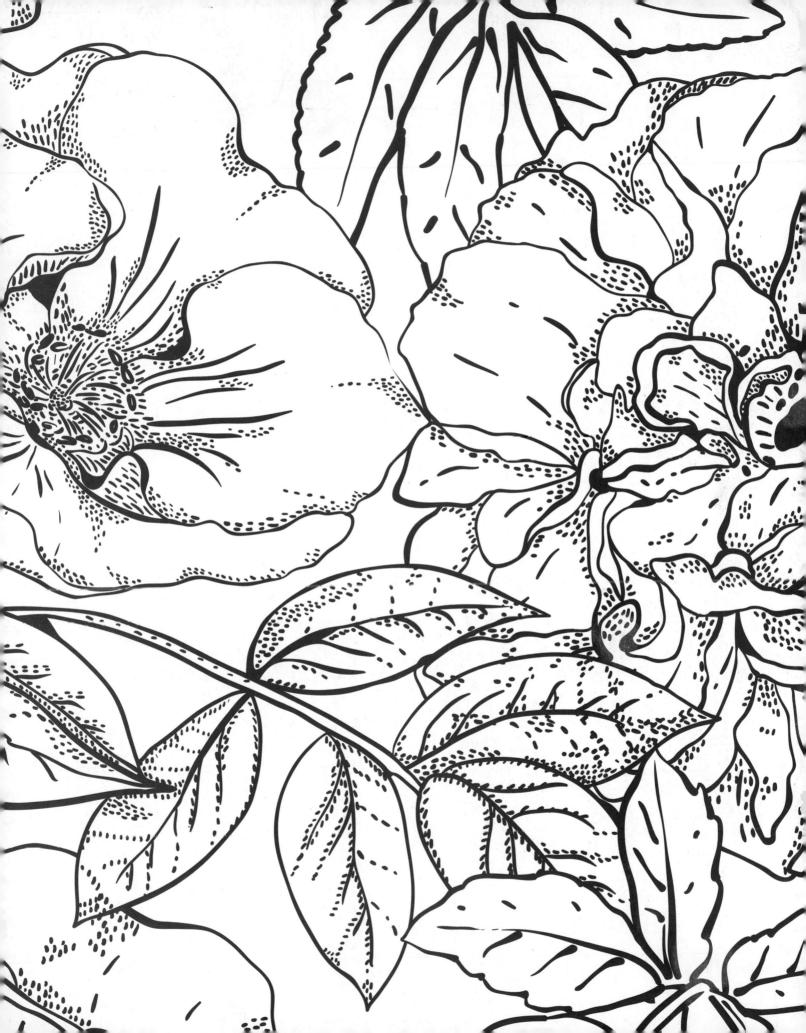

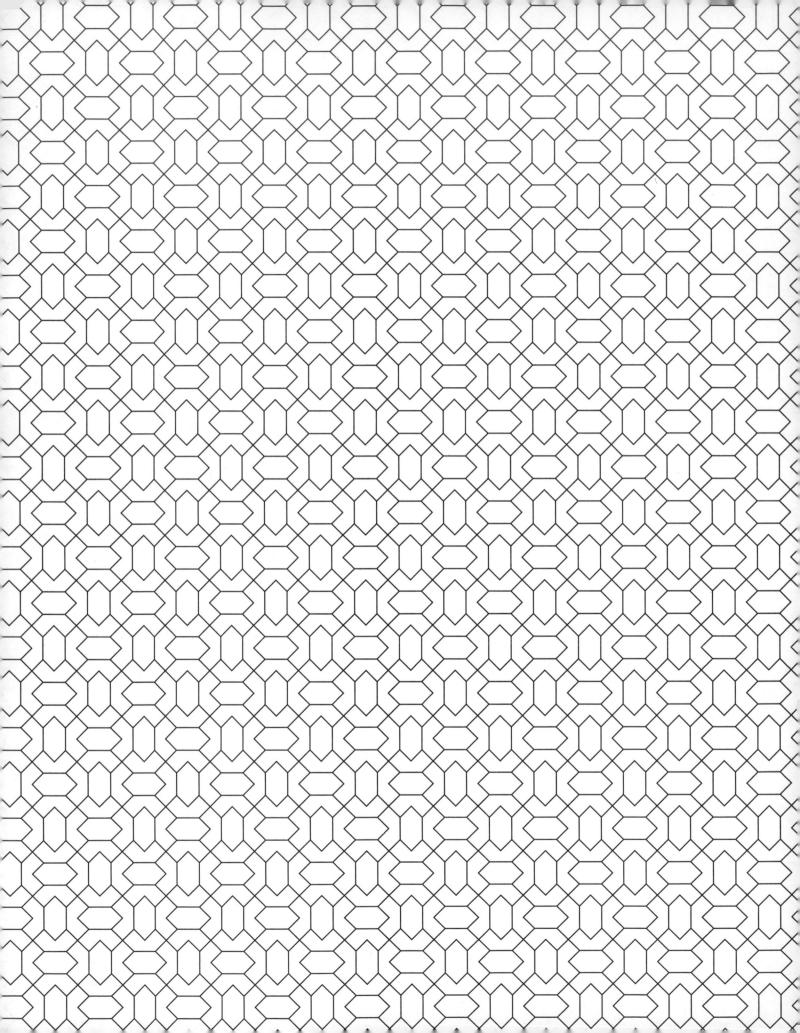

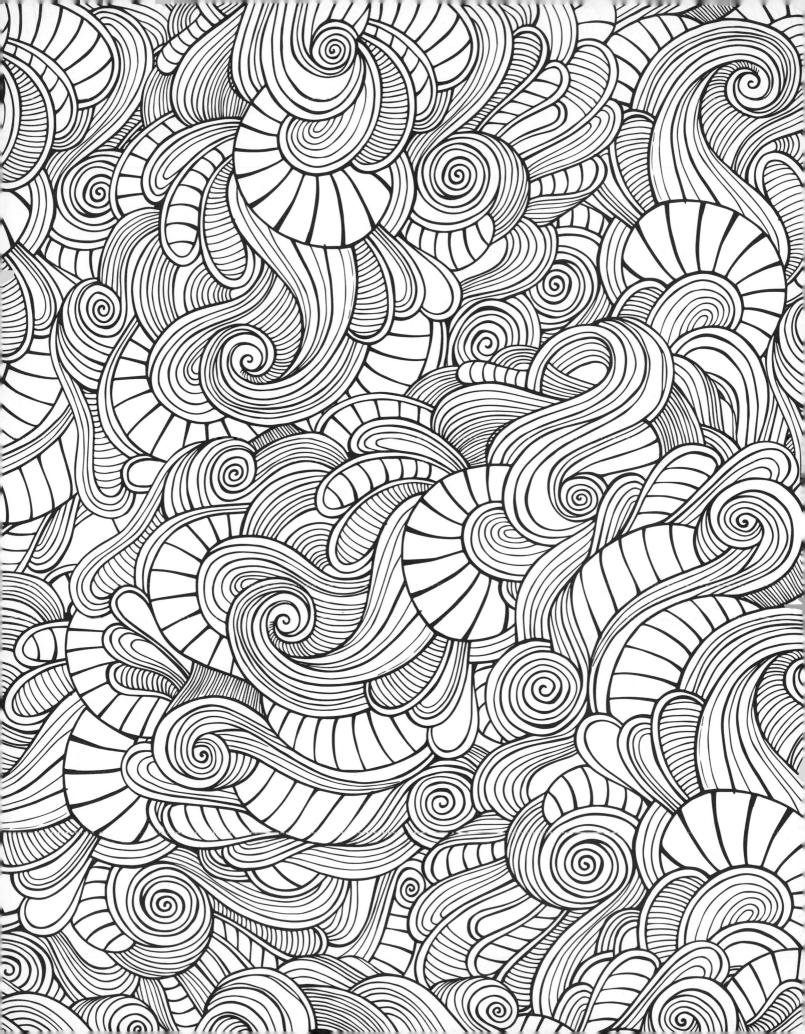

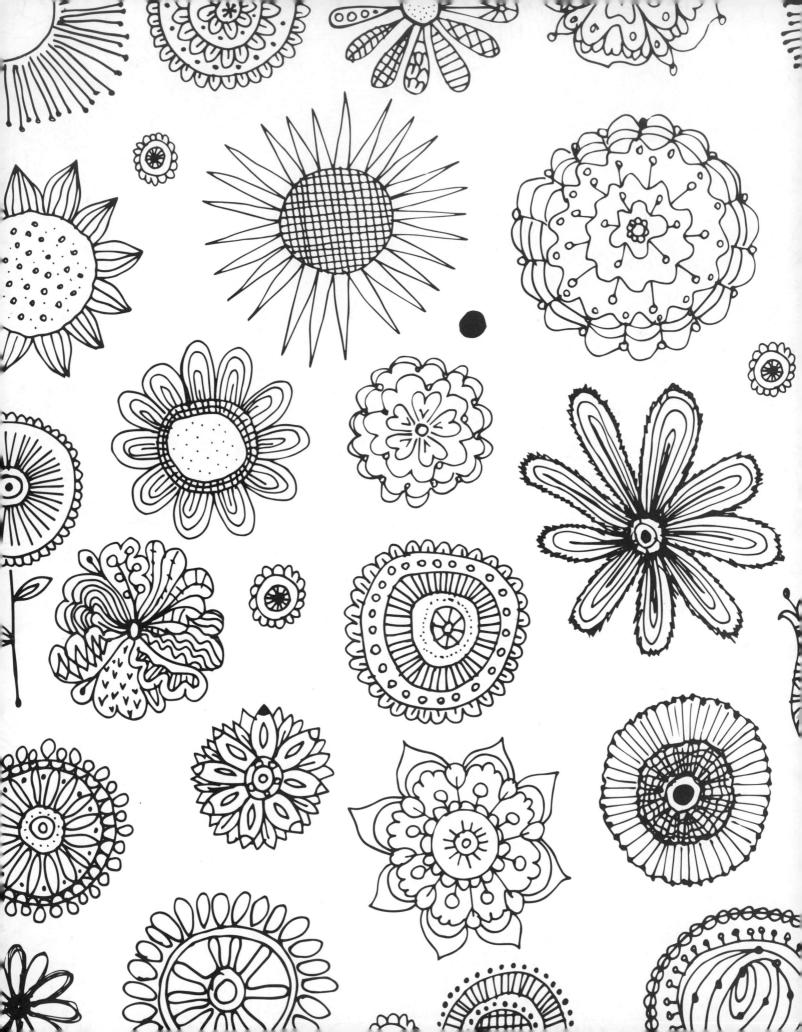

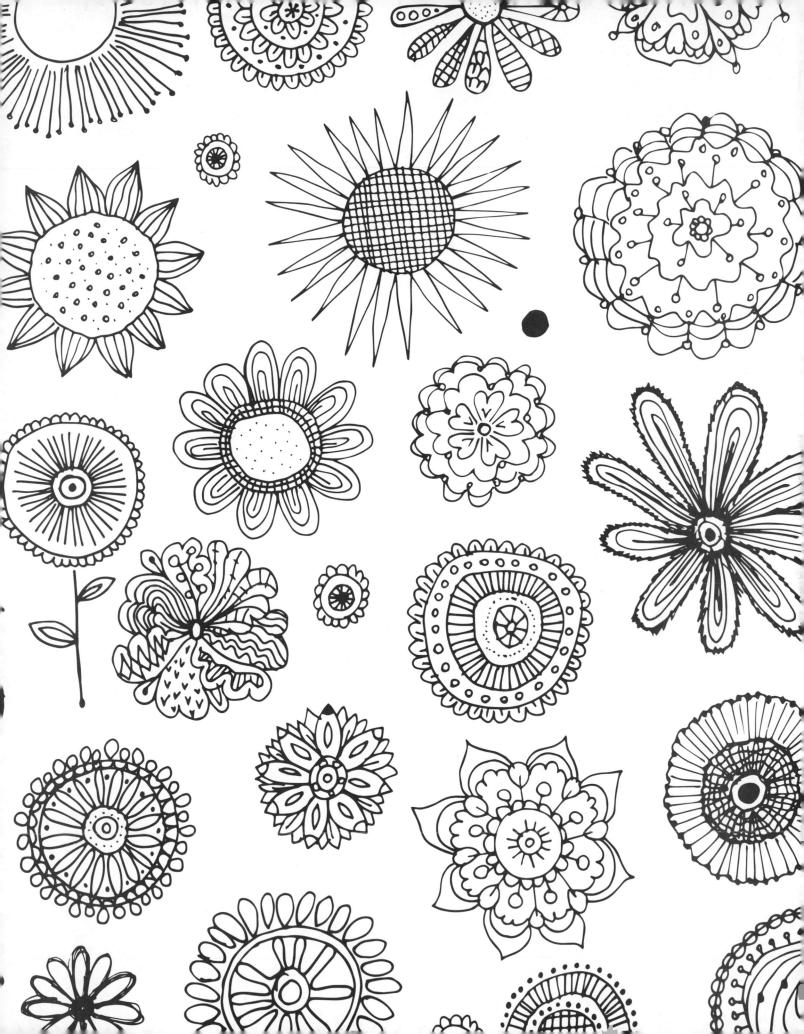

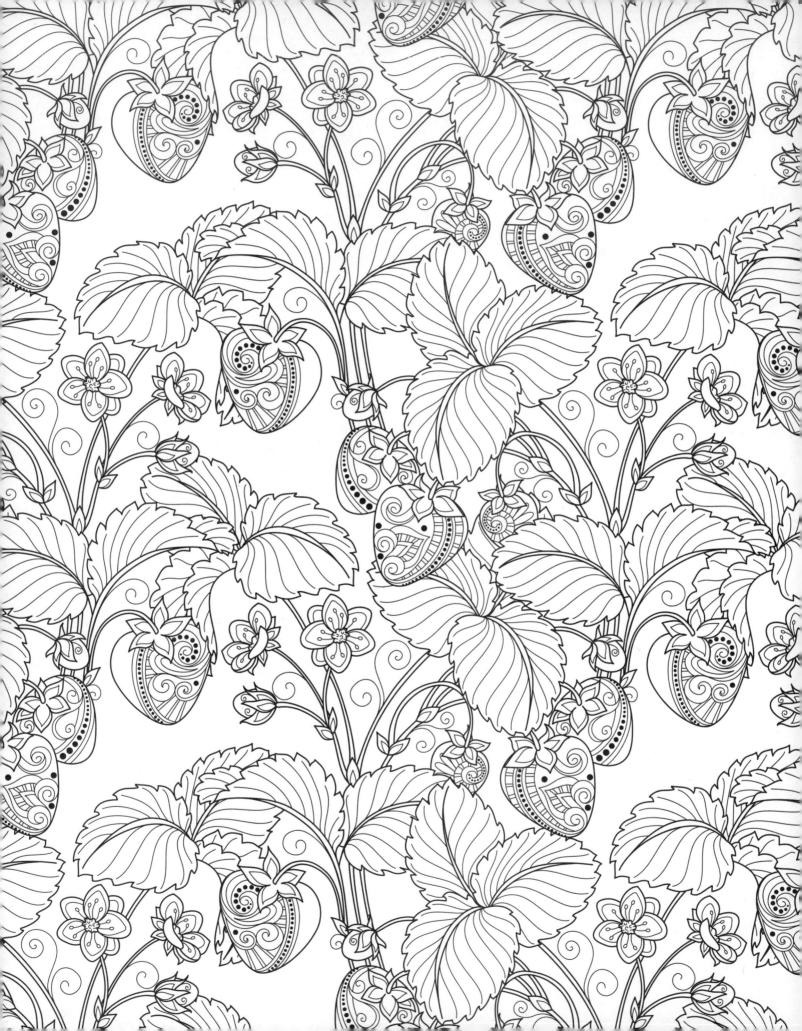

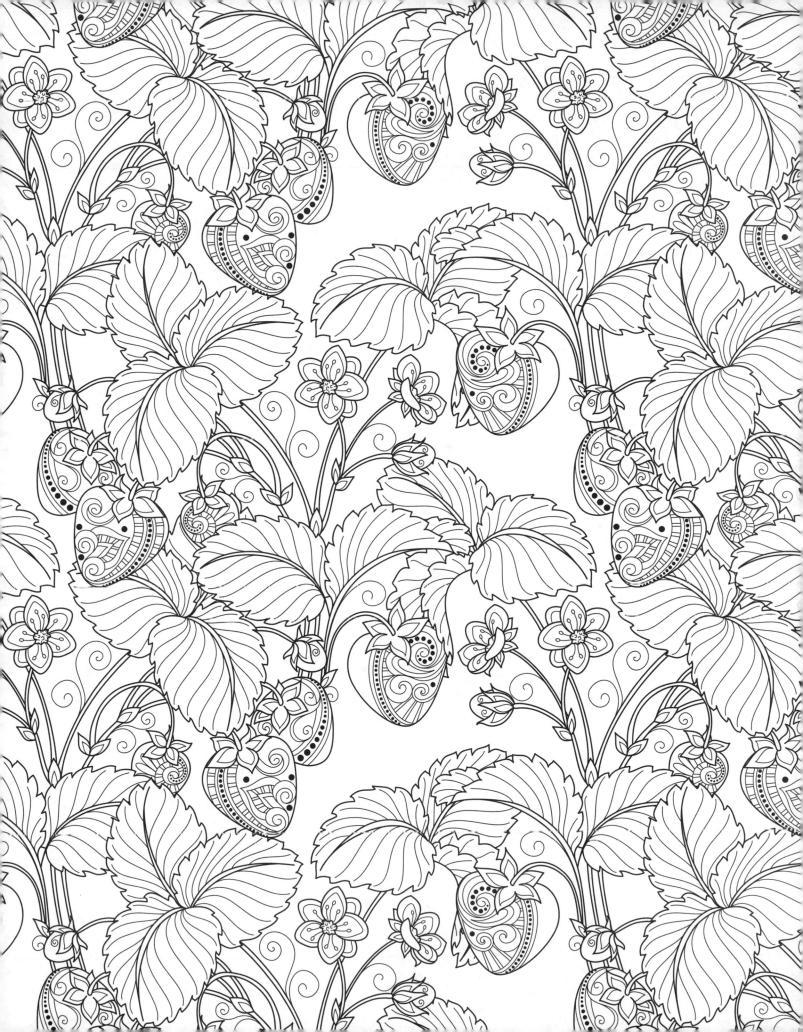

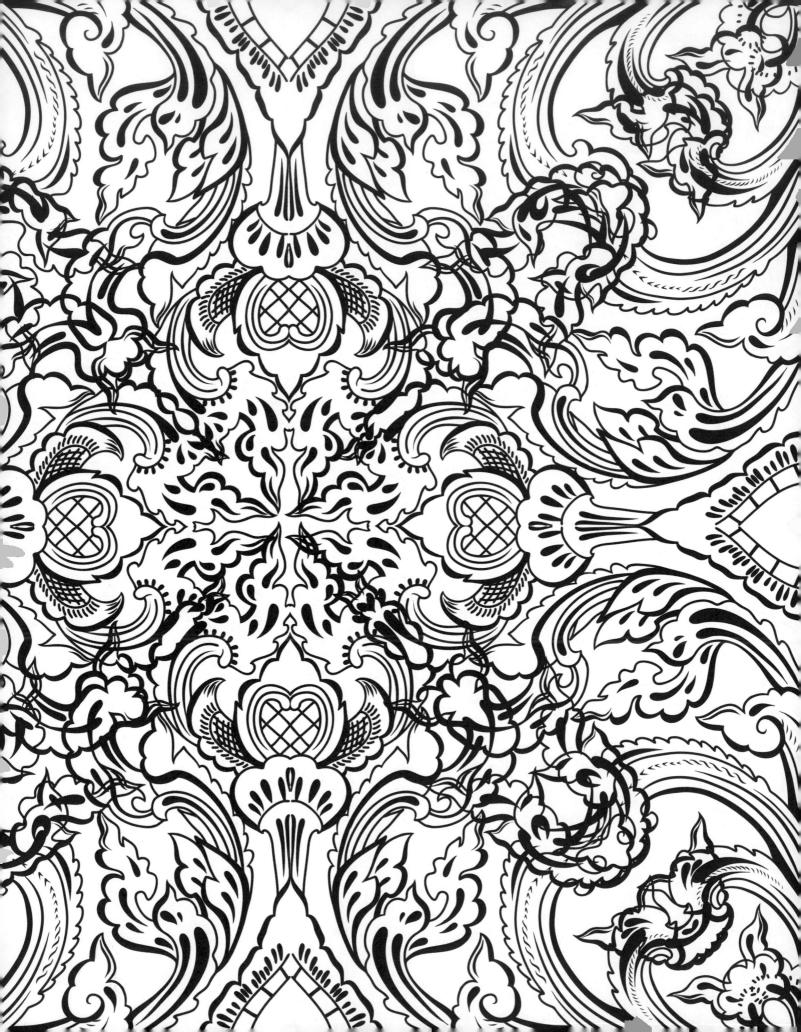

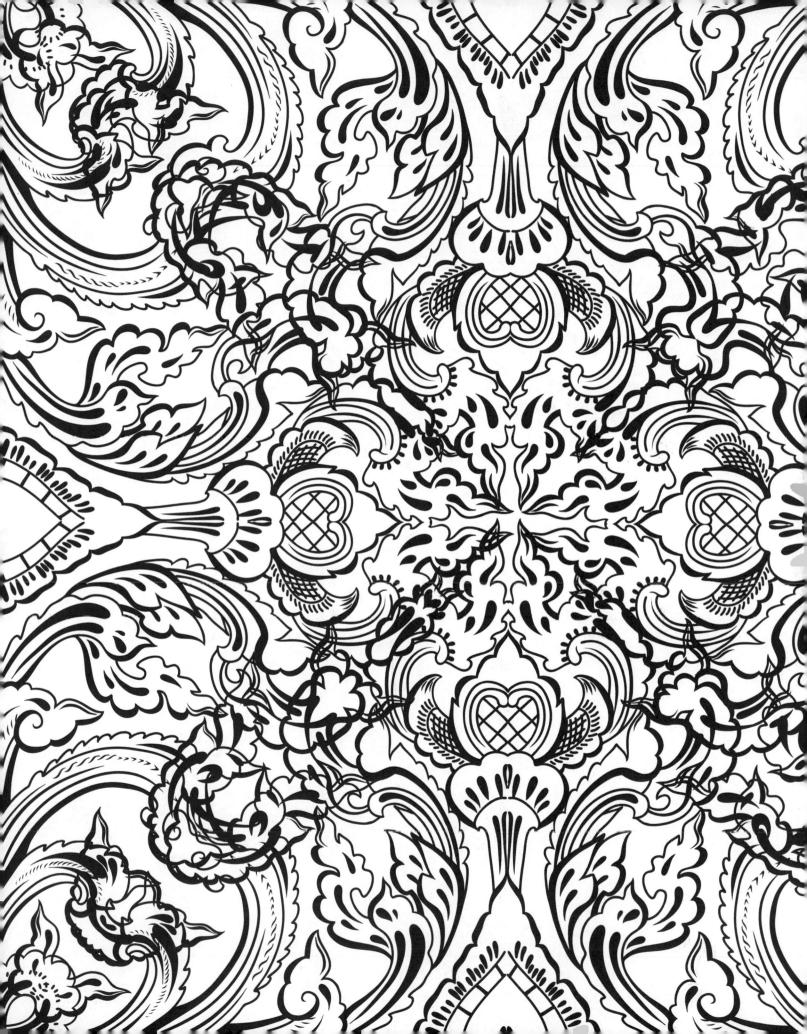

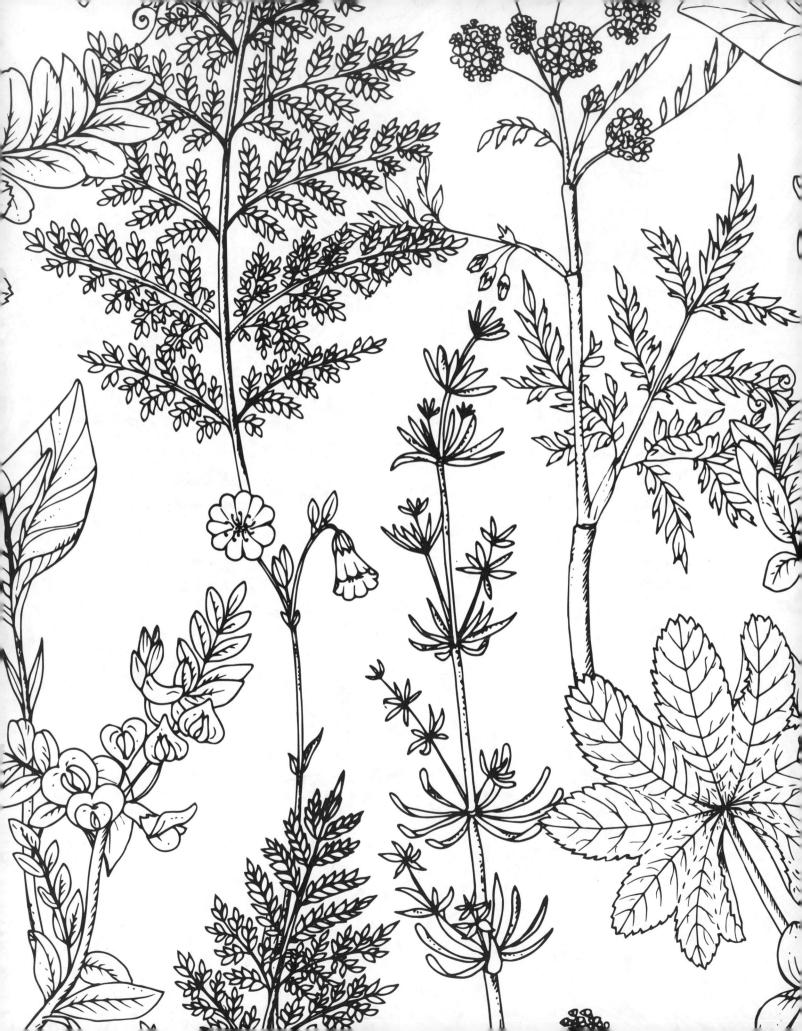

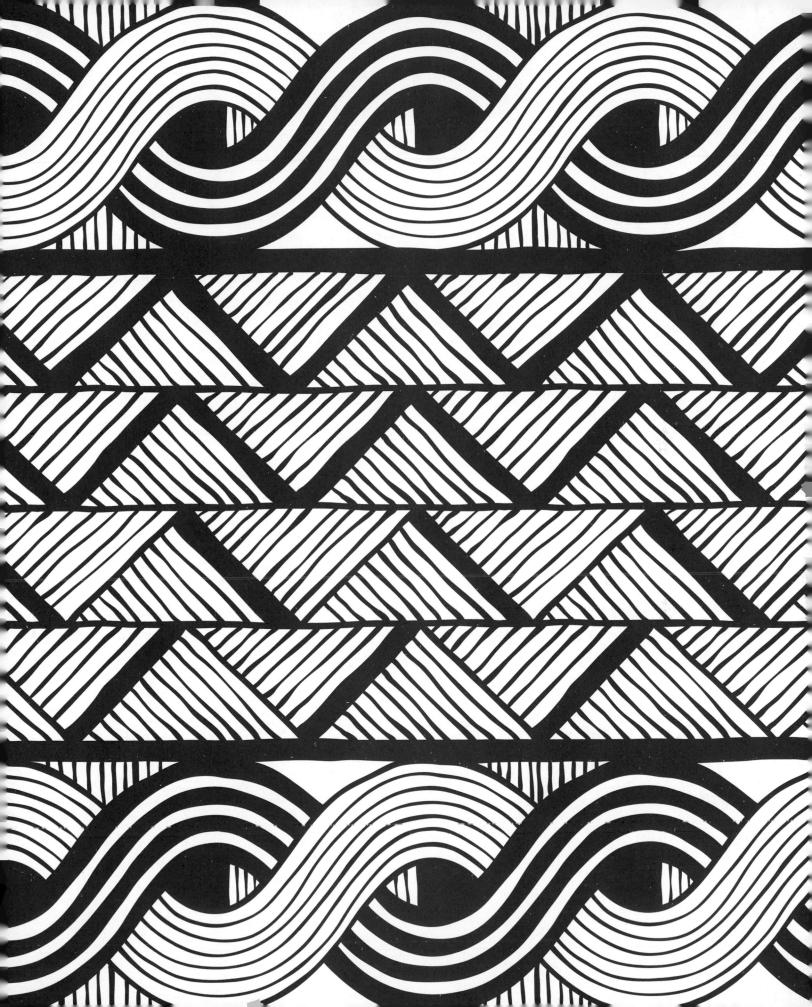

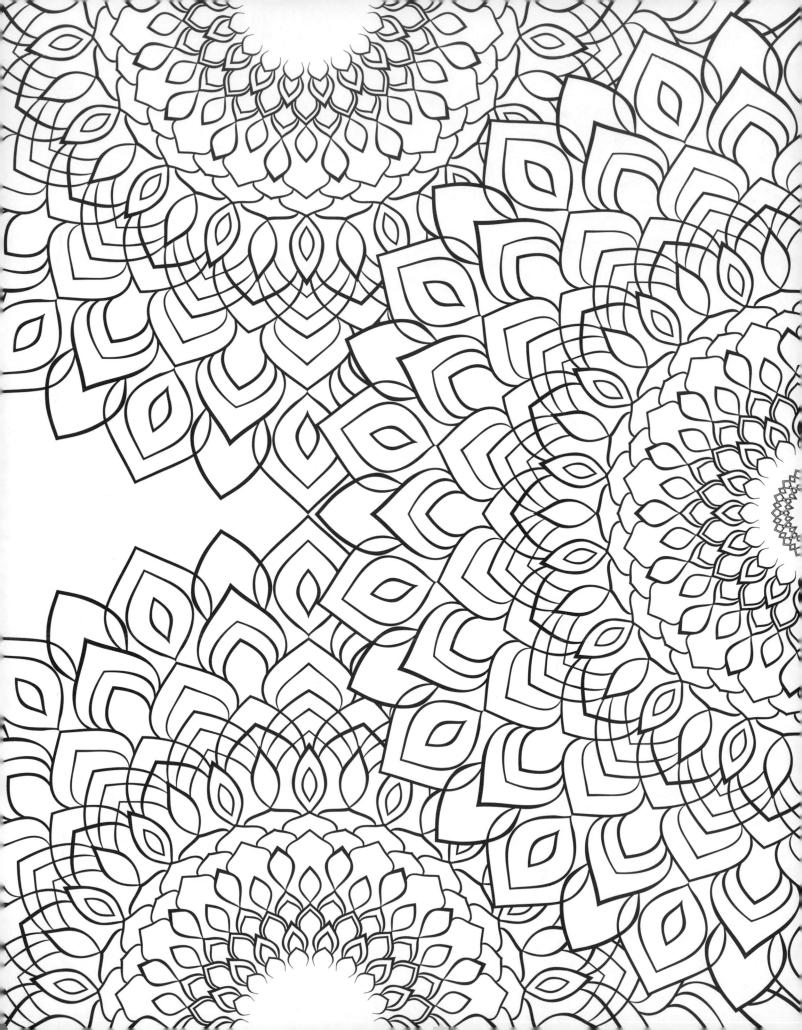

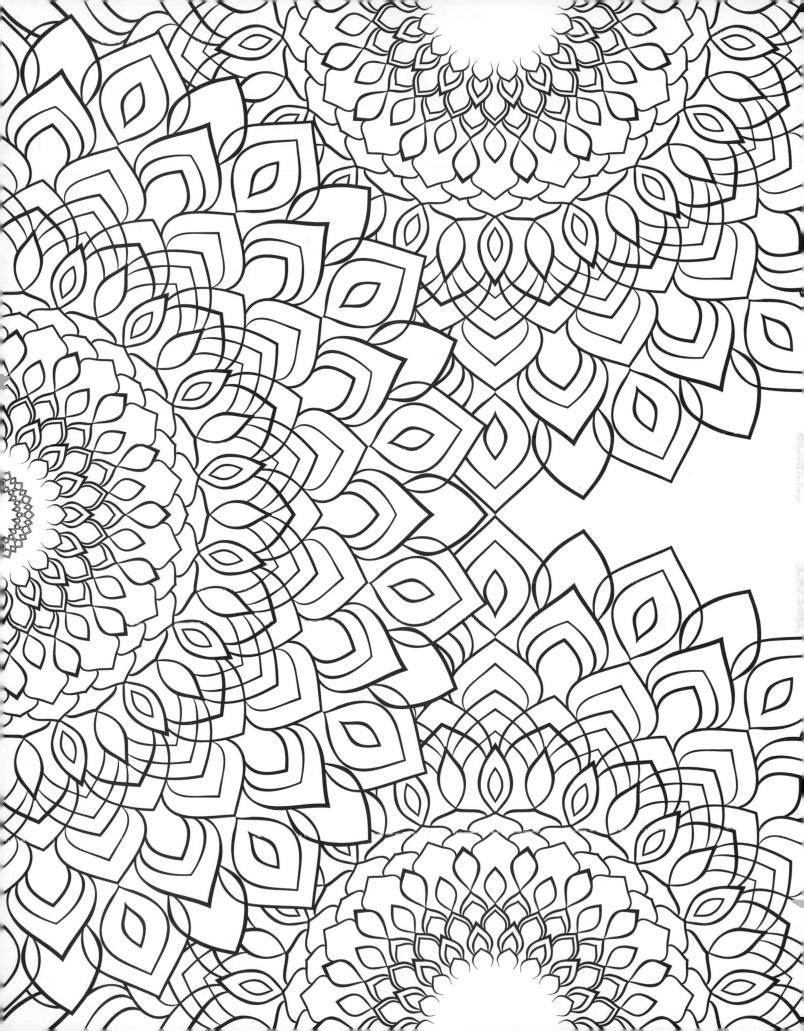

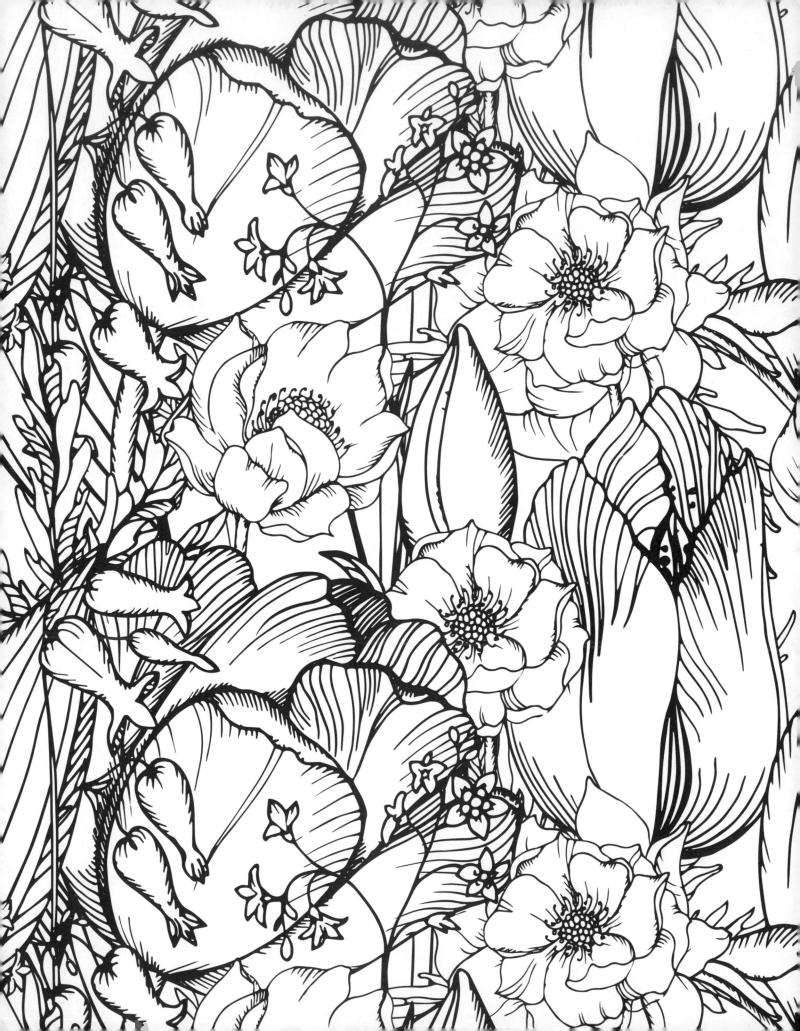

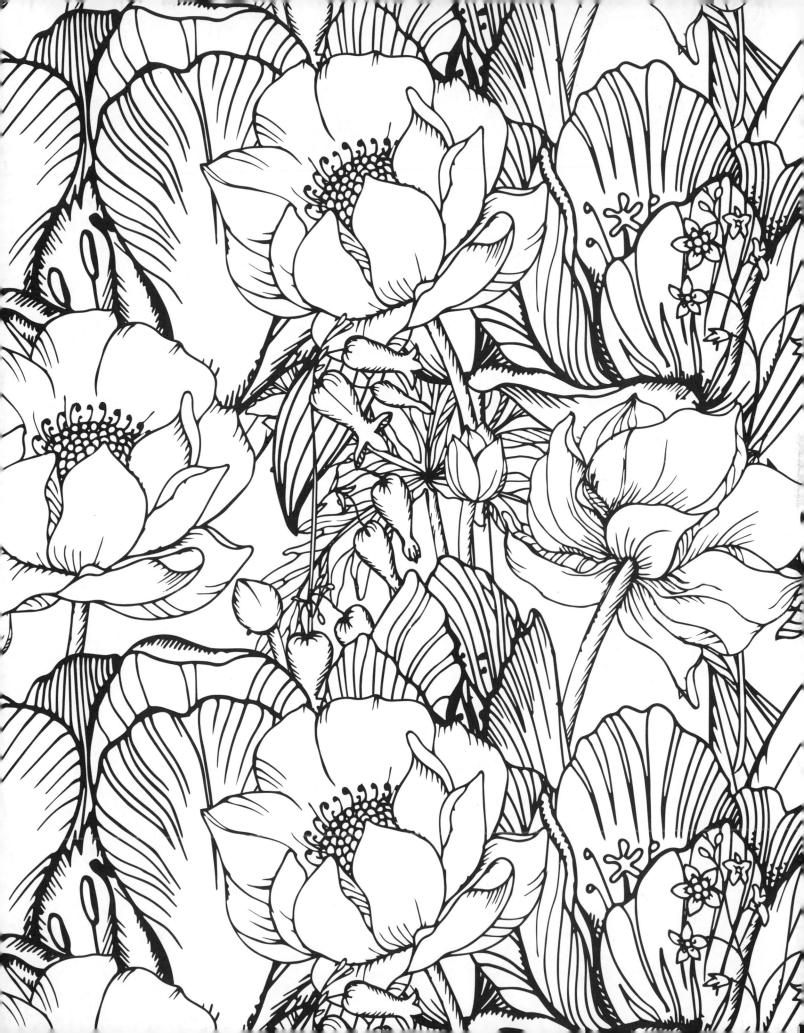

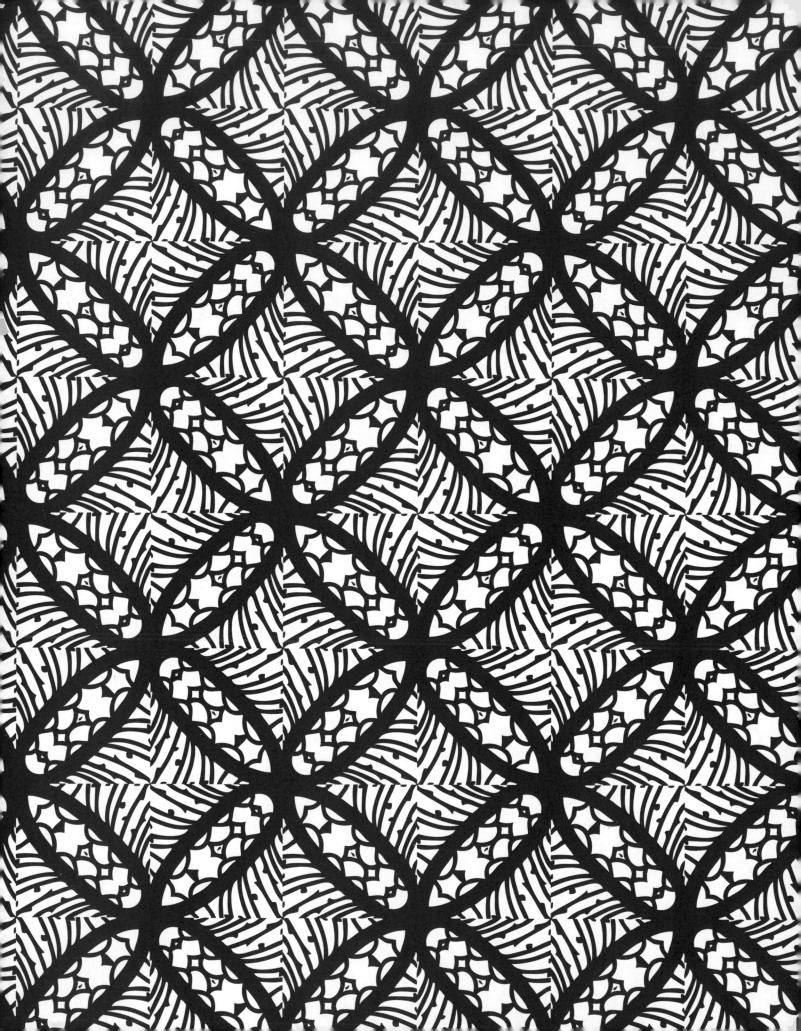

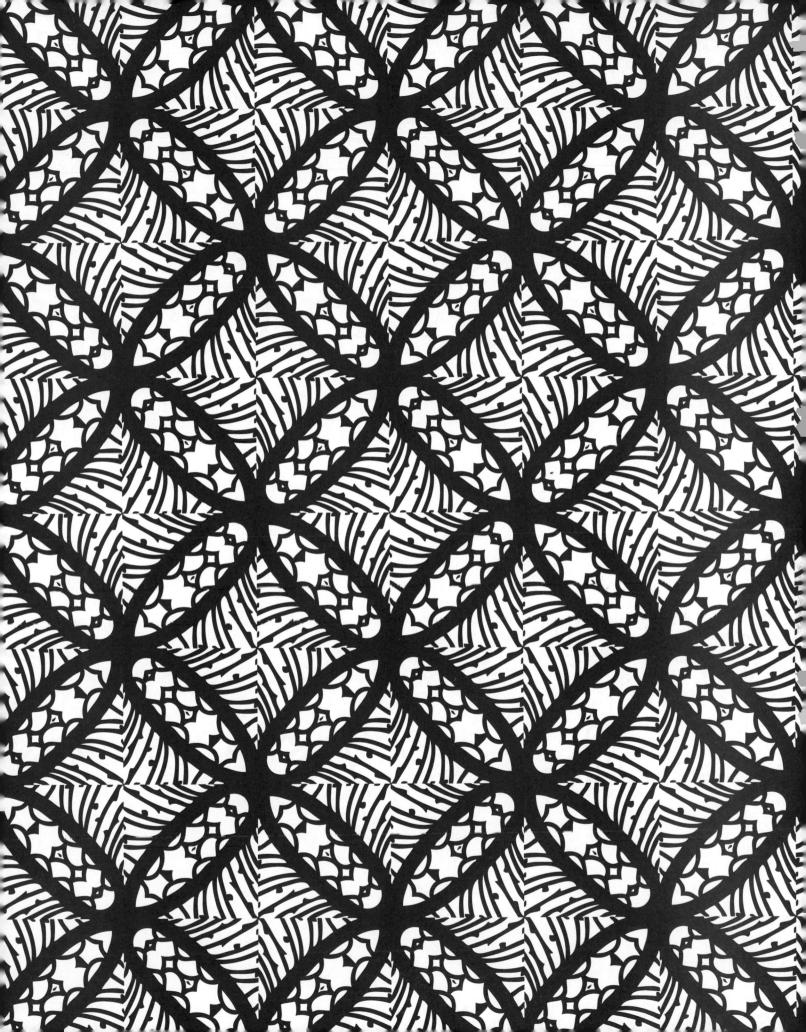

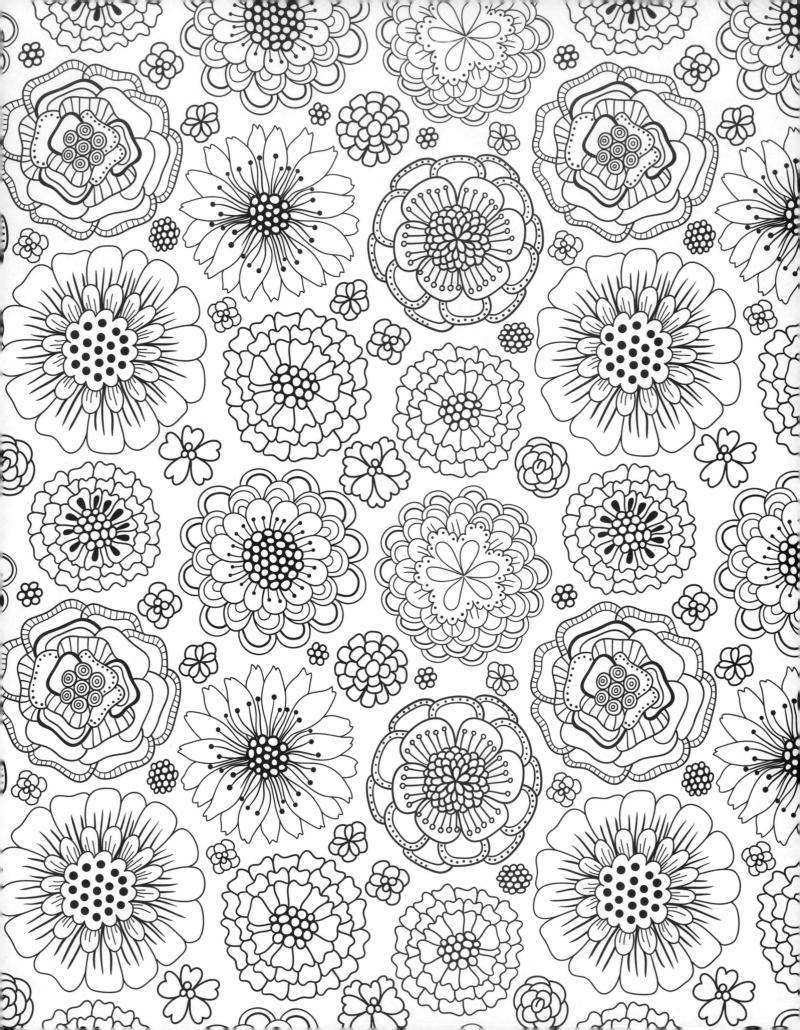

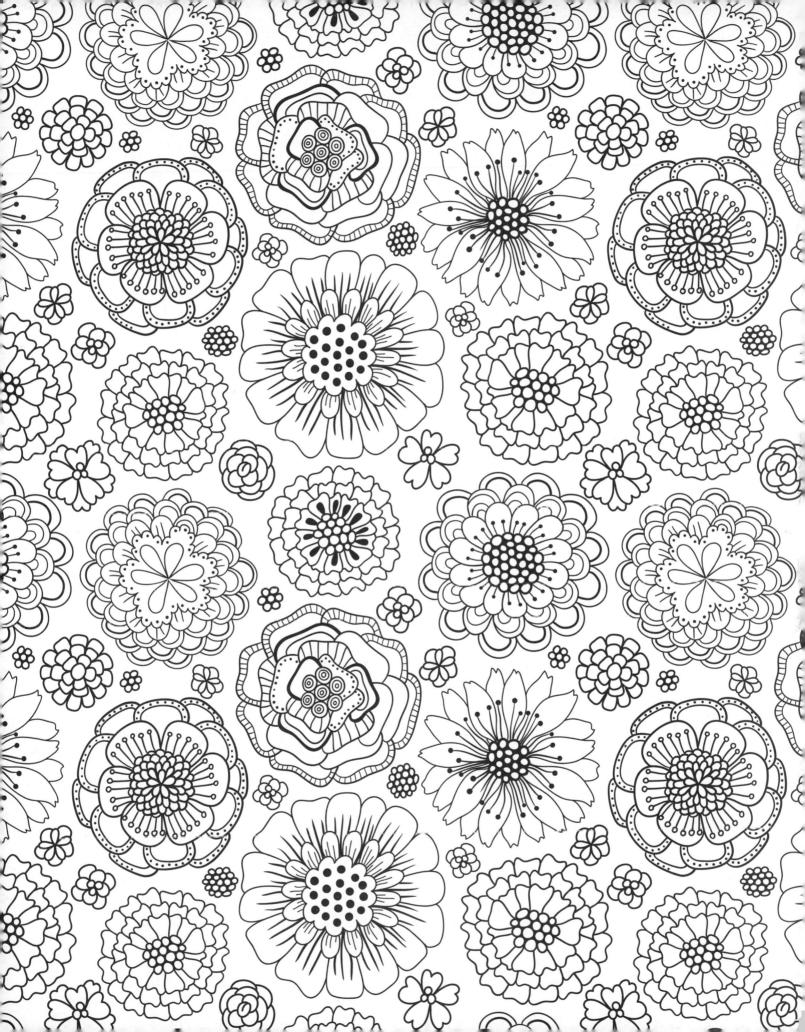

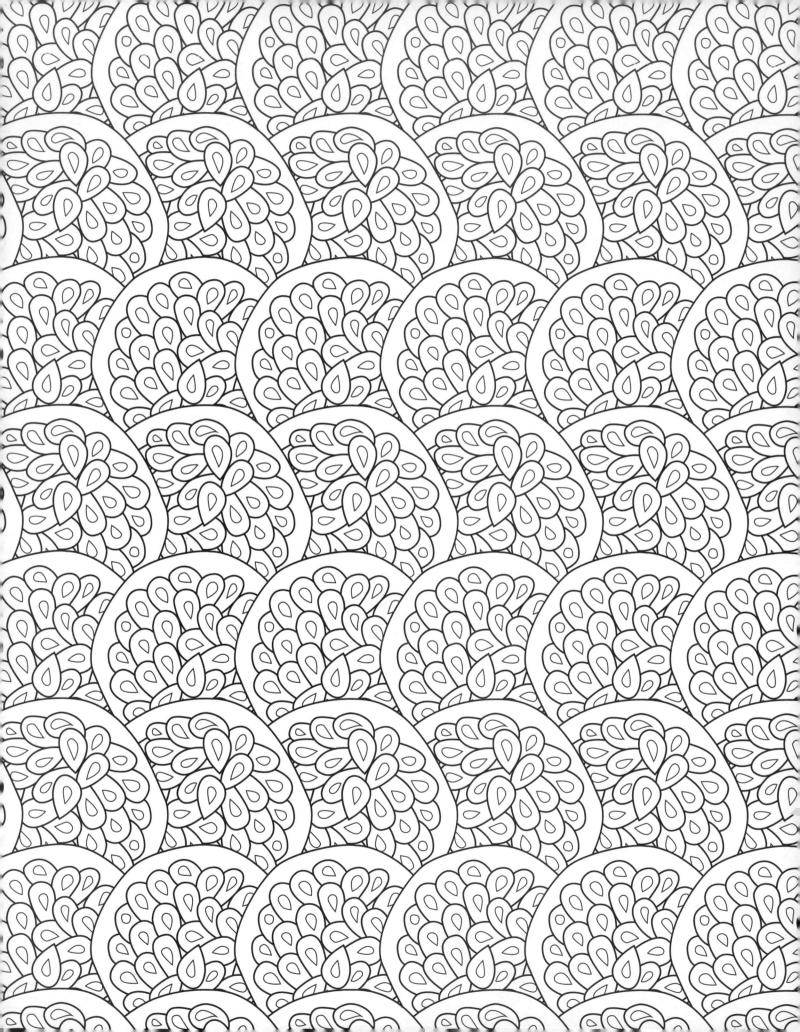

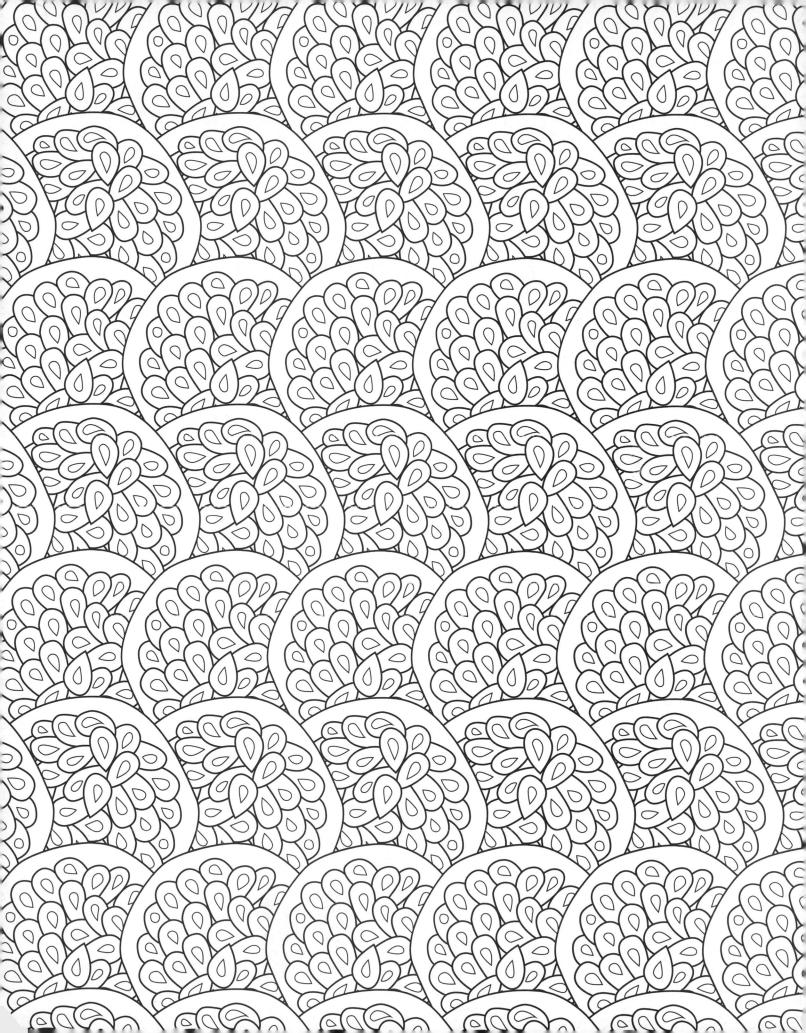

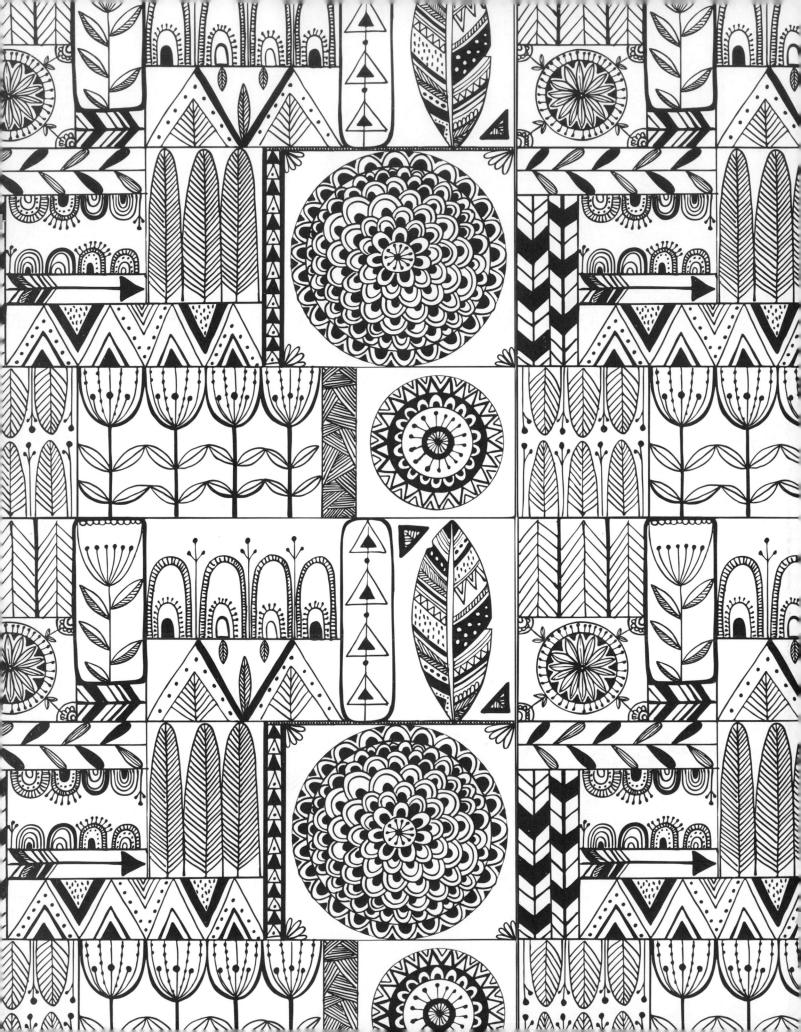